D0982719

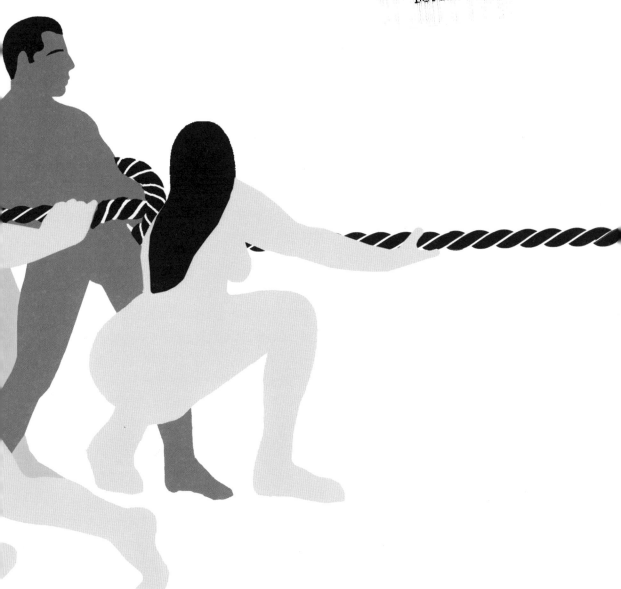

QUEER
X
DESIGN

QUEER X DESIGN

50 Years of Signs, Symbols, Banners, Logos, and Graphic Art of LGBTQ

ANDY CAMPBELL

BLACK DOG
& LEVENTHAL
PUBLISHERS
NEW YORK

CONTENTS

INTRODUCTION

Shortly after turning sixteen I was given the keys to my parents' rusty, gray Chevy Astrovan. Ready to begin exploring my hometown of Austin, Texas, one of the first stops I made was the local gay bookstore, Lobo. There I bought a thin, rainbow-striped bumper sticker with the intention of immediately adhering it to the back of "my new car." In my head such an action was a declaration—a public claiming of a piece of my identity I was still coming to terms with. But this potential for increased public visibility forced me to pause and reconsider. What if the sticker inflamed a fellow driver, causing an accident on the road? What if I got nasty looks or terrible catcalls? Was I prepared? This is how I came to be petrified in the midst of my teenage liberation—unsure of what I was doing or what the potential consequences might be. This existential crisis likely only lasted half a minute, but I remember time creeping to a halt with the weight of what seemed like a monumental decision.

Snapping out of it, I spat on a paper towel and cleaned the grime off the van's bumper. After peeling the long, slick backing off the sticker, I adhered it to the back bumper.

What I didn't know, but I suppose intuitively believed, was that minor acts like putting a sticker on a car aggregate and have the capacity to shift lived worlds. A thin rainbow stripe on the back of my car was a relatively insignificant yet nevertheless public indication that the driver was an LGBTQ person or ally. Things weren't as bad as I had feared, for as many times as I was the target of repulsed glares and shouts—likely due to my bad driving—I received twice as many friendly waves and honks from other LGBTQ folks and allies. Their bumpers sported rainbow stickers, too, and pink triangles, HRC logos, and a variety of queer-positive slogans.

In many respects I was quite privileged. I grew up in a liberal household and city, during a decade

when lesbians, gays, bisexuals, transgender people, and queers were newly welcomed into popular culture—albeit, not with the same zeal or nuance in all cases. Pedro Zamora and Ellen DeGeneres were on television; I could rent *Paris Is Burning* from the "gay and lesbian" section of my local Blockbuster (and I did, many times); RuPaul had a talk show on VH1; mainstream bookstores carried a small clutch of lesbian and gay magazines (*Out*, *The Advocate*, *Curve*, and *XY*) and feminist and gay bookstores carried everything else; I found my first boyfriends in online chat rooms and message boards; and I could avail myself of LGBTQ youth services and counseling if I ever needed them. It seemed that each year more and more people in my own life and in national culture came out publicly, expanding my community by degrees. I didn't yet understand the substantial importance of the decades of activism, struggle, and losses that preceded the good life I was able to live as a young, white, middle-class, gay kid in a fairly liberal Southern city in the 1990s.

Still—I remember reading about downtown gay bashings on a semi-regular basis; my mother and I watched in horror as the torture and murder of Matthew Shepard garnered national news coverage; and now, years later, I think of the transgender people who were murdered and whose lives and deaths were so stigmatized that their passing did not garner national sympathy or outrage. I never believed, despite the uptick in popular visibility, or the then-current claims to "lesbian chic," that my friends or I were safe in this world. With visibility comes vulnerability; every new milestone of acceptance prompts virulent backlash and bigotry.

My biological extended family didn't truly understand this aspect of LGBTQ life until my cousin, Christopher Loudon, was killed in combat operations in Iraq. In the days leading up to his funeral,

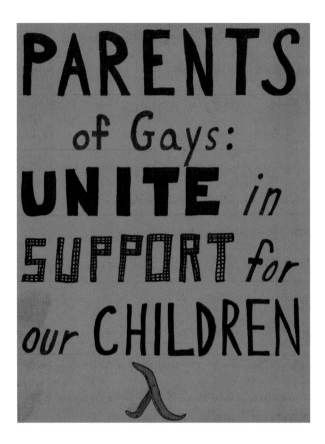

Jeanne Manford's original sign was a precursor for the national organization now known as PFLAG.

word arrived that Fred Phelps and his Westboro Baptist Church congregation, long famous for their "God hates fags" protests, were planning to picket our family's tragedy. On the day we all gathered at a local church in rural Pennsylvania, Phelps's followers showed up, carrying signs that claimed the death of my cousin was evidence of God's wrath visited upon a nation that too easily accepted LGBTQ people ("fags" was their term of art) into their fold. Phelps overstated the case—reality and sense often escaped him. My aunts and uncles didn't understand, in the depths of their grief, how anyone could say such vile

things. It pressed at the boundaries of my imagination, too, but my world had long included an awareness of people like Phelps. I found that in the midst of our collective mourning, I needed to do a fair amount of educating—and my family, a fair amount of listening.

I relay these anecdotes to point out the ways that LGBTQ life and politics regularly suffuse both the everyday and the extraordinary, just as the histories of LGBTQ communities are littered with mundane and outrageous acts. And for as much as we understand these histories, or think we understand them,

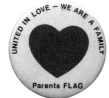

Some early examples of PFLAG buttons.

there is still much more to uncover and learn. One of the aspects of LGBTQ histories that has yet to receive sustained attention is the profound importance of design in the social and political livelihoods of LGBTQ people.

The history of the ally group PFLAG (Parents, Families, and Friends of Lesbians and Gays) is an instructive example. When Queens schoolteacher Jeanne Manford marched with her gay son, Morty, in the 1972 Christopher Street Liberation March in New York, she couldn't have known that her simple, handwritten sign reading "PARENTS of Gays: UNITE in SUPPORT for our CHILDREN" would essentially establish one of the most visible and important LGBTQ ally groups in the United States. Written in bold block letters on an attention-grabbing orange poster board, Manford's text possessed an educator's design intelligence—the capitalized words offering a truncated and expedient message to those standing on the sidelines of the march. Three years after the Stonewall uprisings, Manford's altruistic and

visible support of her child speaks beautifully to the intertwined legacies of LGBTQ-identified and non-LGBTQ-identified people acting in concert in coalitional struggles.

Manford's sign worked. And because of the outpouring of support she received from both LGBTQ people as well as parents and families, she and her husband cofounded Parents FLAG, which eventually became the national organization known as PFLAG. Over the decades of its existence, PFLAG has provided grassroots local and national support to a variety of LGBTQ causes—including anti-discrimination legislative initiatives, the development of educational materials aimed at destigmatizing and supporting LGBTQ people, and the rallying of sympathetic faith communities to larger LGBTQ causes. PFLAG's designs changed apace with the organization. Buttons from the organization's first decade sometimes rendered PFLAG's initialism literally as a waving flag—a clever, visual punning. Years later a poster designed for the organization's 1985 national

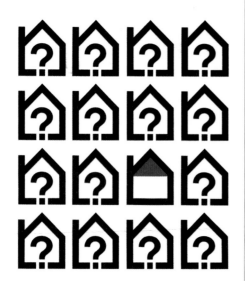

WHAT WILL THE NEIGHBORS SAY?

October 25 - 28, 1985
Colony Square Hotel
Atlanta, Georgia

**Parents FLAG
1985 Convention**

Fourth Annual Meeting of the
Federation of Parents and Friends
of Lesbians and Gays

Design: Tom Vitale

PFLAG's sly poster for its 1985 national convention.

convention dramatized the pearl-clutching protesta-
tions of their target demographic with visual wit and
sophistication. Riffing off the form of a gridlocked
suburban neighborhood, the poster moves its viewer
from stigmatization to acceptance. One house in the
neighborhood features a pink triangular roof, indi-
cating the presence of LGBTQ life inside. The other
houses contain question marks—visually manifest-
ing the question rendered in large, pink, capitalized

letters nearby: "What will the neighbors say?" But
the question marks also signify in another way, ques-
tioning what an LGBTQ family member might over-
look—that other households, too, might be dealing
with the same thing.

In 2004 PFLAG debuted its current logo, com-
prised of an interlinked red heart and orange triangle
placed atop a yellow starburst. The heart represents
the love of families and friends, and the triangle has
long been recognized as a symbol of LGBTQ commu-
nities. The starburst, in the words of the organization,
"represents the power of this united front to move
equality forward." Using the associative language of
symbolic representation, PFLAG, and many of the
groups discussed in this book, use design to leverage
visual cues that signal their commitments to a set of
shared principles and values. This is not unique to
LGBTQ communities and organizations—in fact, it
could be argued that anti-LGBTQ groups do the same
thing (those heinous Westboro Baptist Church plac-
ards were every bit as designed as Manford's), but this
book considers the signs, symbols, banners, graphic
art, and logos that power LGBTQ communities in
their ongoing struggles and celebrations. In short,
these are examples of designs that are largely made for
us, by us. Paying attention to the intricacies of their
histories can, in the words of queer architectural and
design scholar Aaron Betsky, "amaze us, scare us, or
delight us, but certainly open us to new worlds within
our daily existence."

A few distinct tensions mark national LGBTQ
histories and emerge as key features in LGBTQ
design. The first and perhaps most important of
these is the ambivalent relationship between seeking
broad societal acceptance and finding innate value

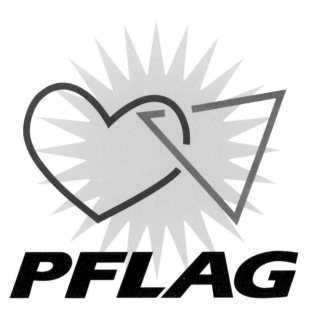

The current logo.

in homosexuality's outlaw history. For some, such as bisexual activist Lani Ka'ahumanu, there is a bright line between these two approaches. "Remember," Ka'ahumanu warns us, "assimilation is a lie, it is spiritual erasure." Her statement can be read as an excoriation of the values of assimilation—whereby one plays down one's differences to fit in with a larger social group—but it can also be taken as a call to innately *value* difference. Not everyone in LGBTQ communities feels the same as Ka'ahumanu. Some are vocal about simply wanting to lead a "normal" life (whatever that may mean), with all the trappings that would come with such a desire. Indeed, this tension exists graphically, too, in the difference between the unabashed flamboyance of Gilbert Baker's rainbow pride flag and the focus group–tested logo of the Human Rights Campaign—who, in working closely with design firm Stone Yamashita Partners, made LGBTQ concerns palatable to a broad swathe of the U.S. electorate.

Many of these tensions over assimilation play out in the arena of language. LGBTQ people have constantly defined and redefined the words and terms used to describe their desires, gender identities, and political interests. Over the period covered in this book LGBTQ people have called themselves homophiles, homosexuals, gays, lesbians, faggots, dykes, trannies, queers, genderfuck, transgender, and so much more. Such identitarian terms are historical, emerging at particular times and falling away after years of use. Speak of "homophiles" and one hearkens back to a time when men and women spearheaded pre-liberation political organizations such as the Mattachine Society. Saying the word "queer" recalls the activist moment immediately following the start of the HIV/AIDS pandemic. Queer Nation, one of

The pink triangle, reclaimed and resignified.

the most prolific and vociferous organizations during this time, reclaimed "queer" from its popular usage of denigrating and devaluing the lives of LGBTQ people, and developed the telling slogan and political chant: "We're here! We're queer! Get used to it!" The same is also true of visual symbols. What was once a symbol of the vilest intolerance—for example, the pink triangle as used by the Nazis to mark homosexual men during the Holocaust—was actively reclaimed and resignified as a badge of empowerment and solidarity. What more convenient foundation for such political alliances than a shared experience of oppression?

The second tension regards *who*, exactly, is the imagined audience for LGBTQ design. Some items in this book, like the "gay money" stamps created throughout the 1970s, eighties, and nineties, are forthright in their address of a broadly conceived national community. The idea was that money stamped with phrases like "Gay $" and "Dyke Dollars" could make visible the purchase power of LGBTQ people. Gay money could come from the local convenience store or supermarket; anyone could have gay dollars in their

wallet or purse. In striking contrast to gay money's public address, Bob Mizer's "Subjective Character Analysis"—an ideographic code that identified the sexual characteristics and behaviors of his many hunky male models—was meant to be circulated only among a relatively small coterie of like-minded individuals. Flags, like Monica Helms's transgender flag, do both at once: affirming the experiences of trans individuals while also announcing their presence within larger LGBTQ and straight communities. In their materiality, composition, typography, iterability, and language, LGBTQ designers identify and aim their messages at particular audiences.

Many of the designs in this book demonstrate a third tension, which is that LGBTQ livelihoods are marked by both struggle and celebration; agitation and compromise. If the civil rights movement of the mid-twentieth century taught us anything, it is that the terms of liberation must be demanded and taken; for they are not generally given freely by those in positions of power. As one of the historical influences on the gay liberation movement (along

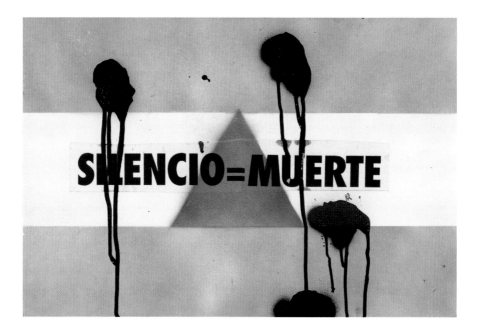

A powerful Spanish-language version of the iconic Silence=Death design.

with the near-contemporaneous women's libera-tion movement), U.S. civil rights movements of the 1950s and 1960s offered a template for imagining and seizing a different life. The equals sign, the upraised fist—these are common motifs in LGBTQ design derived directly from the civil rights graphics that came before. The equals sign, for example, is central to the "Silence = Death" logotype developed by a small group of graphic designers and artists in the early years of the AIDS pandemic. As one of the most dire and devastating events in LGBTQ history, the AIDS pandemic (which is still ongoing, despite the devel-opment and distribution of more and more new phar-maceuticals) is no cause for celebration, but rather for action. The stirring designs of the Silence = Death Collective and the various art and design groups allied with ACT UP (AIDS Coalition to Unleash Power)

rage against government inaction, pharmaceutical opportunism, and public apathy. Performative activ-ist strategies such as "die-ins" and ceremonial scatter-ings of ashes in places of political power accompany the seemingly more inert graphics developed by these groups. But these signs and graphics must be imag-ined in motion—in the upraised hands of protestors, covering their torsos and heads as they show up for themselves and their communities. But not every-thing is doom and gloom. In the midst of the AIDS pandemic, C. M. Ralph, who was witness to the dev-astation of HIV/AIDS in San Francisco, developed the first queer video game—Caper in the Castro—as a kind of love letter to her communities. Filled with in-jokes and intrigue, Ralph's game provided lightness in a time of great darkness, a celebration when there seemed to be little to celebrate. It remains, for me,

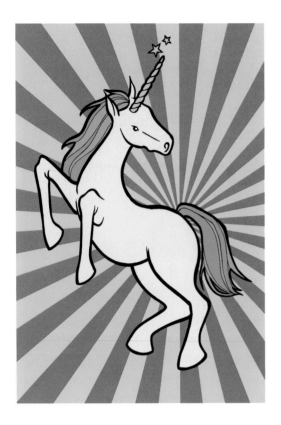

Dandy Unicorn

one of the most remarkable designs of the period for this reason alone.

Today, my everyday world is indelibly marked by LGBTQ design. Banners of the rainbow flag are placed at intervals along the University of Southern California's main thoroughfare during the month of June; ten feet from my office door is a newly minted gender-neutral restroom—a white triangle on a blue circle marking that anyone is welcome; and on top of my bookshelf rests a cardboard sign that I carried in the 2011 QueerBomb! march and rally. Some symbols I have a particularly personal relationship with—such as Dandy Unicorn, the gender-ambivalent figurehead/

mascot of The Gay Place, and the weekly LGBTQ section of the *Austin Chronicle*, an alternative news weekly. During graduate school I worked for The Gay Place, then under the editorship of Kate X Messer. She commissioned choreographer and designer Lindsey Taylor to design a unicorn mascot for The Gay Place. Magical and unique, the unicorn that Taylor created spoke to the values of difference and empowerment so endemic to LGBTQ histories. Soon, Messer and I *became* Dandy Unicorn—using the persona to comment on people's Facebook walls and organizing contingents in the local pride parade under the sign of our mascot.

I took these lessons of Dandy Unicorn to heart after moving to Houston. Realizing that there were many gay bars, but no queer spaces that welcomed gender nonconforming and trans revelers, a small group of friends (myself included) started a queer dance party called Dykon Fagatron. Held monthly, the party featured DJ sets and live performances. Before throwing our first event, Ana Elise Johnson—one of Dykon Fagatron's primary collaborators—created what would be the logo of the party. Realizing that one of the barriers to welcoming genderqueer revelers into an exclusively gay space was the presence of gender-neutral restrooms, the logo Johnson developed ultimately also hung on the doors of the venue's restrooms. Taking the concept of the pan-gendered restroom to its absurd and playful extreme, Johnson's design included both male and female pictographs, as well as iconography related to disability, dissent, and monstrosity. It was a ridiculous graphic, meant to poke fun at the gendered separation of spaces; and a signal to all that no matter how you identified, this party was for you. The success of the party proved the intelligence of Johnson's design—just as the conversations

One version of the Dykon Fagatron logo.

between regular bar patrons and Dykon Fagatron partygoers proved the utter variety of LGBTQ experience.

What Dandy Unicorn and the Dykon Fagatron logo crystallize for me is the fact that design has the capacity to change some of the terms of everyday life, no matter how slight. But for LGBTQ design to move forward, we must be aware of its past. The poet, publisher, and activist Audre Lorde makes this point beautifully, in one of her essays in the compendium *Sister Outsider*: "But there are no new ideas waiting in the wings to save us as women, as human. There are only old and forgotten ones, new combinations, extrapolations and recognitions from within ourselves—along with the renewed courage to try them out."

LGBTQ design is about audacity, trying things out, and sometimes failing. Because LGBTQ people have historically been denied positions of political and economic power—or even basic protections from those who would threaten our lives and livelihoods—many of the designs discussed in this book share, by dint of circumstance, similar origin stories: namely, courageous individuals and small groups working

together to visualize and imagine new political horizons. There is an honesty and earnestness in this task. But for too long these designers' and activists' contributions have gone uncollected and untold. I hope that in some small way this book changes that. I have gathered here examples of LGBTQ design from the pre-liberation period to now, giving form to the manifest complexities, contradictions, and innovations of LGBTQ communities. The designs contained in this book have been culled from a variety of archives, public institutions, and private organizations—some are being published for the first time.

One thing is certain: from the homophile movements of the 1950s to the growing concerns of contemporary LGBTQ movements in tackling intersectional oppressions, the depth and breadth of the U.S. LGBTQ experience is deep and vast. In assembling this astonishing collection of LGBTQ design, I take a cue from the poet Essex Hemphill, who wrote, "I need the ass-splitting truth to be told, so I will have something pure to emulate, a reason to remain loyal." Consider this a first, and not a final, attempt to tell some of these stories.

Pre-
Liber

ation

PRE-LIBERATION

Homosexuality, and heterosexuality by extension, is a modern invention. The mutually constitutive terms were coined in an 1868 letter sent by Karl-Maria Kertbeny, an Austrian-born Hungarian journalist, to Karl Heinrich Ulrichs, a writer and sexual reform campaigner in Germany. Up until then, Ulrichs had referred to men who had sex with other men as "urnings" or "uranians"—a term derived from the Greek goddess Aphrodite Urania, formed from the testicles of the sky god Uranus. Ulrichs's term suggested a third gender, a purposeful melding of male and female energies, whose natural result was the development of same-sex attraction. Although homosexual behavior has been documented in nearly every society—modern and ancient—before Kertbeny coined the term "homosexual," at least in Europe and in the United States, men who had sex with other men were not known under strict identitarian terms, but rather for their behavior as sodomites—those who engaged in non-procreative, penetrative sex. The term "lesbian" was preceded by the term "tribade," which derived from the Greek and Latin word for "rub," erroneously suggesting that lesbian sex was, by default,

non-penetrative. Interestingly, the term "bisexual" predates both "homosexual" and "uranian"—having been in use for at least a century by botanists.

This brief rehearsal of some of the key terms of proto-LGBTQ identities is necessary, because identities are historical effects of social conditions, consolidated at specific moments in time. It may be odd—truly queer—to think that a man who had sex with another man in the late nineteenth century was not gay, or that a woman who loved another women in the nineteenth century was not a lesbian (as was the case with Emily Dickinson and her [eventual] sister-in-law Susan Gilbert), but this is essentially the point. Claiming such would be anachronistic—placing the more familiar terms of today onto the past. Although we use the words "lesbian" or "gay" to name female-female and male-male desire today, and "transgender" to name a variety of gendered and sexed identifications outside of the normative male/female, masculine/feminine binaries, these were not terms in circulation in the years leading up to the uprisings at Gene Compton's Cafeteria (San Francisco), Cooper's Do-nuts or the Black Cat (Los Angeles), and the

Stonewall Inn (New York)—the events that signaled a cultural shift toward the conditions of liberation.

Even without the familiar identifying terms of today, men who had sex with other men, women who had sex with other women, and those who fell outside of normative gender and sex binaries were subject to extreme social pressures and legal persecution and prosecution. Punishment for sodomy and the more vague "crimes against nature" effectively criminalized homosexual activity—even though sodomy covered a range of activities (such as oral sex) not exclusive to male-male or female-female sexual expression. Dress code laws prohibited cross-dressing and other visible forms of transvestite appearance. These laws were enforced selectively, and importantly did not apply to the many vaudeville performers who dressed in the clothes of the opposite gender. Their transgressions were sanctioned because they were assumed to be only temporary and for the purposes of entertainment. All of these restrictions were imposed supposedly to uphold the moral standards of broadly defined and imagined city, state, and national communities. That these communities were never assumed to include

other LGBTQ people is evidence of the second-class status of the LGBTQ community. Thus, some of the earliest evidence that we have of LGBTQ life in the United States come in the form of arrest records, individuals arraigned under repressive legal regimes.

As the philosopher Michel Foucault described in the indispensible first volume of his sprawling and unfinished *History of Sexuality* series of books, such repressions actually occasioned the innovation and sedimentation of sexual cultures. In response to police surveillance and oppression, the first organizations dedicated to the causes of criminal justice reform and mutual support were established. Groups such as Chicago's Society for Human Rights or the Los Angeles–based Mattachine Society melded a broadly liberal politics—Mattachine's founder, Harry Hay, was a labor activist and an avowed Communist—with a growing sense of urgency regarding the dismissal and perceived disposability of homosexual lives. Such organizations, because they oftentimes had to operate in secret, developed rich visual codes, which stealthily hid references to homophile political concerns and causes in the guise of benign symbols. Mattachine's

name and primary symbol was that of the jester, a reference to Il Mattaccino—the jester character from the Italian commedia dell'arte theatrical tradition, who often had the ability to speak truth to the power of the king. Hay and the members of Mattachine thought of their role in similar terms; while seemingly frivolous and the butt of many jokes, the jester could also be a surreptitious agent of social change.

The pre-liberation period was a time of innovation in terms of the most common symbols of LGBTQ communities. The astrological signs for Mars and Venus were imported from the natural sciences (most especially the taxonomical writings of eighteenth-century Swiss naturalist Carl Linnaeus) where they identified the effective sex of male and female plants, respectively. Although the history of the interlinked Mars and Venus symbols is murky at best, the presence of astrological symbols in Bob Mizer's "Subjective Character Analysis," for example, suggests that these were somewhat known symbols within homophile communities. The pink triangle was a less common, but nevertheless present, signifier, as it had been the symbol used by Nazis to identify and exterminate male homosexuals. Lesbians were branded with a black triangle, the symbol for "asocial" men and women, a broad category that included prostitutes, those who had sex with Jews, and thieves.

This latter point illuminates a common problem within LGBTQ histories, which is the relative invisibility of lesbians in broad historical overviews of the period. Lesbians, like gay men, developed a host of organizations and institutions during the pre-liberation period—and some exceptional individuals, such as the blues singer Ma Rainey, were well known, even publicly promoted, for their purported love of other women. Lesbians appeared in popular culture on the covers of pulp novels—with more masculine-presenting women commonly framed as insidious corruptors of their (always assumed) more feminine-presenting counterparts. Groups like Del Martin and Phyllis Lyon's Daughters of Bilitis developed noteworthy visual symbols—such as the "qui vive" logotype (French for "on alert")—as they argued for the decriminalization of their lives.

The 1950s also saw the establishment of the gay male motorcycle clubs—famously inspired by Marlon

Brando's portrayal of a bike gang tough in the 1953 film *The Wild One*. The first of these groups, the Satyrs Motorcycle Club (or MC) of Los Angeles, used the impish, mythological creature as their club insignia—and it appeared on newsletters, flyers, banners, and patches (also known as club colors). To escape the repressive regimes of urban centers—where the police and mafia controlled the conditions of gay social life—the members of gay MCs rode out into the country for long holiday weekends where they could socialize without interference. These clubs marked the beginnings of contemporary gay and lesbian leather/BDSM communities and cultures.

In 1964 *LIFE* magazine ran a story entitled "Homosexuality in America." It was a watershed piece of journalism from the garrets of the mainstream press, and it did LGBTQ people no favors. Over the course of several pages the author and photographer portrayed gay male social life (lesbians and transgender folks were largely left by the wayside) as set within a dark and dangerous milieu, filled with men who were either too effeminate ("sweater queens") or too masculine ("leathermen"). Clark Polak, a homophile activist living in Philadelphia, published *Drum* magazine in response. *Drum*'s first issue featured a story written by P. Arody (likely a pseudonym for Polak), entitled "Heterosexuality in America," satirically lambasting the loose sexual mores of Hollywood stars and the average American heterosexual. Polak was also involved in a sequence of annual pickets beginning on July 4, 1965, and ending in 1969, by local homophile organizations such as the Mattachine Society and the Janus Society in front of Philadelphia's Independence Hall—the building then housing a symbol of American democracy, the cracked Liberty Bell. Participants of these events called them "annual reminders," and they were conceived to prompt Philadelphia's residents to remember that LGBTQ persons were consistently denied basic civil and human rights. These "annual reminders" were the model for the popular political and performance form known variously as the gay freedom/liberation march or gay pride parade.

In the period before the Stonewall uprisings, LGBTQ people experienced broad societal discrimination and prejudice, which they met with innovation, imagination, and action.

FIRE!!

Although it only existed for one issue, *FIRE!!*, a quarterly literary magazine dedicated to "younger negro artists," nevertheless had long-lasting and wide-ranging effects. The poetry, illustrations, and stories within represented the collective efforts of seven giants of the Harlem Renaissance: Wallace Thurman, Langston Hughes, Zora Neale Hurston, Gwendolyn Bennett, Aaron Douglas, Richard Bruce Nugent, and John Davis. Of these, Hughes and Nugent were gay. Thurman, whose uptown apartment served as an informal salon for many of these luminaries of the Harlem Renaissance, featured murals painted by Nugent, as did several other clubs around Harlem (some with apparently explicit homoerotic content).

Nugent contributed two items to *FIRE!!*, the first a pair of drawings, both depicting women whose bodies are bracketed by lively geometric design. Appearing separated across several pages, these drawn women nevertheless form an imaginary couple. Nugent's other contribution was a prose poem entitled "Smoke, Lilies, and Jade," the first literary work written by an African American to openly discuss homosexuality. Nugent did not publish the piece under his surname, fearing that the overt sexual politics would reflect badly on his family. In this, and in other ways, gay and lesbian artists of the Harlem Renaissance balanced a desire to be open about their sexuality, while also taking into account the broad stigma such desires received.

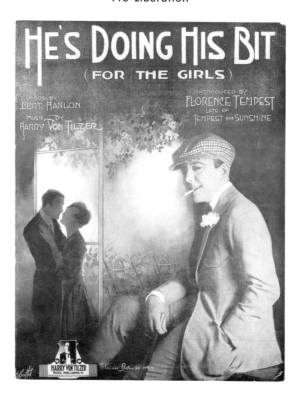

FLORENCE TEMPEST SHEET MUSIC ILLUSTRATION

Born Claire Lillian Ijames, the American vaudeville performer known as Florence Tempest impressed audiences with her cross-dressing abilities while crooning the lyrics to songs such as "I Love the Ladies" and "I Want a Boy to Love Me." The former tells the story of a distracted college boy who gives up his studies to chase women; while the latter was a more forlorn and pining tune. The songs at once celebrate and lightly mock gender stereotypes. Before radio usurped vaudeville's audiences, popular songs would be released as sheet music, and cover illustrations did much to communicate a song's content and sentiments. In many of these sheet music covers, Tempest is dressed in boy drag, in dandified suits and workmen's clothes.

Tempest's cross-dressing presentation was an outgrowth of her earlier performances with her biological sister (they worked together under the name Tempest and Sunshine). Sheet music from these early performances show Tempest dressed in masculine clothing and her sister in more feminine attire.

Tempest was hardly the only cross-dressing vaudeville performer. It is important to remark that such theatrical cross-dressing did not necessarily align with incipient LGBTQ identities. Instead, cross-dressing performances of Tempest's kind were valued as a type of illusion, on par with other performance genres such as magic or blackface, both of which were also ubiquitous on the vaudeville stage.

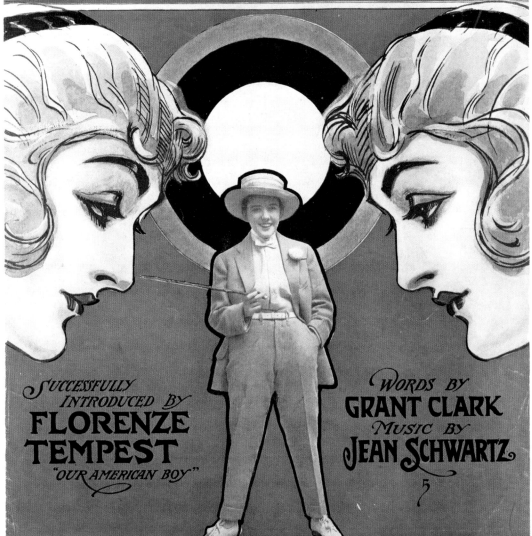

IT'S THE WONDERFUL WAY HE LOVES

WRITTEN ESPECIALLY FOR MISS FLORENCE TEMPEST

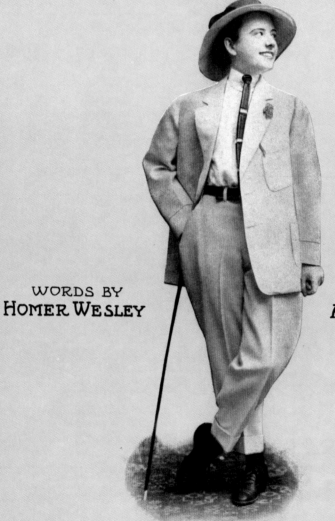

WORDS BY
HOMER WESLEY

MUSIC BY
AL. PIANTADOSI

5

POPULAR EDITION
LEO. FEIST INC. NEW YORK
ASCHERBERG HOPWOOD & CREW, LTD. LONDON, ENGLAND

I WANT A BOY TO LOVE ME

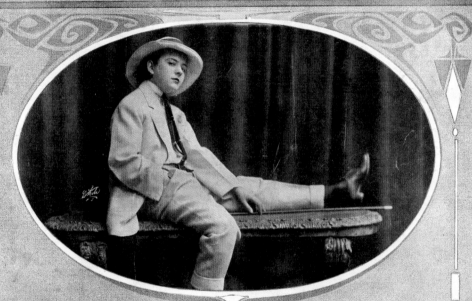

AS SUNG BY

FLORENCE TEMPEST

IN HER MUSICAL PRODUCTION

"COLLEGE DAYS"

LYRIC BY

STANLEY MURPHY

MUSIC BY

HENRY I. MARSHALL

JEROME H. REMICK & CO. NEW YORK-DETROIT

1148

BANTAM BOOKS

25¢

THE NOVEL OF A LOVE SOCIETY FORBIDS

THE PRICE OF SALT

CLAIRE MORGAN

"[handles] explosive material...
with sincerity and good taste." New York Times

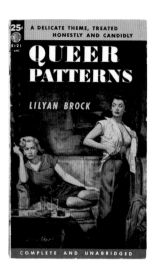

LESBIAN PULP FICTION

Joining other popular genres such as mystery, romance, and western, lesbian pulp fiction was once standard fare, available for purchase at bus stations and corner stores. The lurid covers of the novels dramatized the common stigmas attached to mid-twentieth-century lesbian identities—featuring a butch, more masculine-presenting woman guiding, leading, and even preying upon a more feminine-presenting woman. While such compositions may seem comic or campy today, these women were visualized as both true gender aberrations and titillating eye candy for an assumed male readership. But if these covers appealed to men, the moral messaging inside the covers was aimed squarely at a female readership. These novels often ended with the couple in dire straits—death was a common, and condemning, plot device. As titillating as they were, the message was clear: disaster unquestioningly follows sexual deviance, and no homosexual could reasonably expect a happy ending within their lifetime.

One novel that went on to become a classic of American fiction, and that defied many of the conventions of lesbian pulp fiction, was Patricia Highsmith's *The Price of Salt* (recently popularized as *Carol*, in a film directed by Todd Haynes). Like many writers who sought to write about lesbian lives and loves, Highsmith initially used a pseudonym—Claire Morgan. The book's cover (left) depicts two women inhabiting a space that is paradoxically domestic (notice the couch), dangerous, and otherworldly. A man lurks in the distance, a former lover come to reclaim his partner. In terms of its plot *The Price of Salt* is notable not only for its literary ambitions but for its refusal to succumb to an unhappy ending, as Highsmith's narrative ends on an ambiguous note. In 1983, the lesbian publishing house Naiad Press offered to reprint Highsmith's novel, stipulating a higher price if the author used her own name over the pseudonym, an offer Highsmith refused. It wasn't until the novel was retitled *Carol* (1990) that it finally carried Highsmith's byline.

"PROVE IT ON ME BLUES" ADVERTISEMENT

Went out last night, had a great big fight
Everything seemed to go on wrong
I looked up, to my surprise
The gal I was with was gone.

So begins "Prove It on Me Blues," one of Gertrude "Ma" Rainey's most explicit songs about the vicissitudes of lesbian love. The historian Jonathan Ned Katz called the sauntering tune an "assertive song of lesbian self-affirmation and defiance," and the accompanying print advertising campaign put out by Paramount Records (a popular publisher of "race" records) confirms Katz's assessment. In the ad Rainey is shown twice, once in an illustrated headshot, and a second time dressed up in a smart three-piece suit flirting with a pair of elegantly attired women. A police officer across the street swings his billy club, an explicit acknowledgment of the potential threat of

physical violence from law enforcement tasked with administering moral or "vice" laws—laws that effectively criminalized homosexuality, as well as transgender and gender non-binary people. In many instances people who dressed counter to gendered expectations had to retain at least three items of gender-appropriate clothing. For women this was somewhat feasible, as stockings, bras, and panties could be concealed under otherwise masculine clothing, but for men dressing against normative gender conventions this proved to be more difficult. The tricky politics of Rainey's dress is reflected in a later verse of "Prove It on Me Blues":

It's true I wear a collar and a tie
Makes the wind blow all the while
Don't you say I do it, ain't nobody caught me
You sure got to prove it on me.

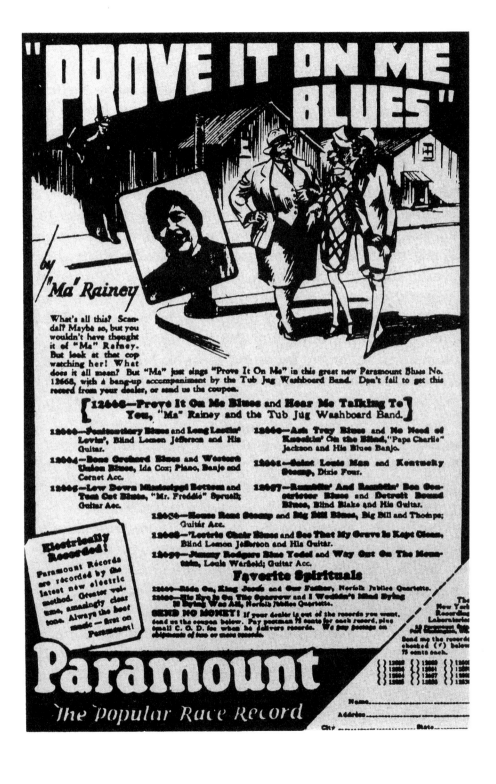

The Homosexual Magazine

one

something

about

sailors

TWENTY-FIVE CENTS

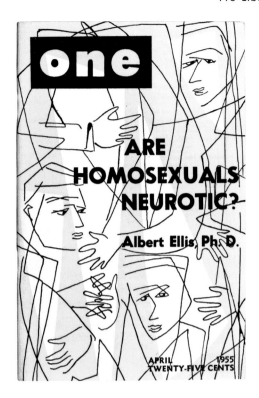

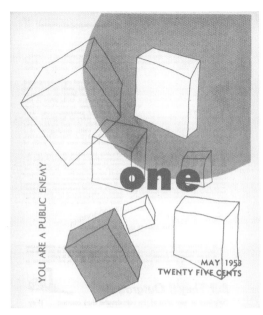

ONE MAGAZINE

Devised as the voice of the newly incorporated homo-phile (homosexual) organization ONE, Inc., the first issues of *ONE* magazine feature the jazzy, abstract designs of founding board member Joan Corbin (who went by the pseudonym Eve Elloree). Even before designing the first issue of *ONE*, Corbin and her part-ner were involved in the nascent LGBTQ movement as early subscribers to the first lesbian publication, *Vice Versa*, while the two lived in Ann Arbor, Michigan. Corbin's illustration work for *ONE* featured geometric designs that frame the key social questions surround-ing the place of homosexuals in contemporary society: "You are a public enemy" reads one cover, and another asks "Are homosexuals neurotic?" Corbin would first draw her designs, later transferring them to printing blocks, so they could be used to print multiple copies of *ONE*.

A key function of publications like *ONE* is their ability to cohere reading publics, calling forth a reader-ship of like-minded individuals with similar interests. This was dangerous work: during the first two years of the magazine's life, for example, it was seized twice for violating obscenity laws (although the editors were never convicted). Despite these setbacks, the magazine continued to be in production until 1967. As one of the few overly pro-gay publications in existence during the 1950s, the magazine had a broad impact on successive generations of LGBTQ activists and publishers.

THE LADDER

"Qui Vive" (French for "on alert") is the logoized motto of the Daughters of Bilitis—the first exclusively lesbian organization in the United States. It appears on many of the early covers of the group's magazine, *The Ladder*, first published in 1956 (above). Initially the "Qui Vive" logo was devised as a wearable pin, designed so that group members could identify one another in public without blowing their cover. During a time when homosexuality was criminalized, privacy and discretion were dire necessities. Like *ONE* magazine, the publication promoted a conservative take on gay politics and visibility. The editors (and founders of the Daughters of Bilitis), Phyllis Lyon and Del Martin, advocated for women to wear feminine dress—countering the butch/femme dynamic pervasive among lesbian communities at the time. Assimilation was the coin of the realm, and *The Ladder* proved a useful tool in a bid for respectability.

The earliest covers of *The Ladder* (right) feature a silhouetted line of people all ambling toward a skyward ladder. Indicative of the Daughters of Bilitis's concern for public appearances, the couple on the cover appear to be a normative heterosexual couple. Still, the play on words of the magazine's title combined with the cover imagery would have been resonant for a lesbian readership: it depicts people climbing the ladder out of the well of loneliness (a reference to Radclyffe Hall's signal novel, *The Well of Loneliness*).

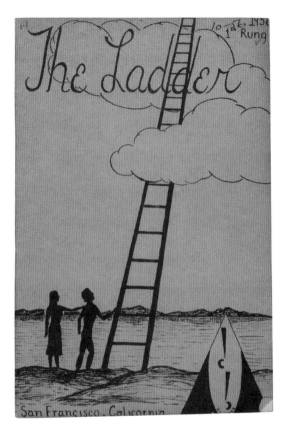

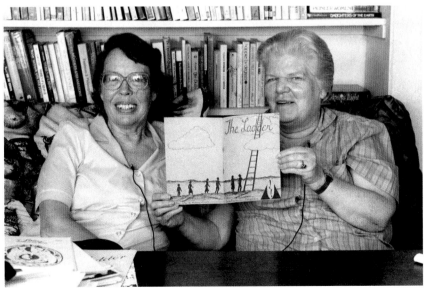

Phyllis Lyon with Del Martin, who is holding an early issue of *The Ladder*.

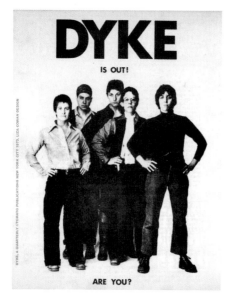

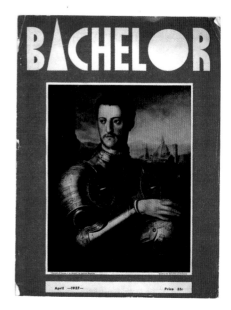

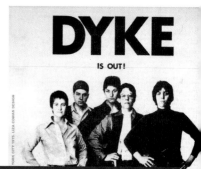

UNDERCOVER

If you want to know about LGBTQ communities and their histories, read a magazine. In their seriality and handily consumable format, magazines have been central to the public expression and networking of various LGBTQ communities. Developed from every quarter of the LGBTQ community, each periodical has its own mission and purpose, coalescing its own readership around a set of shared concerns. A magazine's cover can tell you a lot about what is contained within. Although published well before the establishment of homophile political movements, the editors of *Bachelor*, a short-lived publication aimed at bachelor men, often put provocative works of art on their covers. If the magazine spoke of homosexuality, it was in highly controlled and veiled, coded language. Later magazines such as *DYKE* hilariously sent up the typographic and graphic design choices of *LIFE*, a mainstream magazine known for its photojournalism. An early cover of *Azalea*—a magazine of "third world" womens' writings (women of color)—images a brownred woman in profile with two linked Venus symbols as an earring.

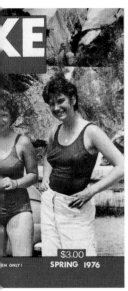

$3.00

EN ONLY! **SPRING 1976**

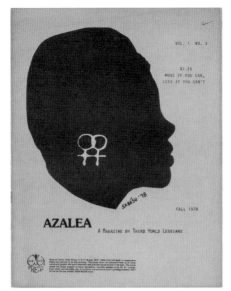

VOL. 1 NO. 3

$3.25
MORE IF YOU CAN,
LESS IF YOU CAN'T

FALL 1978

AZALEA
A Magazine by Third World Lesbians

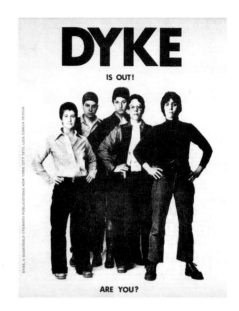

DYKE
IS OUT!

ARE YOU?

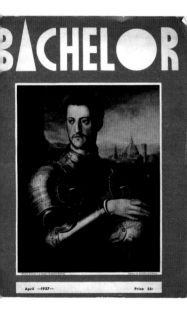

BACHELOR

April —1937— Price 35¢

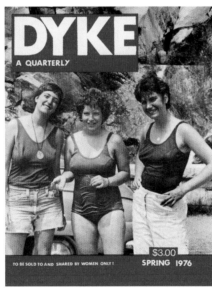

DYKE
A QUARTERLY

$3.00

TO BE SOLD TO AND SHARED BY WOMEN ONLY! **SPRING 1976**

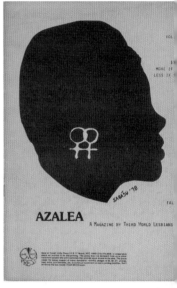

VOL

MORE IF
LESS IF

AZALEA
A Magazine by Third World Lesbians

FAL

DYKE
IS OUT!

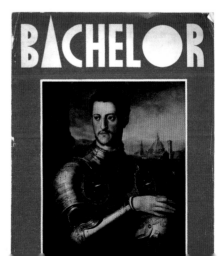

BACHELOR

DYKE
A QUARTERLY

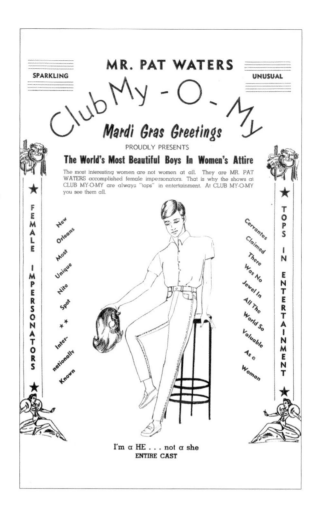

CLUB MY-O-MY ADVERTISEMENT

"The most interesting women are not women at all... they are accomplished female impersonators, tops in entertainment." So goes a bit of matchbook advertising copy distributed to patrons at New Orleans's Club My-O-My. The text is repeated in this advertisement, and accompanies an illustration of a young man, looking forlornly at a wig he holds in his right hand. Pitched to both straight and gay audiences, the floor shows at Club My-O-My reveled in both the glamour and the "exotic" nature of the performances (the words "sparkling" and "unusual" appear at the top of this image, linguistically framing the depiction of the female illusionist below). But even at its best, Club My-O-My, like many venues in New Orleans and elsewhere in the United States, was racially exclusive in the years before desegregation, serving only white patrons for most of its existence.

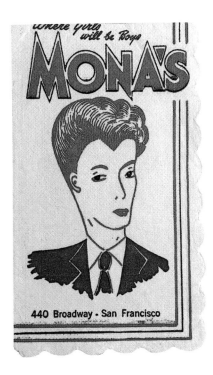

MONA'S 440 CLUB NAPKIN

Modeled after drag clubs like the My-O-My, Mona's 440 Club in San Francisco pioneered a different, yet related, model. Both the waitstaff and entertainers (Gladys Bentley was a staple) wore male attire, and in this way it was like the gendered reverse of Club My-O-My. While there were many semi-public places for gay men to socialize, this was not necessarily true for lesbians, and Mona's represented an early prototype for the lesbian bar, spawning several others in San Francisco's North Beach neighborhood. This napkin, with its red, white, and blue depiction of an androgynous youth—short hair done up in a masculine style— signaled the primary attribute of the club.

AFLAME

What's a queer to do in a gay bar? Laugh, drink, dance, socialize, and, before the establishment of anti-smoking ordinances in major metropolitan areas, smoke. Matches were de rigueur, and bars would make their own matchbooks to accommodate puffing patrons. They became de facto calling cards and advertisements, with a bar's logo reproduced on the matchbook cover. In this sense, they could wind up traveling hundreds of miles from their initial location, spreading the gospel of the existence of queer space. Some matchbooks even doubled as "trick cards," dedicating blank space on the exterior or interior for writing the name and number of a new potential lover. After the closure of particular bars and clubs, matchbooks are one of the few remaining indicators of where a bar existed, and during what years. In all their glorious variety matchbooks represent one aspect of the design and material cultures of LGBTQ social lives.

"THE GOLD COAST"
1138 N. CLARK ST.
CHICAGO 10, ILL.
DE 7-9110

CLOSE COVER BEFORE STRIKING

Dyke

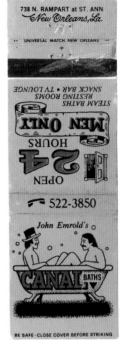

738 N. RAMPART at ST. ANN
New Orleans, La.

•• UNIVERSAL MATCH. NEW ORLEANS

STEAM BATHS
RESTING ROOMS
SNACK BAR • TV LOUNGE

MEN ONLY

OPEN 24 HOURS

☎ 522-3850

John Emrold's

CANAL BATHS

BE SAFE-CLOSE COVER BEFORE STRIKING

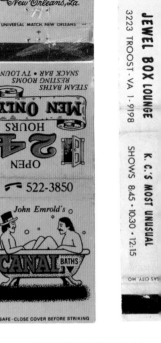

STRIKING

JEWEL BOX LOUNGE
3223 TROOST · VA 1-9198

SHOWS 8.45 · 10.30 · 12.15

K. C.'S MOST UNUSUAL

KAS CITY, MO

Dyke

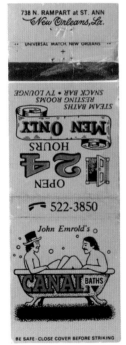

738 N. RAMPART at ST. ANN
New Orleans, La.

•• UNIVERSAL MATCH. NEW ORLEANS

STEAM BATHS
RESTING ROOMS
SNACK BAR • TV LOUNGE

MEN ONLY

OPEN 24 HOURS

☎ 522-3850

John Emrold's

CANAL BATHS

BE SAFE-CLOSE COVER BEFORE STRIKING

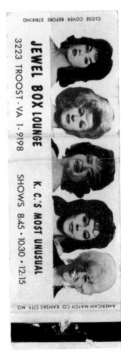

CLOSE COVER BEFORE STRIKING

JEWEL BOX LOUNGE
3223 TROOST · VA 1-9198

SHOWS 8.45 · 10.30 · 12.15

K. C.'S MOST UNUSUAL

AMERICAN MATCH CO. KANSAS CITY, MO

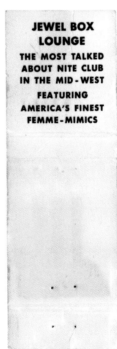

JEWEL BOX LOUNGE
THE MOST TALKED ABOUT NITE CLUB IN THE MID - WEST
FEATURING AMERICA'S FINEST FEMME - MIMICS

•• UNIVERSAL MATCH CORP. DENVER

116 E. 9th Ave.
Denver, Co.
837-8217

GARBO'S

BE SAFE-CLOSE COVER BEFORE STRIKING

"THE GOLD COAST"
1138 N. CLARK ST.
CHICAGO 10, ILL.
DE 7-9110

738 N. RAMPART at ST. ANN
New Orleans, La.

•• UNIVERSAL MATCH. NEW ORLEANS

STEAM BATHS
RESTING ROOMS
SNACK BAR • TV LOUNGE

STRIKING

JEWEL BOX LOUNGE
3223 TROOST · VA 1-

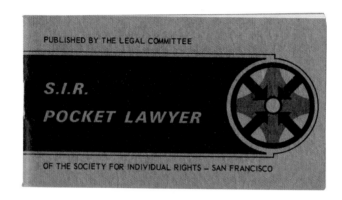

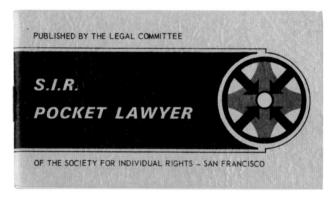

S.I.R. POCKET LAWYER

"On the advice of my attorney, I deny everything!!" This is the script the S.I.R. Pocket Lawyer ventriloquizes for those who might be arrested under ubiquitous (supposedly "moral") anti-vice laws. One of the most popular and useful items produced by the Society for Individual Rights (founded 1964 in San Francisco), the Pocket Lawyer outlined what an LGBTQ person might expect during the process of being arrested ("Remember, the walls have ears") and what one could do to protect oneself ("Be sure to get that badge number"). S.I.R.'s booklet also featured recommendations for friendly attorneys and bail bondsmen who had a track record of being discreet, lest one's arrest be published in the local newspaper—a common public humiliation of the time. Designed to fit easily within a pants pocket, this diminutive booklet tells us a great deal about what it was like to be an LGBTQ person in the years before

ON THE ADVICE OF MY ATTORNEY

I DENY EVERYTHING !!

DENY EVERYTHING, even if it does
not seem to have anything to do with
the arrest, and even if it makes you
sound stupid.

gay liberation: namely, that one was a constant target of police harassment and brutality.

The Pocket Lawyer prominently displays the logo of S.I.R.—featuring four arrows pointing inward toward a single circle. The interface between the individual and larger society, with all its pressures, is dramatized in this bit of graphic design. It also neatly illustrates S.I.R.'s mission to consolidate information and services for its membership. But for the figurative societal arrows pointing inward, the group's activities manifested in the other direction as well. S.I.R.'s activities were not limited to legal aid, as the organization was a driver of lesbian and gay social life, sponsoring dances, bowling leagues, and political discussions. In 1966 S.I.R. opened the first gay and lesbian community center in the United States, beginning a grassroots movement of institutions dedicated to serving the social, medical, and legal needs of LGBTQ communities.

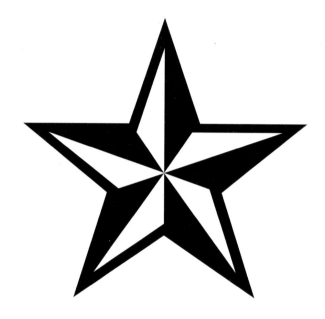

NAUTICAL STAR TATTOO

In their signal study of the pre-liberation lesbian community in Buffalo, New York (*Boots of Leather, Slippers of Gold*), the historian Elizabeth Lapovsky Kennedy and the activist Madeline D. Davis provide an interesting detail about a local identifier used "among the tough bar lesbians," describing it as "a star tattoo on the top of the wrist, which was usually covered by a watch." Kennedy and Davis continue, "This was the first symbol of community identity that did not rely on butch-fem imagery." Since that time the star—sometimes described as a nautical star—has enjoyed a small resurgence as a marker of lesbian identity. Although seemingly innocuous in its design, and small enough to be hidden under a wristwatch, it was nevertheless known by law enforcement as a sign of an arrested person's lesbian identity.

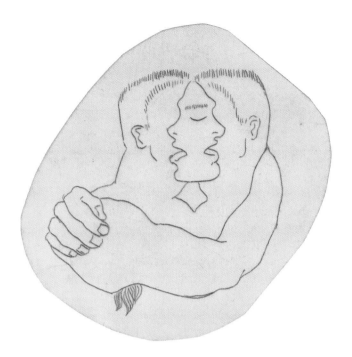

PHIL SPARROW'S TATTOO FLASH

During the 1940s and 1950s the United States was undergoing something of a "tattoo renaissance," despite, or perhaps because of, tattooing's outlaw associations. One of the most important figures during this time was the polymath Samuel Steward, an erstwhile academic, (erotic) novelist, and tattoo artist. Steward was an eager subject for Alfred Kinsey's famous studies on human sexuality, a pen pal to Gertrude Stein and Alice B. Toklas, and is known for keeping a detailed "stud file" of his sexual contacts.

As a tattooist, Steward went under the name Phil Sparrow and served Chicago's population of ostensibly straight sailors and bikers in gay parlance referred to as "rough trade." Some of his acetate flash (pre-designed tattoos) show a different side of his tattooing practice, as in this example, which depicts two male figures embracing, their faces overlapping, armpit hair dangling down to a point. Its tenderness is in stark opposition to the rough-and-tumble designs that Steward built his career on.

Bob Damron's Address Book 1968

Edited by Hal Call

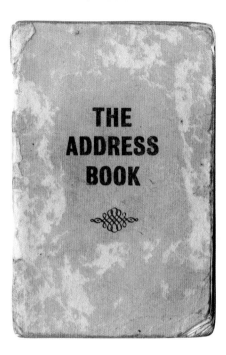

DAMRON'S ADDRESS BOOK

When Bob Damron published his first "address book"—a basic listing of known gay venues in California and across the United States, he was responding to a need among the gay community for a compendium of places to socialize. Hal Call, then-president of the Mattachine Society (a national homophile organization), funded the first few editions of the Damron guide—seeing it as a necessary component of building and sustaining a vibrant gay social life. Damron had been a bar owner (of the Red Raven in Hollywood, California) and found a second career as an alcohol distributor, making it possible for him to travel the country and develop a network of local gay contacts. The earliest editions of "The Guide" were small enough to fit in a pocket and contained only the addresses of the various bars, restaurants, and theaters that graced its pages. The first guide (above) was published in 1965 and was designed to look like a generic address book. Subsequent editions further embellished this initial design idea, before eventually settling into a color-blocked standardized format in the 1970s and 1980s. Later versions of the guide offered additional information, both in the form of commentary written by Damron, and an initialized code: OC stood for "Older/More Mature Crowd" and RT for "Raunchy Types—Hustlers, Drags, and other 'Downtown' Types," for example. Although geolocational cruising apps such as Grindr have done much in recent years to streamline cruising, Damron guides are still published today, making it possible for someone to, in the words of Damron's motto, "See America. Find a friend."

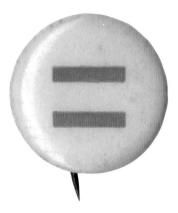

EQUALITY FOR HOMOSEXUALS BUTTONS

As an undergraduate at the University of Texas at Austin, Randolfe Hayden "Randy" Wicker was given a copy of *ONE* magazine. While back in New York on break he enrolled as a member of the local chapter of the Mattachine Society and soon thereafter founded his own homophile organization (opaquely named "Wicker Research Studies") that sought to connect gays and lesbians across Texas, Louisiana, and Mississippi. After graduating, Wicker moved back to New York and spearheaded one of the first public protests in LGBTQ history—a 1964 protest regarding the treatment of homosexuals by the U.S. military. Five years later, when the Stonewall uprisings were happening in Greenwich Village, Wicker was working at his button shop nearby. His location was strategically useful for printing and distributing movement buttons, like the ones seen here.

While the phrases and symbols of the two buttons remain resonant (the equality sign lifted from civil rights movement imagery), the color is what is most remarkable. According to the historian Vern L. Bullough, who was at one point employed by Wicker to drive a Volkswagen van and distribute such buttons nationwide, the lavender color of the button was a sticking point in an argument between Wicker and fellow activist Frank Kameny (originator of the slogan "Gay Is Good"). Kameny thought the button's text should be black, and Wicker thought otherwise. Since Cole Porter's 1929 song "I'm a Gigolo" insinuated that the narrator had "just a dash" of lavender (and thus queerness) in his nature, Wicker's buttons proclaim their alliance with homophile identities both linguistically and formally.

EQUALITY FOR HOMOSEXUALS

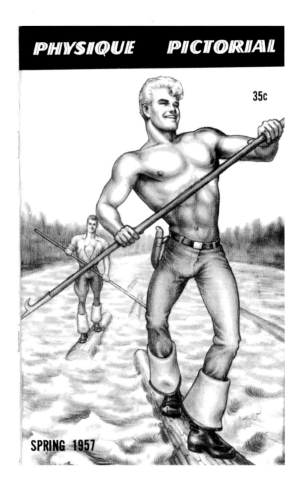

PHYSIQUE PICTORIAL

35c

SPRING 1957

BOB MIZER'S *PHYSIQUE PICTORIAL*
AND SUBJECTIVE CHARACTER ANALYSIS

Over the course of his fifty-year career as a "beef-cake" photographer, Los Angeles–based Bob Mizer photographed more than ten thousand male models, selling his prints through his magazine and catalog *Physique Pictorial*. Begun in 1951, *Physique Pictorial* initially pitched itself, like other similar publications (*MANual*, for example, or *Fiseek*), as a bodybuilding and wellness magazine. The pretense was flimsy, as most beefcake magazines only narrowly evaded rigid

laws against sending obscene materials through the mail by photographing their models wearing nothing but thin posing straps. *Physique Pictorial* also featured and sold the drawings of artists like Tom of Finland (the cover above is the first appearance of the Finnish leather artist's work in the magazine—a series of images dedicated to Scandinavian loggers).

A year after the 1962 *MANual Enterprises v. Day* Supreme Court decision ruled that nude male

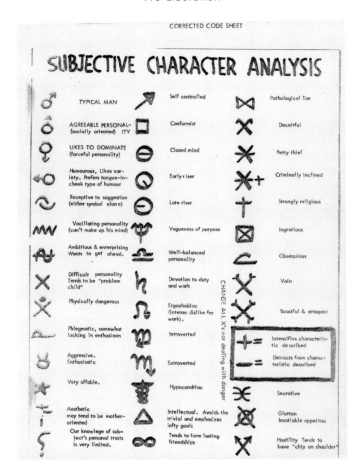

CORRECTED CODE SHEET

SUBJECTIVE CHARACTER ANALYSIS

photographs were not necessarily obscene, Mizer began to include cryptic symbols alongside the basic stats of his models. He sent out two different legends for these symbols (some appropriated from common astrological symbols) that were meant to describe a model's personality and sexual traits. The clipped astrological symbol for Mercury, for example, indicates a model is "Aggressive, Enthusiastic." These various symbols were drawn fused around a central circular core, describing manifold sexual characteristics in as little space as possible. In another version of this chart (more selectively distributed to his subscribers) Mizer uses more sexual descriptors. In this more explicit chart, the Mercury symbol stands for: "Likes to be on top, doesn't just lie there, is a ball."

JOSÉ SARRIA ALBUM COVER AND CAMPAIGN POSTER

José Sarria worked in the years following the end of World War II at San Francisco's famed Black Cat bar—a gathering place for bohemians, poets, gays, and hustlers. Sarria began as a cocktail waiter (the only male to be given such a role) and, as a high tenor, was soon performing for patrons as the bar's hostess. He could handily hit a high C, and this allowed him, unlike many other queens working at the time, to sing in his natural voice. Sarria performed campy parodies of operas like *Carmen* and *Madame Butterfly*, while also eviscerating audiences with his silver-tongued wit. In 1964 Sarria proclaimed himself Empress José Norton the First (Daughters of Bilitis founders Phyllis Lyon and Del Martin were dubbed duchesses), beginning the court tradition in drag communities. On the cover of this album (pitched in publicity materials as "America's Newest Party-Fun Record!"), Sarria appears in a wedding gown, laughing as he lifts the hem to reveal the tops of his stockings. Toned a brilliant red, the image contrasts with the small black-and-white photograph of Sarria in more masculine clothes, reading a newspaper on a park bench. Similar to some of the conventions used in late nineteenth- and early twentieth-century sheet music featuring cross-dressing performers, this smaller photograph cements Sarria's drag virtuosity, while also presenting the "authentic" version of the performer.

Sarria's gifts for entertaining his community were equally matched by his political guile. A member of the Society for Individual Rights (and the earlier League for Civil Education), Sarria ran for the San Francisco Board of Supervisors in 1961. This political campaign poster (lower right), like many of the era, presented the candidate as a professional (the suit, tie, and combed-back hair), while also acknowledging his political aspirations. "Equality!" is written at the bottom of the poster as a kind of campaign slogan—printed in a type that mimics a cursive handwriting, as though Sarria had signed the poster with the word himself. To certain members of San Francisco's electorate, the word itself would have been a tacit acknowledgment of the candidate's homosexuality. The presentation of Sarria the queen and Sarria the candidate couldn't be more different, and yet he was a trailblazer in both realms. Although he ultimately lost, Sarria was the first openly gay person to run for city-wide office in San Francisco, arguably laying the foundation for Harvey Milk's candidacy fifteen years later.

City & County of
SAN FRANCISCO
City Election,
Tuesday, Nov. 7th
1961

Elect

JOSÉ JULIO
SARRIA

Supervisor

"Equality!"

197

70s

1970s

The 1970s was the decade in which LGBTQ people loudly announced their arrival within the national public sphere and demanded their liberation. To be homosexual, bisexual, or transgender during this time was still, in many ways, to be an outlaw, and speaking out or living as an out LGBTQ person was to put one's life and livelihood in danger. "Coming out" rendered members of LGBTQ communities both newly visible and vulnerable. Protests and uprisings, such as the impromptu rebellion in response to consistent police harassment at the Stonewall Inn (a bar on Christopher Street in Greenwich Village, Manhattan) in June of 1969, set the tone for insurgent LGBTQ people to call for an end to state-sanctioned violence, incarceration, and wanton discrimination.

In the popular imagination the Stonewall uprising remains *the* event marking the beginning of gay liberation. But the reality is much different. The Stonewall uprising was the last in a longer line of protests, uprisings, and rebellions taking place in large U.S. cities. There were, for example, similar outcries against discrimination and police brutality at Cooper's Do-nuts in Los Angeles (1959), a full decade before Stonewall. Transgender people, some of whom were sex workers, made a claim for their political power at Gene Compton's Cafeteria (San Francisco) in 1966, by throwing a cup of coffee in an arresting officer's face. In their 2005 documentary on the Compton's Cafeteria uprising, *Screaming Queens*, historians Susan Stryker and Victor Silverman interviewed witnesses and contributors to the events of that warm August night, enriching our understanding of their complicated and courageous decisions. A year and a half later, on New Year's Eve, undercover police officers arrested revelers at Los Angeles's Black Cat

Tavern; the traditional midnight kiss gave the police enough convenient cover to arrest and incarcerate partygoers at random. Backlash to this event was swift and robust. In other words, the Stonewall uprising was both the product of a constellation of political resistances as well as the actions of a dedicated few for whom kowtowing to unjust and prejudicial laws was no longer a workable reality.

Taking place on the yearly anniversary of the Stonewall uprisings, "Gay Freedom Day" or "Christopher Street Day" rallies and parades emerged as one of the most potent political forms in LGBTQ history. At first these were not identified primarily with "pride" but rather the conditions of "liberation"—both personal and societal. It wasn't until the end of the 1970s and 1980s that these political protests became known colloquially as "gay pride parades."

The "homophile" of the 1950s and 1960s was out, and "gay," "lesbian," and "homosexual" replaced the word in common parlance. "Gay is good" was a mantra of the 1970s, joining similar destigmatizing cultural sentiments such as "black is beautiful" in vogue among black activist groups such as the Black Panthers. Although LGBTQ spaces continued to be woefully segregated—white people and people of color often had separate clubs, bars, and restaurants—there is some indication of intersectional coalition building. Huey P. Newton, one of the cofounders of the Black Panthers, wrote an open letter to women and homosexuals, identifying them as similarly "oppressed groups" and further suggested to his comrades that "we should try to unite with them in a revolutionary fashion." In turn, some white and non-black Gay Liberation Front members showed up to Black Panther rallies in solidarity, wearing

armbands with the acronym of their political organization. Although not sustained enough to effect a true coalitional critique of oppression in the United States, these important early efforts arguably laid the groundwork for future political work.

Despite these still dire situations, LGBTQ social institutions such as gay bars, taverns, magazines, and political organizations grew like wildfire. Like the bars in the period before liberation, many gay and lesbian spaces remained under the financial control of organized crime syndicates, who were only too happy to sell alcohol to an underserved market. Despite this fact, bars and clubs were important spaces of collective imagining, manifesting the utopian promise of a space where everyone could share in the experience of being queer. These places also became the sites of community activation, as the poster made for a community fund-raiser at Jewel's Catch One relates.

As in the decades before, there was broad disagreement over how one should be a homosexual or a trans person in public and within private life; some thought that assimilation offered the safest path and suggested that access to opportunities and institutions wouldn't significantly change unless the straight world saw gay, lesbian, and trans people as "normal" in some way. For others it was society, not the homosexual or trans person, that needed to change. Through activist forms such as civil disobedience and protest, these anti-assimilationist contingents staked out positions that later generations would come to reclaim as queer.

LGBTQ people began to emerge as a market. Shops such as the Pleasure Chest, although ostensibly agnostic in their mission, centered the sex lives of LGBTQ people, distributing new and inventive toys that continued to power the sexual revolution

for decades. Although still many years from the tar-get-marketing efforts of large corporations, a small but robust cottage industry grew up around the needs of LGBTQ people. Magazines and buttons, in particular, are good indexes as to the popular struggles of LGBTQ people during the 1970s. Like *ONE* and *The Ladder* before them, magazines such as *RFD* and *Mirage* cohered certain readerships—rural homosexuals and trans people, respectively. There are dozens more, each fascinating in its own right. Unlike magazines, which built fairly coherent identities for the sake of particular readerships, buttons offered the chance to display a wide variety of political and personal affiliations on the cheap.

Many stalwart symbols and graphics—such as the lambda or the rainbow flag—were developed during this decade, making it one of the most prolific and creative periods in LGBTQ design history.

Most of the designers and artists discussed in the following pages did not have prestigious careers or a lot of cash—rather, they saw a political need and filled it in turn. Some of these innovations in graphic design and visual culture were occasioned by violence or prejudice—such as the gutsy Lavender Menace t-shirts created by the Radicalesbians, which at once reclaimed an epithet famously lobbed at lesbians by a leader in the women's liberation movement while also poking fun at the panic that undergirded such fears. Still, the point was clear—lesbians would and could be a menace to the women's liberation movement if it didn't live up to its promise of liberation for *all* women. Other innovations, such Gilbert Baker's rainbow flag, were exercises in self-definition, a refusal to be overdetermined by the oppression of the era.

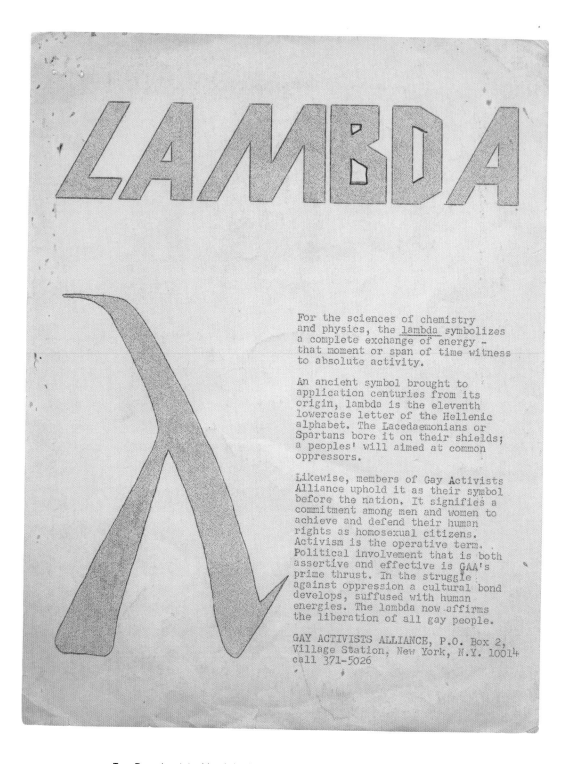

LAMBDA

For the sciences of chemistry
and physics, the lambda symbolizes
a complete exchange of energy -
that moment or span of time witness
to absolute activity.

An ancient symbol brought to
application centuries from its
origin, lambda is the eleventh
lowercase letter of the Hellenic
alphabet. The Lacedaemonians or
Spartans bore it on their shields;
a peoples' will aimed at common
oppressors.

Likewise, members of Gay Activists
Alliance uphold it as their symbol
before the nation. It signifies a
commitment among men and women to
achieve and defend their human
rights as homosexual citizens.
Activism is the operative term.
Political involvement that is both
assertive and effective is GAA's
prime thrust. In the struggle
against oppression a cultural bond
develops, suffused with human
energies. The lambda now affirms
the liberation of all gay people.

GAY ACTIVISTS ALLIANCE, P.O. Box 2,
Village Station, New York, N.Y. 10014
call 371-5026

Tom Doerr's original lambda drawing, and accompanying explanatory text.

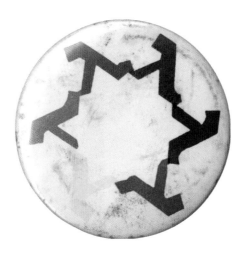

TOM DOERR'S LAMBDA SYMBOL

A founding member of the Gay Activists Alliance, graphic artist Tom Doerr designated the lambda as the group's symbol—taking its meanings from chemistry, where the Greek letter signifies "a complete exchange of energy." Appearing on all GAA apparel and press materials, Doerr's lambda quickly spread beyond the confines of the GAA and became the first widespread symbol of gay liberation. It emblazoned flags, banners, posters, t-shirts, and other logo designs; the lambda was truly ubiquitous. Although Doerr initially designed the lambda to be gold, it was commonly reproduced in lavender.

The choice of the lambda was not without controversy—the GAA considered logo proposals depicting the head of an eagle or a fighting cock. Some felt that the lambda was not expressive enough, or that its political associations with gay people were not obvious. Despite these concerns, the lambda has remained a steadfast, if now less visible, symbol of gay liberation movements. Today many university gay and lesbian student associations as well as social-affinity groups use the lambda in their names and designs. Perhaps they feel the same way Doerr did about his design, that "in the struggle against oppression a cultural bond develops, suffused with human energies. The lambda now affirms the liberation of all gay people."

THE ASSOCIATION OF BLACK GAYS

The lambda has been deployed in numerous ways across LGBTQ design from liberation onward. Sometimes, as in the logo for the Association of Black Gays in Los Angeles, the lambda is combined with other meaningful symbols, such as a clenched fist (a symbol originating with black power movements and later appropriated by the gay rights movement.) The Association of Black Gays used the lambda-fist as a visual identifier for their particular group, and it appeared on posters, newsletters, flyers, and official group communiques. The clenched fist in ABG's logo wields the lambda, as though it were a shield or a flag—indicating that this group has effectively claimed the symbol as their own. The flyer at the right advertises the group so that more members might join. It lays out its mission in plain terms ("to improve the situation of black gays in Los Angeles") and indicates a growing political power ("We've met with Mayor Bradley, have organized against bars that discriminate"). The last line of flyer's body text ("And we're friendly") is a cheeky reminder that coalitions are built through social bonds—friends become family, comrades in a struggle for liberation from intersecting opressions.

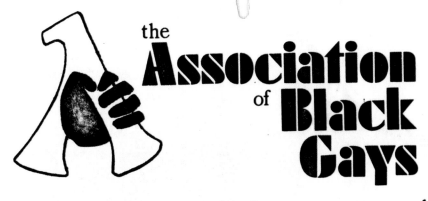

the Association of Black Gays

The ABG is a group of black, gay women and men. We are a political and social organization striving to improve the situation of black gays in Los Angeles. Our group is now a year old. Politically, we have fought long and hard to end the double oppression we face. We've met with Mayor Bradley, have organized boycotts against bars that discriminate, and have met with gay community leaders many times. We have rap groups, a newsletter, and social functions. And we're friendly.

For more information:

Write us. ABG
% 5723~3ᴿᴰ Ave.
Los Angeles 90043

(Please include a 13¢ stamp, if you can.)

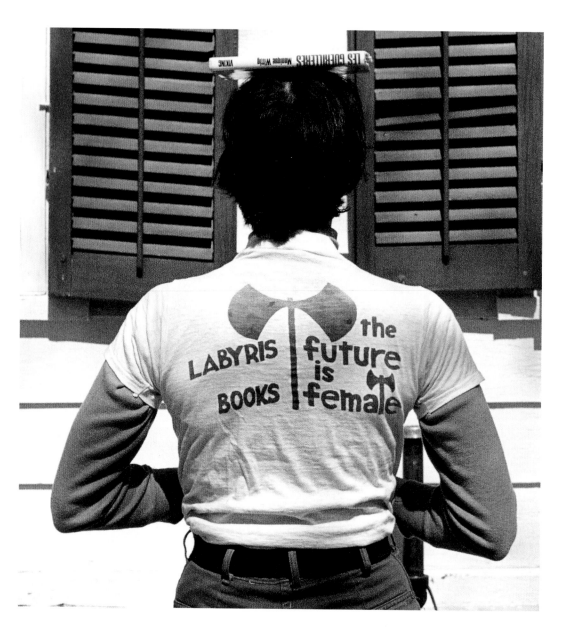

The labrys appears on the back of a t-shirt made to promote Labyris Books, the first women's bookstore to open in New York City.

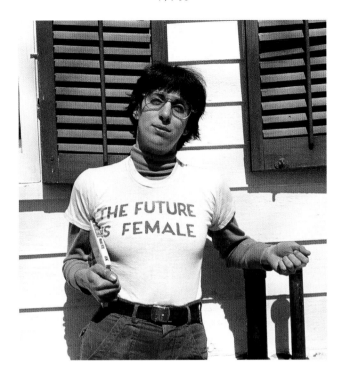

LABRYS

In their book *Lesbian Peoples: Material for a Dictionary*, Monique Wittig and Sande Zeig give a succinct definition of the labrys, sometimes spelled "labyris," citing it as a "name for the double-headed axe of the ancient amazons and to the representation of this arm as the emblem of amazon empires." According to ancient Greek literature and art, the Amazons were a war-loving, matriarchal people; and, as folklorist and historian Adrienne Mayor points out, recent archaeological finds have confirmed the existence of hundreds of female warriors on the Scythian steppes (long thought to be the geographic environs of the Amazons). Such findings support what feminist historians have long claimed, which is that matriarchal societies existed in the ancient world alongside their better-known patriarchal counterparts.

The labrys was reclaimed by feminists in the 1970s as a symbol of radical lesbian feminism. It famously appeared on the cover of Mary Daly's *Gyn/Ecology: The Metaethics of Radical Feminism*, and in one evocative passage she imagines one being smelted from the gathered tools of patriarchal oppression. Daly read the axe's double edge as a metaphor for the "A-mazing Female Mind," which must be attuned to the many impediments to women's liberation. A consistent symbol of radical lesbian feminism, the labrys has appeared on t-shirts, buttons, jewelry, and more. A labrys is a tool—sometimes a weapon—but it does nothing without the hand that carries it. As such it is a fitting symbol for political and social action.

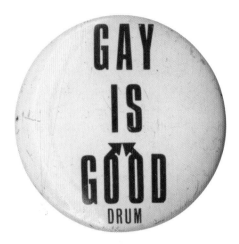

GAY IS GOOD BUTTON/GAY IS ANGRY POSTER

These two items, one with the slogan "Gay Is Good" and the other exclaiming "Gay Is Angry," represent a perennial divide in the realm of LGBTQ politics, between assimilationist and self-affirming politics on the one hand and anti-assimilationist (and often also anti-capitalist) politics on the other.

The button was likely produced by Randy Wicker, but its phraseology was coined by astronomer Frank Kameny, who was fired from his federal job under Eisenhower's Executive Order 10450 (which stipulated, in part, that anyone found out to be homosexual could be fired from federal employment). Kameny's encomium on self-love stands in relation to other political affirmations of the time—especially the "Black Is Beautiful" slogan of the black power movement. Both "Gay Is Good" and "Black Is Beautiful"

remind a speaker that societal stigma can be sloughed off and potentially replaced with positive valuation and love. Introduced as a key talking point of incipient gay liberation movements, "Gay Is Good" levels its claim in the realm of the moral—as many LGBTQ people were told by their families and religions that they were *not* good, even, in some cases, evil.

"Gay Is Angry" responds directly to the accrued effects of these stigmas and reminds LGBTQ people of the revolutionary power of rage. The calendar graphic, which is credited to "Juan Carlos y Nestor," depicts a giant clock/bomb rising out of the detritus of urban living. Butterflies—a common symbol of transformation—flap around the fuse. Juan Carlos y Nestor's message is literally timeless (the clock has no hands), suggesting that any time is a good time for gay rage.

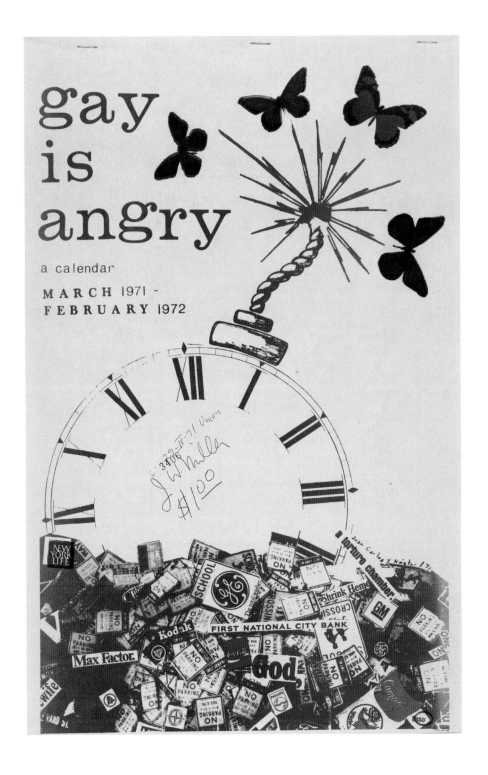

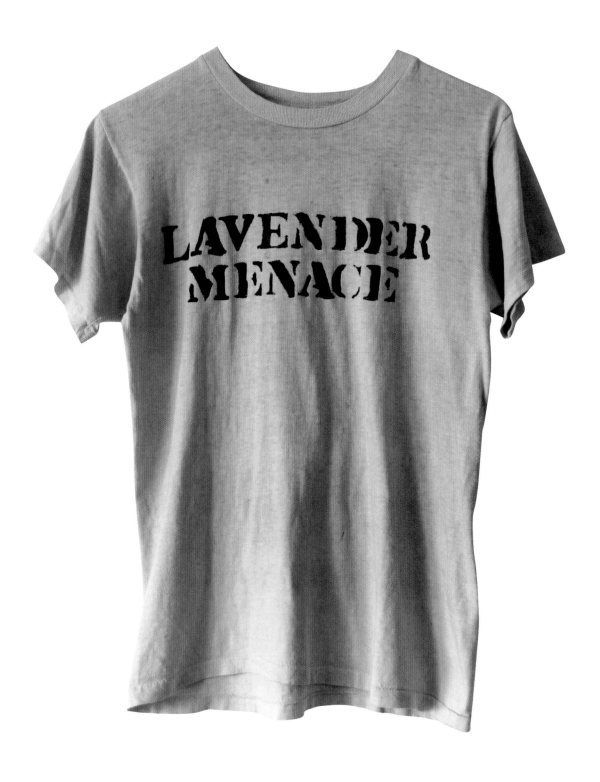

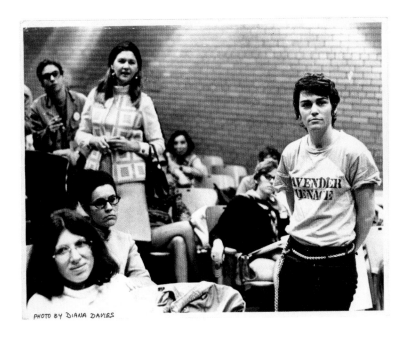

PHOTO BY DIANA DAVIES

LAVENDER MENACE T-SHIRT

The phrase "lavender menace" was initially coined by Betty Friedan, cofounder and president of the National Organization for Women, to describe the perceived threat of lesbians within the women's liberation movement. In response, the writer and activist Rita Mae Brown (standing in the foreground of the photograph above) along with Artemis Brown, Karla Jay, and others identifying themselves as the Radicalesbians, dip-dyed a clutch of t-shirts lavender and silkscreened Friedan's pejorative put-down boldly across the chest. The Radicalesbians wore these shirts when they stopped the proceedings of NOW's Second Congress to Unite Women and handed out their manifesto "The Woman-Identified Woman," which centered the struggles of lesbian feminists. "What is a lesbian?" the manifesto rhetorically asks, answering in return, "A lesbian is the rage of all women condensed to the point of explosion." Their appropriation of the hostility and fear with which some within the women's movement regarded them was what we might now call a queer move, seeking to reveal and ultimately change the inclusivity of an organization that purported to speak and work on behalf of *all* women. With humor and nerve the Radicalesbians founded a strain of lesbian feminist thought that irrevocably changed the conversation around the intersections of sex and gender within the women's liberation movement.

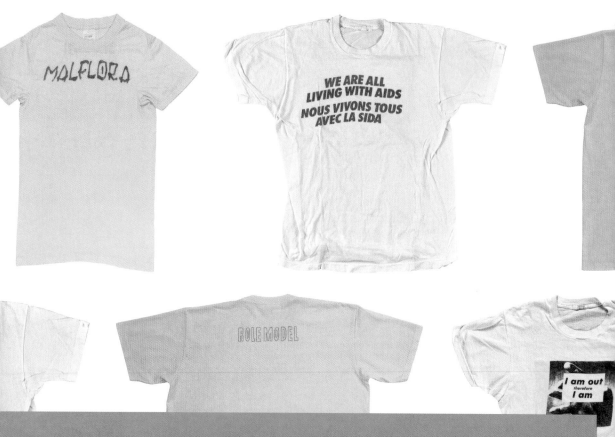

BODY LANGUAGE

The t-shirt began as a simple undergarment—something that factory workers and servicemen could wear underneath more rugged outerwear. Even today the t-shirt retains some of these working-class affiliations. Marlon Brando's rugged appearance in *A Streetcar Named Desire* (1951) fueled the t-shirt's popularization—marking it as a symbol of masculine coolness. Soon, entrepreneurial companies began to screen-print designs and logos on plain white tees—effectively using their broad bodily real estate to promote any number of interests and political viewpoints. It is no wonder, then, that many of the most creative visual designs of LGBTQ movements appear on t-shirts. Groups such as Queer Nation and ACT UP

and makers like Joey Terrill used the t-shirt to play with the stigmatization and the reclaiming of identities. Terrill's shirt, in particular, is an interesting case: initially handmade, the shirts were produced for a small group of Terrill's familiars for the 1976 Christopher Street West parade in Los Angeles. Men wore shirts emblazoned with the word "maricón" and women "malflora"—each a slur in Spanish. On the back of the tee, written in block letters, are the words "role model," countering the anti-gay rhetoric of Florida songstress and orange juice spokesmodel Anita Bryant and earnestly suggesting that LGBTQ chicano/a people could serve as political role models for the rest of the nation.

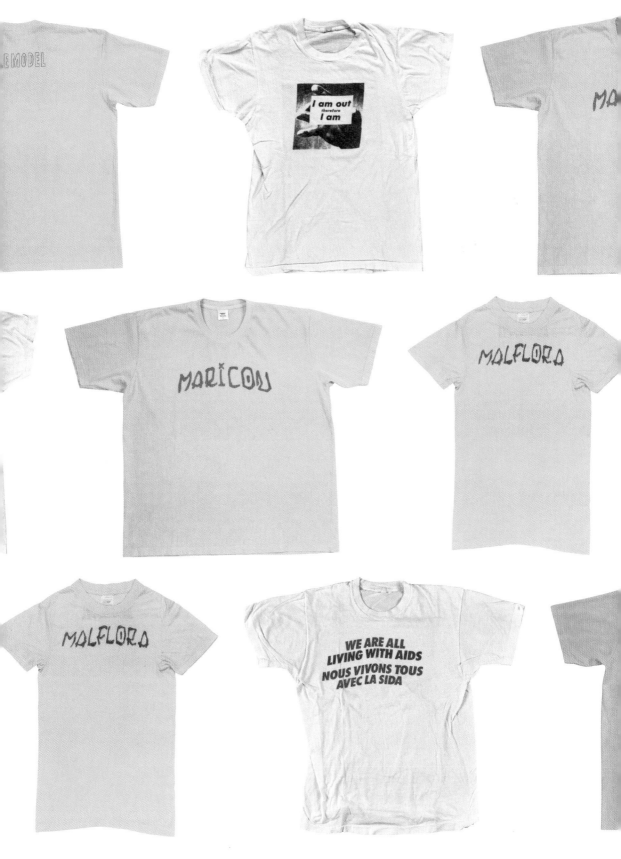

THE FUTURE
IS FEMALE

THE FUTURE
IS FEMALE

Today t-shirts remain an important medium for conveying a broad range of affiliations with political struggles to associations with particular brands and corporate interests. Some shirts, like the feminist bookstore Labyris Books's "The Future is Female" shirt have been remade in recent years to signal political optimism in the face of rampant gender discrimination. Others, such as Dean Sameshima's "RESEARCH: A Cocksucker's Guide to Freedom vol. 1" gather the logotypes of a range of LGBTQ books and magazines, effectively serving as an ad hoc archive of queer culture. Both Sameshima and Roy Martinez are artists for whom making t-shirts is an integral part of financially supporting and conceptually furthering their respective artistic practices. Martinez (who makes clothing under the name Lambe Culo—"lick ass" in Spanish) taps academic theory in shirts displaying phrases such as "Visibility Is a Trap" (a phrase originally written about prison architecture by the theorist Michel Foucault), and "Feeling Brown, Feeling Down" (the title of an article about depression and communities of color by the late performance studies scholar José Esteban Muñoz).

IS FEMALE

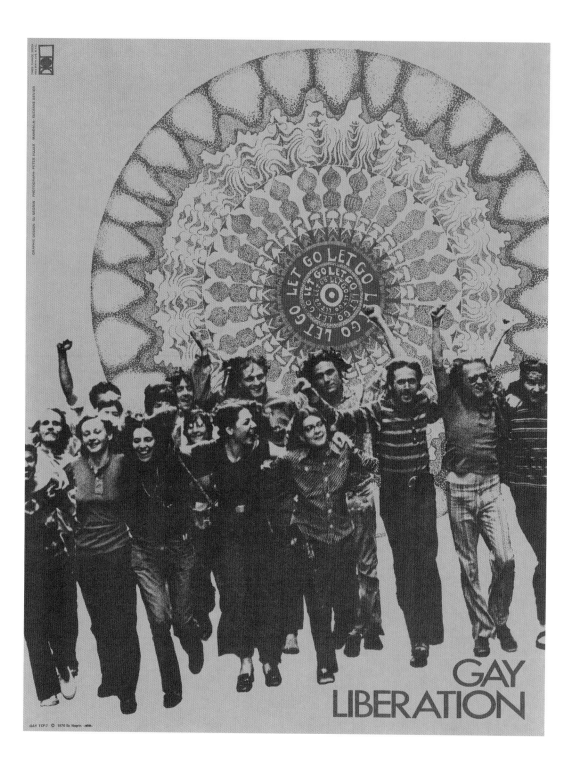

GRAPHIC DESIGN: SU NEGRIN · PHOTOGRAPH: PETER HUJAR · MANDALA: SUZANNE BEVIER

LET GO LET GO
LET GO LET GO
GO LET GO

GAY
LIBERATION

GAY TCP-7 © 1970 Su Negrin

GAY LIBERATION FRONT POSTER

"Let Go," implores this poster produced by the Gay Liberation Front, an activist organization formed in the immediate aftermath of the Stonewall uprisings. It communicates as much about emergent gay liberation politics as it does a broader psychedelic culture that nurtured it in part. A mandala hovers, halo-like, around a group of joyful protesters. Fists are raised, laughs are shared; this is political action as a social scene—a complaint levied in the language of a good time. Much is known about the source photograph for this poster, which was taken by Peter Hujar, a participant in New York's vibrant downtown art scene. Hujar's lover, Jim Fouratt, was a founding member of GLF and appears here in striped pants.

But this poster, designed by Su Negrin and featuring a mandala drawn by Suzanne Bevier (she appears at the far right in Hujar's photograph), resituates Hujar's image. Negrin, the co-publisher of Times Change Press (which produced this poster), was involved in the women's liberation movement as well as a variety of leftist causes. The poster's colorway, lavender and red, makes an implicit connection between an incipient gay liberation movement and other leftist social protest movements. Bevier's invective to "let go" is thus a call to let go of the oppressive social restrictions that preclude the full political participation of LGBTQ people. Negrin's control over the means of production, as well as the content of the messaging, meant that she could bring together in a single poster her various efforts among sometimes disparate activist communities.

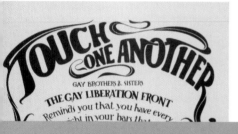

POST UP

Posters, like t-shirts, are notable for their public address; but unlike t-shirts, which demand the presence of a body, a poster remains up for as long as the public, or the owners of the surface onto which a poster is affixed, allows. The most effective posters combine strong graphic representation with highly edited and potent text, creating an evocative play of word and image. The poster for the 1979 "3rd World Conference" entreats its viewer with a question taken from a contemporaneous Blackberri song: "America, when will the ignorance end?" In successive multicolored and silhouetted profiles the poster's designers relay the racial diversity of LGBTQ communities, suggesting that everyone has a stake in anti-racism work. A very different kind of message was emblazoned on flyers and posters made only a few months before, in response to the White Night riots that immediately followed the light sentencing of Dan White, who murdered San Francisco's mayor George Moscone and openly gay supervisor Harvey Milk. A burning police car—one of the most intense visual symbols of protest—is accompanied by the unrepentant declaration: "No apologies!"

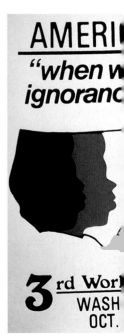

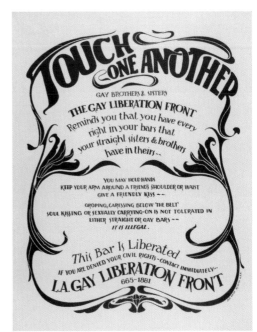

MIRAGE MAGAZINE

Angela K. Douglas, who grew up in Oklahoma, Florida, California, Hawaii, and Japan, founded the Transexual Action Organization, the first transgender rights organization, less than a year after trans women participated in the Stonewall uprisings. *Mirage*, with Douglas as editor, began publication four years later and was a clearinghouse for trans politics, visibilities, and affinities. A summary biography of Douglas appears in the magazine's fourth issue and points to both the joy and the precariousness of being an out trans person in the years immediately before and following gay liberation: "Angela's interests include foreign languages, UFOlogy, esoteric philosophies, boating, and jazz. She's been arrested several times and has been in both men's and women's jails..."

One of the members of TAO, Suzun David, about whom little is known, was responsible for many of the graphics in *Mirage* and the earlier *Moonshadow* newsletter (which Douglas also edited). In David's psychedelic illustrations trans women are presented as cyclopic robots and aliens, nearly melting into their surroundings. While often modeled on real people, taken together David's drawings suggest a trans-futurist vision for the world. These visuals highlighted one of the more unconventional emphases of *Mirage,* which updated its membership on "ESP, UFOs, and the occult" on a regular basis. "We must all let the Space People know," wrote Douglas in an early issue, "we are willing to work with them and they are most welcome to live with us"—effectively extending a hand of civility and care in a world that too often did not do the same for trans people.

MIRAGE MAGAZINE

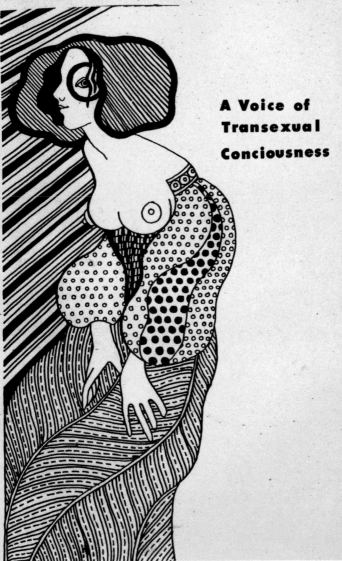

A Voice of
Transexual
Conciousness

ASSOCIATION OF BLACK GAYS

INVITES YOU TO

Get on Down
and Party

FOR THE

ERNEST MARSHALL

(DEFENSE FUND DRIVE)

THANKSGIVING EVENING

NOV. 25, 1976 9: P.M. – 2: A.M.

CATCH ONE

4067 PICO BLVD. LOS ANGELES, CALIF.

TICKETS; ADV. $1.50 AT DOOR $2.00

★ **DOOR PRIZES** ★

Printed by - Quick Service Printers - 11111 S. Wilmington Ave. - 569-3714

JEWEL'S CATCH ONE POSTER

When Jewel Thais-Williams purchased the Diana Bar in 1973, it might have been hard to imagine the potential glory of the place. Most of the regular patrons she inherited in the transition left—it was rare for a queer woman of color to tend bar, much less own one. But a growing mélange of customers soon took their place and made Jewel's Catch One a second home; they arrived weekly and on major holidays (such as Thanksgiving) when returning home to family might not be a welcome prospect. Gay bars and dance clubs are places that promise a particular kind of freedom for their patrons—loud music, full-body connection, and the abandonment of repressive social mores that structure queer daily life outside. Over its forty year lifespan (1973–2015), Thais-Williams's club came to be a near-spiritual gathering place for LGBTQ people of color and their allies alike, hosting legendary Halloween costume contests, concerts by the likes of disco divas Sylvester and Donna Summer, and charity events like the one promoted on this poster.

The Association of Black Gays, whose logo was a black fist grasping a lambda, was especially concerned with the case of Ernest Marshall, an adult male arrested in 1975 for sodomy and oral copulation. Both were illegal at the time, effectively criminalizing gay men's sexual lives—although they were hardly the only people to engage in such activities. In this letter-pressed poster, spare yet scintillating, the Association of Black Gays invites their community to "get down and party"—and to find some reason, amidst the pain of legal and familial persecution, to come together.

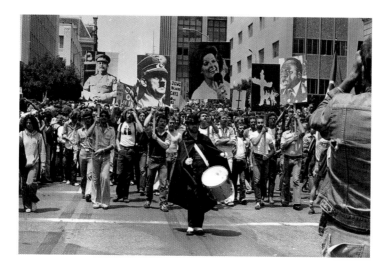

Anita Bryant appears in this bombastic protest display at the 1977 San Francisco Gay Day Parade, alongside the likes of Joseph Stalin, Adolf Hitler, the KKK, and Idi Amin.

ANITA BRYANT SUCKS ORANGES

Pageant queen and popular singer Anita Bryant was the driving force behind one of the twentieth century's most visible and contentious anti-LGBTQ campaigns. A brand ambassador for the Florida Citrus Commission, Bryant used her public platform to oppose an anti-discrimination law passed in Dade County (Miami, Florida) protecting lesbians and gay men from workplace harassment and discrimination. Her organization to repeal the law, Save Our Children, Inc., stoked the fears of Miami residents by falsely claiming that homosexual teachers were trying to recruit and molest their children. LGBTQ people responded in kind—with outrage and a broad, comprehensive campaign of their own that included buttons, t-shirts, albums, and protest banners. Tried-and-true tactics such as boycotts of Florida orange juice and spectacular protests (during one notable

"zap," Bryant was pied in the face) were successful at drawing attention to the celebrity's exclusionary politics—in stark contrast to her sunny public persona. This button (right) brilliantly distills the acrimony and stakes of the fight. In using the button's round format as a stand-in for the product that Bryant represented—Florida oranges—the designer(s) attach an "acidity" to the singer and her politics. This button, and many others like it, sought to change public perception of Bryant's crusade; unfortunately, it was Bryant who was ultimately successful in repealing the Dade County ordinance. Her victory inspired similar legislative efforts in other states. In California, the Briggs Initiative/Proposition 6 would have barred lesbians and gay men from teaching in public schools, but voters ultimately defeated the referendum.

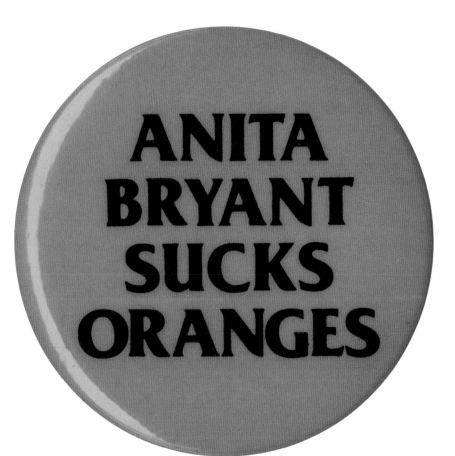

LESBIAN CONCENTRATE
A LESBIANTHOLOGY OF SONGS AND POEMS

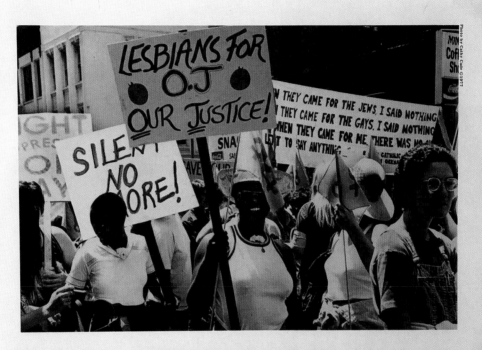

Photo by Cathy Cade ©1977

LESBIAN CONCENTRATE: A lesbianthology of songs and poems

Along with many of you (we suspect), we were amused when a part-time orange-juice pusher began to rant against homosexuals. Later we were horrified at the intensity of the attack and the support it generated. We now have to match that force — flip-flop it back onto itself. We think the proper response is to recognize our bonds and support each other as strongly as we can. This is more than just time to come out. We think it's time for energetic affirmation of lesbian identity and culture.

Part of the proceeds from this record will go to Lesbian Mothers' National Defense Fund.

Featuring

Don't Pray for Me
Nina
Prove It on Me Blues
Sweet Woman
A History of Lesbianism
Gay and Proud
Leaping Lesbians
Sugar Mama
Kahlua Mama
No Hiding Place
For Straight Folks...
Ode to a Gym Teacher
Woman-Loving Women

Written by

Mary Watkins
Meg Christian / Holly Near
Gertrude (Ma) Rainey
Cris Williamson / Jennifer Wysong
Judy Grahn
Debbie Lempke
Sue Fink / Joelyn Grippo
Gwen Avery
Virginia Rubino / Gioia Siciliano
Mary Watkins
Pat Parker
Meg Christian
Teresa Trull

Performed by

Linda (Tui) Tillery
Meg Christian
Teresa Trull
Cris Williamson
Judy Grahn
Berkeley Women's Music Collective
Sue Fink
Gwen Avery
BeBe K'Roche
Mary Watkins
Pat Parker
Meg Christian
Teresa Trull

℗©Olivia Records, Inc. PO Box 70237, Los Angeles CA 90070 Jacket Made in Canada

Part of the anti-Bryant campaign included cheeky re-orientations of orange-related imagery. Here orange juice is refashioned as "Lesbian Concentrate" for this record of songs and poems.

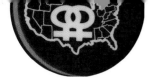
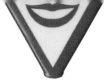

COMMIE faggot.

GAY LI

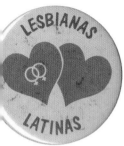

LESBIANAS

LATINAS

PROJECT 10 ..WITH LIBERTY AND JUSTICE FOR ALL"

LESBERADO

SUPPORT GAY TEACHERS

Stonewall was a riot... now we need a REVOLUTION!

The L.A.P.D. FREED the Slaves April 10, 1976

1 out of 10

WE ARE EVERY

MEN USE CONDOMS

LESBIANAS

PROJECT 10 WITH LIBERTY

BUTTON UP

A button is a message pinned on the body, appealing to anyone passing by. The first mass-produced political buttons date to the end of the nineteenth century and were commonly used to rally support for political/presidential campaigns. Since then, the medium of the button has been deployed by activists on behalf of innumerable political and social causes. LGBTQ rights movements have been no different—often taking advantage of the physically restricted real estate of a button to snappily address supporters and critics.

The buttons reproduced here represent only a small sampling of the thousands of buttons created by LGBTQ people, covering a vast affective range from the pluckily humorous to the deadly serious. Because of their small format, many people collected buttons, aggregating them on vests, hats, and jackets. When they are installed on the body, you can effectively "read" a person's political and sexual interests; and in this way, sometimes buttons speak on behalf of the person who wears them.

LATINAS

..WITH LIBERTY AND JUSTICE FOR ALL"

LESBERADO

FRONT

...how we need a
REVOLUTION!

The L.A.P.D.
FREED
the Slaves
April 10, 1976

MEN
USE CONDOMS
OR BEAT IT

LESBIANAS
LATINAS

PROJECT 10
"..WITH LIBERTY
AND JUSTICE
FOR ALL"

Lipstick
Lesbian

Sissie
HIPPIE+
★
COMMIE
faggot.

SMASH
IMPERIALISM

GAY LIBERATION FRONT

Stonewall
was a
riot...
now
we need
REVOLUTIO

SUPPORT GAY TEACHERS

MEN
USE CONDOMS
OR BEAT IT

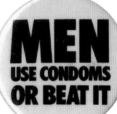
LESBIANAS
LATINAS

The
L.A.P.D.
FREED
the Slaves
April 10, 1976

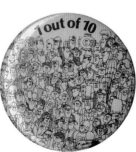
1 out of 10

WE ARE EVERYWHERE

Lipstick
Lesbian

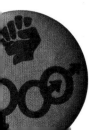

MEN
USE CONDOMS
OR BEAT IT

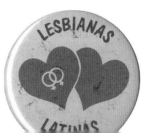
LESBIANAS
LATINAS

PROJECT 10
"..WITH LIBERTY
AND JUSTICE
FOR ALL"

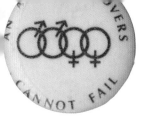

fag
got

ACTION=LIFE

A C T U P L.A.

CYNTHIA

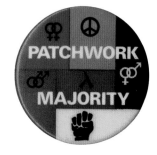

PATCHWORK

MAJORITY

U.S. OUT!

LESBIANS & GAYS AGAINST INTERVENTION IN LATIN AMERICA

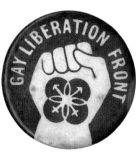

AN ARMY OF LOVERS

CANNOT FAIL

CYNTHIA·NY

OUT OF THE
CLOSETS
INTO THE
STREETS

GAY LIBERATION FRONT

f
g

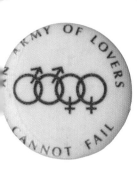

AN ARMY OF LOVERS

CANNOT FAIL

GAY
FREEDOM
DAY
1978

fag

CYNT

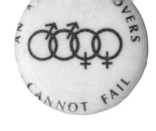

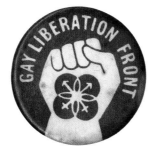

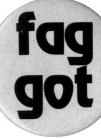

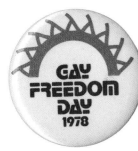

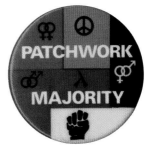

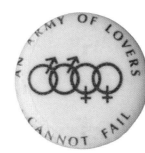

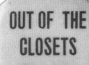

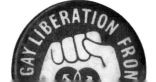

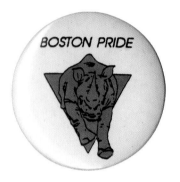

LAVENDER RHINOCEROS

Some symbols last for decades and others only for a short time. The lavender rhinoceros, designed by Daniel Thaxton and Bernard "Bernie" Toale, is an example of the latter. Initially debuted in 1974, the lavender rhinoceros existed locally in Boston, Massachusetts, for only a few years. Intended as a symbol of the strength and fortitude of LGBTQ communities, the rhinoceros in retrospect seems like a queer choice. As Toale related, "The rhino is a much maligned and misunderstood animal and, in actuality, a gentle creature." To make this point clear, the designers added a small red heart, a common symbol for affection and love. The rhino's personality characteristics—gentle, but tough when provoked or angered—seemed to speak to the position of LGBTQ people. At the time that Thaxton and Toale proposed it as a symbol of the new gay liberation movement, there was not widespread agreement on what the primary symbols of the movement should be. The initial campaign was largely disseminated through the dedicated advertising spaces of Boston's subway system. But increasing advertising costs prevented the designers of the lavender rhino from continuing to distribute it in this venue—and so the symbol went by the wayside, usurped in popularity by other symbols, such as the lambda. Thaxton and Toale's symbol did have a limited effect, though, as it inspired the moniker of Denver, Colorado's first LGBTQ magazine, *The Rhinoceros*.

FEY-WAY STUDIOS

Although performance artist and photographer Robert Opel is probably best remembered for streaking the 1974 Academy Awards (the show's cohost David Niven snidely remarked, "Fascinating to think that probably the only laugh that man will ever get in his life is by stripping off and showing his shortcomings."), his influence on LGBTQ communities in San Francisco was arguably much more consequential. A constant irritant in the political aspirations of gay activists who sought to seamlessly assimilate into society (Opel was denied the opportunity to walk in the San Francisco Gay Freedom Day Parade in his "Mr. Penis" costume), Opel was also fiercely supportive of artists dedicated to the unflinching representation of homoerotic desire.

In 1978 Opel established Fey-Way Studios, an art gallery dedicated to homoerotic art. He located it in San Francisco's South of Market neighborhood, a hotbed of speculative development and a flourishing leather/BDSM scene. The gallery hosted the first U.S. exhibition of Tom of Finland's work and became a gathering place for West Coast LGBTQ and leather artists. This business card, printed on holographic stock, conveys something of the eccentric strangeness of Fey-Way: loud, brazenly gay, and optically unapologetic. Unfortunately, Fey-Way Studios did not survive into the 1980s; Opel was murdered one July night in 1979 while minding the gallery. The community that Opel built around Fey-Way was deeply shocked by this sudden turn of events, and nothing like it has ever replaced it.

PLEASU

PLEASURE CHEST LOGO

Here's how a *New York Times* article from 1972 describes the Pleasure Chest, a fledgling New York City sex shop: "Open every day except Sunday, [the store] consists of two small rooms. The front room includes a display of waterbeds, flashing lights and erotic art, while the back room contains the artificial sex organs, love potions, candles, jewelry, leather products, 'bondage' devices and other gadgets." Cresting the wave of "the new morality" (the pornographic feature-length film *Deep Throat* had recently received wide and public theatrical release), Duane Colglazier and Bill Rifkin's entrepreneurial venture sought to normalize and streamline the experience of buying sex toys and pornography. To signal this, they invested in a well-lit West Village storefront, instead of solely relying on catalog sales, thus bringing the sex toy trade onto Main Street.

Once Rifkin and Colglazier, both of whom were formerly employed in the financial sector and both

ECHEST

of whom were gay, transformed their entrepreneurial venture into a full-fledged sex store (the Pleasure Chest began by selling only waterbeds), their marketing and advertising campaigns began to center a specifically gay clientele. Although not exclusive to gay men and lesbians, early Pleasure Chest catalogs openly courted a gay male clientele with their homoerotic framings (toys and gear were sold via drawings of imaginary men, using their Pleasure Chest products with creative verve). Although not its first logo, the Pleasure Chest's current logo is a visually punning piece of graphic design. Its manifold legs suggest movement, while also tastefully depicting mutual oral sex, or 69ing. The body(s) in the logo are gender ambiguous, allowing a customer to project their own sexual desires onto the design. Still in business, the Pleasure Chest was a key institution in the historical broadening of U.S. sexual mores.

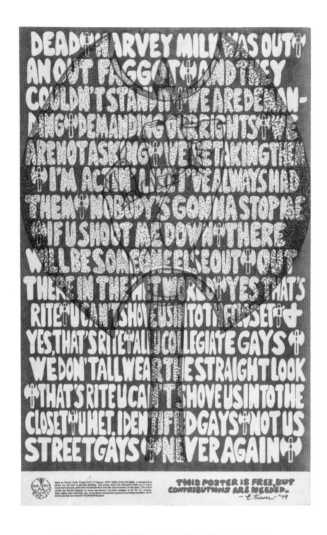

COME! UNITY PRESS POSTERS

Gay liberation was one of many political concerns addressed by the designers and printers of New York's Come! Unity Press. Organized as an "urban intentional community," the members of the cooperative print shop republished philosophical, political, and poetic tracts (by the likes of Thomas Paine, Friedrich Hölderlin, and Bertolt Brecht) as well as posters addressing a variety of activist causes, including but not limited to the American Indian Movement, Latin American indigenous and leftist political groups, and prison abolition organizations. Founded on a "pay-what-you-wish" model, the Come! Unity collective constantly struggled with financing their radically inclusive operation. Their output was equally heterogeneous—as they variously printed newsletters and magazines addressing

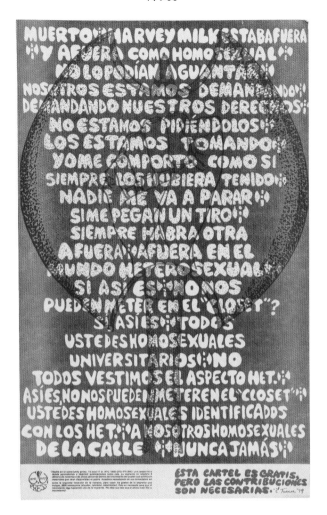

anarchist feminist thought and gay science fiction, for example.

These two posters, created shortly after the public murder of out San Francisco city supervisor Harvey Milk, expressed the mournful rage that enveloped gay and lesbian communities across the United States. Published in English and Spanish (an unambiguous signal of Come! Unity's inclusion of Spanish-speaking LGBTQ populations), the poster seems to answer the violence visited upon Milk. "If U shoot me down," reads one particularly powerful passage, "there will be someone else out/out there in the het. world/yes that's rite/U can't shove us into the closet." The labrys, or double-headed axe, appears between the statements of the poster's chopped monologue, and again in red, layered over the entire sheet—an upraised fist housed within it.

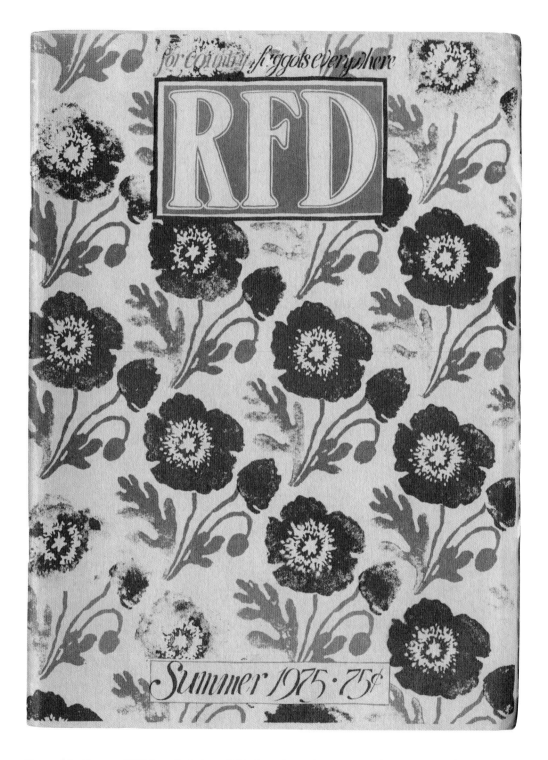

for country faggots everywhere

RFD

Summer 1975 · 75¢

Cover of the Summer 1975 issue featuring a field of pansies, a then-common derogatory term for gay men.

RFD MAGAZINE COVER

A self-described "Country Journal for Gay Men Everywhere," *RFD* released its first issue on the autumnal equinox of 1974. It no doubt took inspiration from the publications coming out of lesbian-separatist back-to-the-land movements—which established intentional communities in the midwest and northwest, throughout the early 1970s. Quarterly periodicals such as *Country Women*, begun by Ruth and Jean Mountaingrove, functioned as de facto guides to self-sustenance—mixing politics, activism, and pragmatic survival tips.

Like its lesbian-separatist counterparts, *RFD* stressed co-harmonious living and consuming the resources of the land sparingly. Although the editorial collective changed with each issue (another similarity between the two periodicals), *RFD* consistently contained almanac information, songs, resources, do-it-yourself projects, and advice on raising plants and animals within a rural setting. The first issue was sent out with a packet of seeds stapled to its cover. The magazine shifted in 1979, after Harry

Hay (founder of the early homophile organization the Mattachine Society) called for a secular "spiritual conference" among "gay brothers" in a "desert sanctuary near Tucson." Thus began the Radical Faeries—a countercultural movement that sought to offer an alternative to the trappings of urban gay life and the increasingly homogenized masculine appearance of many gay men (referred to, tellingly, as "the clone" look). Afterward, *RFD* became much more closely aligned with Radical Faerie philosophy and events, dropping some of the almanac-like content that defined the magazine's first years.

A reader might rightly ask what *RFD* stands for. While usually referred to as "Rural Fairy Digest," in fact, the editorial collective of each issue proposed their own acronymic extension, including: Raspberries, Fresh and Delicious; Raving Flamers' Diary; Rhododendron Forsythia Daffodils; Really Feeling Divine; Rabbits, Faggots, and Dragonflies; Roaring Fresh Decisions; Rightfully Feeling Delirious; Relevant? Funny? Dumb!; Rhyming For Daze.

GILBERT BAKER FLAG

An enduring symbol of celebration and pride, Gilbert Baker's rainbow flag is, above all, a reflection of the diversity and heterogeneity of LGBTQ communities.

Gilbert Baker, who sometimes performed in drag as "Busty Ross," used his outrageous, handmade costumes as activist tools—from his early performances as "Miss Liberty" dancing in a dress made from an American flag to his last appearance at an anti-Trump rally wearing a handmade concentration camp uniform with an inverted pink triangle and gold bar, recalling the humiliations and the brutality inflicted on Jews and homosexuals during the Nazi regime in Germany. In many ways the rainbow pride flag is an outgrowth of this activist spirit.

In 1978 Baker was asked by San Francisco city supervisor Harvey Milk to design a new flag for the upcoming Gay Freedom Day celebrations. Milk believed that the pink triangle that was in somewhat common use at the time was too denigrating and that a different symbol should replace it. The design that Baker conceived has very few peers in the history of LGBTQ design.

Originally, Baker composed his flag with eight colors, and each had symbolic meaning: hot pink—sex; red—life; orange—healing; yellow—sunlight; green—nature; turquoise—magic/art; indigo—serenity; and violet—spirit. The first two rainbow flags, each well over thirty feet long, were hand-dyed and stitched at San Francisco's Gay Community Center. With a team of around thirty volunteers to help, two, in particular, merit mention as major contributors to the success of the rainbow flag: seamster James McNamara and tie-dye artist Faerie Argyle Rainbow (now known as Lynn Segerblom). Segerblom engineered the dyeing of the fabric, and images of the first pride flags display colors with sensuous, mottled depth. When time came to rinse the fabric, the three collaborators went to a nearby laundromat, breaking the rules by washing newly dyed fabric. Baker and McNamara then sewed the flag in tandem, effectively using four hands to push the large bolts of the organically dyed cotton through the sewing machine.

During San Francisco's 1978 Gay Freedom Day festivities Segerblom, Baker, and a bevy of volunteers raised the first gay pride flags. James McNamara stood nearby, taking pictures of the event. The flags succinctly embodied the theme of the day: "Come out with joy, speak out for justice." But Baker's flags did not fly in front of San Francisco's City Hall—a major civic space and common gathering place after the parade—rather, they were flown nearby in United Nations Plaza. In his biography Baker indicated that he and his collaborators wanted to send the message that gay rights was a global and not only a local or national concern.

One common misconception is that both flags that Baker made were essentially the same. One of Baker's flags featured the eight colored stripes running across its length. But the other featured an additional blue canton on the hoist (pole side of the flag), like the American flag. Instead of fifty evenly spaced stars, Baker's flag incorporated several small circles of stars, each lovingly tie-dyed by Segerblom. One errant, queer star appears in the middle of the flag's turquoise

stripe, and has rarely, if ever, been discussed as an important component of the flag's design.

Months later, the mayor of San Francisco, George Moscone, along with supervisor Harvey Milk, who had helped to commission Baker's rainbow flag, were shot by fellow supervisor Dan White. The event galvanized LGBTQ communities in San Francisco and abroad—as White attempted to claim depression, and a recent change in diet to Twinkies, as the reason for his crime. The jury eventually convicted White but of manslaughter rather than murder (which would have carried a much greater penalty).

In response to the Moscone and Milk murders, the Pride Parade Committee decided to endorse and display Baker's flag all along the next year's parade route. Unrelated, but during this tumultuous time, Baker pitched his flag to the Paramount Flag Company for mass production, but hot pink proved impossible to procure as a mass-produced fabric. The Pride Parade Committee's desire to split the colors evenly along both sides of the street posed a problem for a seven-striped flag, and so Baker dropped another color, turquoise, as a concession to symmetry. The result was the six-striped flag most commonly used today.

For the twenty-fifth anniversary of the Stonewall uprising, Baker was tapped by pride organizations in Key West, Florida, to create a mile-and-a-quarter-long rainbow flag. Dramatic aerial images of the flag make it seem as though Key West's roads have suddenly been painted with vibrant rainbow hues. After the parade, the flag was cut up and made into smaller rainbow flags that were then sent out to pride celebrations across the world.

In 2012 Baker suffered a major stroke and lost some physical function on his left side. Through painful physical therapy he eventually had to teach himself how to sew again. Four years later he sewed a group of hand-dyed flags, featuring the original eight colors once again—returning sex and serenity to the powerful symbolics of the rainbow flag. (One of these flags graces this book's cover.) Baker gave one of these flags to President Barack Obama, who displayed it for a time in the White House.

This is the dynamic historical line that Baker's flag traces—from the daily indignities of a homophobic culture to the self-making efforts of queer communities. From mourning, anger, and rage to pride.

Baker's flag is now ubiquitous; it hangs in LGBTQ community spaces and appears in popular culture alike. In the summer of 2018, actress and director Lena Waithe wore a gown with a rainbow cape to the (by definition) fashionable Met Gala—an unambiguous sign of the star's identification with LGBTQ communities. Waithe's positioning of the flag as a high-fashion superhero's cape speaks to the aspirations of those who identify strongly with the flag. The rainbow flag is, by virtue of its bold colorway, difficult to hide or subdue. A room can be dim, and even then, the flag is legible. It demands attention and takes up a great deal of visual space. It is, in a word, itself; and its history reveals that change, far from being anathema to it, is part of its very DNA.

Thirty-fifth anniversary Rainbow Flag hand dyed and sewn by Gilbert Baker.

THE EVOLUTION OF GILBERT BAKER'S FLAG

Because of its central place in the pantheon of LGBTQ design, the flag and its colors have been variously adored, critiqued, and co-opted. Working with the ad agency Tierney, Philadelphia's Office of LGBT Affairs proposed adding two additional stripes, one black and the other brown, to Baker's rainbow flag. The city's LGBTQ affairs office had been tasked with addressing a rash of racial violence happening within Philadelphia's gay bars and clubs. For some, this was an unwelcome addition—as many believed it compromised Baker's design (but as the previous entry has shown, the flag has been anything but stable over the years). For others the flag's new design was a signal of the growing recognition of the interrelated struggles of racial and sexual minorities.

Recently, the graphic designer Daniel Quasar suggested that the rainbow flag ought to change to reflect a more intersectional representation of LGBTQ communities. Xyr design (Quasar uses xe/xem/xyr pronouns) adds black and brown stripes, which, like the Philadelphia flag, reflect the ongoing struggles of LGBTQ people of color, as well as light pink, light blue, and white—the colors of the transgender flag. Adding these colors as a chevron on the flag's hoist, Quasar's design suggests that more work needs to be done on these interrelated fronts if we are going to truly advance the cause of *all* LGBTQ people.

(FACING PAGE) Baker's six-striped flag, the one most commonly seen today, (ABOVE) Daniel Quasar's LGBTQ flag, (BELOW) Flag of Philadelphia's Office of LGBT Affairs, which includes a black and a brown stripe.

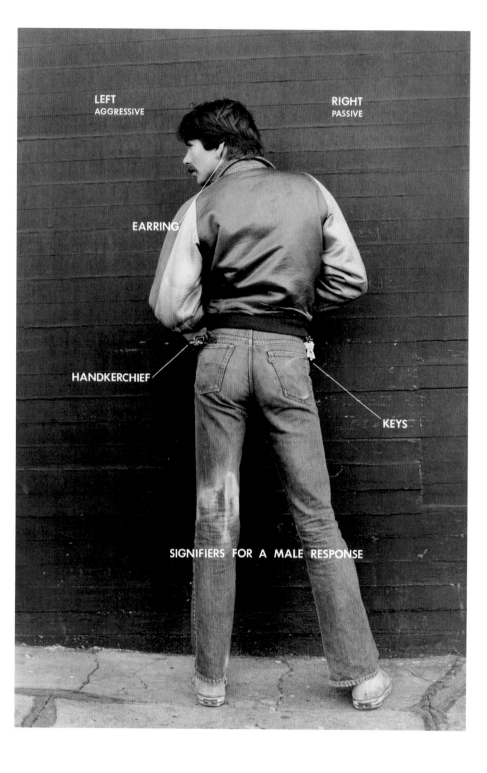

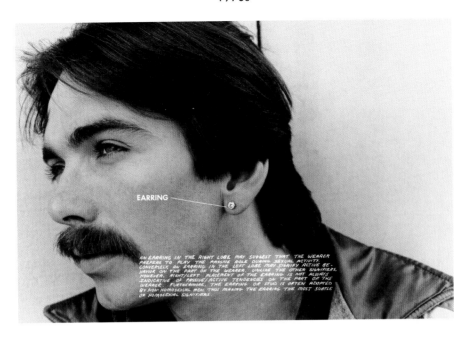

EARRING

AN EARRING IN THE RIGHT LOBE MAY SUGGEST THAT THE WEARER PREFERS TO PLAY THE PASSIVE ROLE DURING SEXUAL ACTIVITY. CONVERSELY, AN EARRING IN THE LEFT LOBE MAY SIGNIFY ACTIVE BE- HAVIOR ON THE PART OF THE WEARER. UNLIKE THE OTHER SIGNIFIERS, HOWEVER, RIGHT/LEFT PLACEMENT OF THE EARRING IS NOT ALWAYS INDICATIVE OF PASSIVE/ACTIVE TENDENCIES ON THE PART OF THE WEARER. FURTHERMORE, THE EARRING OR STUD IS OFTEN ADOPTED BY NON-HOMOSEXUAL MEN, THUS MAKING THE EARRING THE MOST SUBTLE OF HOMOSEXUAL SIGNIFIERS.

HAL FISCHER'S GAY SEMIOTICS

Inspired by the mostly gay male denizens of the Castro neighborhood in San Francisco, and his reading of structuralist theory, erstwhile photography critic Hal Fischer began to take pictures of friends and tricks dressed up with the quintessential signifiers of gay male dress. Over a sequence of four photographs Fischer laid out the meanings of particular items such as a ring of keys hung from a belt loop, earrings, and colored handkerchiefs. These hankies were part of a sexual signifying system known colloquially as "the hanky code," which corresponded particular colors with particular sexual activities. Red, for example, represented the desire to fist (that is, to insert a fist anally) or be fisted, depending which side of the body the hanky was worn on. But Fischer, who sometimes frames his work within the long tradition of Jewish humor, cleverly undercuts the seriousness of the meanings of the

hanky code by feinting toward the hanky's everyday use: "Red handkerchiefs are also employed in the treatment of nasal discharge and in some cases may have no significance in regard to sexual contact."

Working in dialogue with a group of photographers circulating around NFS Press (founded by conceptually oriented photographers Donna-Lee Phillips and Lew Thomas), Fischer expanded rapidly from these four photographs, adding an essay on gay semiotics (or the study of language and its meanings), and photographs of archetypal media images of gay men, leather vestments and gear, and popular forms of gay streetwear. With all the seriousness of an anthropologist doing fieldwork, Fischer's photographs are accompanied by a paragraph of text, or in some cases simple labels, that both edify and eviscerate the idea that one can fully "read" the appearance of gay men.

SLEEVELESS UNDERSHIRT

SATIN GYM SHORTS

WHITE SOCKS

ADIDAS

STREET FASHION
JOCK

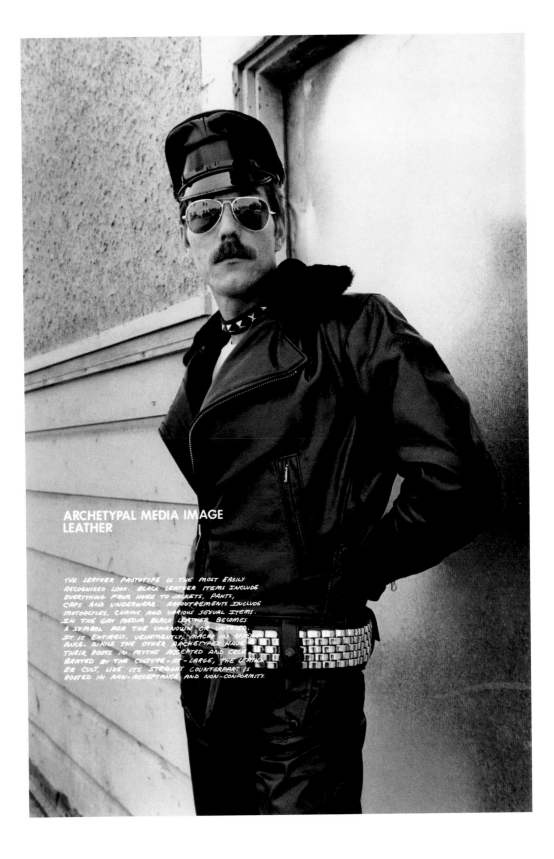

**ARCHETYPAL MEDIA IMAGE
LEATHER**

THE LEATHER PROTOTYPE IS THE MOST EASILY
RECOGNISED LOOK. BLACK LEATHER ITEMS INCLUDE
EVERYTHING FROM HOODS TO JACKETS, PANTS,
CAPS AND UNDERWEAR. ACCOUTREMENTS INCLUDE
MOTORCYLES, CHAINS AND VARIOUS SEXUAL ITEMS.
IN THE GAY MEDIA BLACK LEATHER BECOMES
A SYMBOL FOR THE UNKNOWN OR UNTRIED.
IT IS ENTIRELY, VEHEMENTLY, MACHO IN APPEAR-
ANCE. WHILE THE OTHER ARCHETYPES HAVE
THEIR ROOTS IN MYTHS ACCEPTED AND CELE-
BRATED BY THE CULTURE-AT-LARGE, THE LEATH-
ER CULT, LIKE ITS STRAIGHT COUNTERPART IS
ROOTED IN NON-ACCEPTANCE AND NON-CONFORMITY.

198

30s

1980s

The emergence of what is now referred to as the human immunodefficiency virus (HIV) and its attendant acquired immune deficiency syndrome (AIDS) is perhaps the single most important event of the 1980s, and perhaps the twentieth century more broadly. Initially and colloquially referred to as "gay cancer"—as many of the earliest deaths were of gay men—and then in the mainstream press as gay-related immune deficiency (GRID)—HIV/AIDS decimated gay communities and anodized already existing homophobic beliefs about the perceived sexual promiscuity, and thus moral depravity, of gay men. While epidemiologists and journalists argued over HIV's origins, men and women (both LGBTQ and straight—the virus remains unprejudiced) were dying by the thousands. The United States government—and in particular the Reagan administration—was largely unresponsive to the crisis. To get a sense of

how incomprehensible this silence was, think about how quickly news travels today regarding any new potentially deadly epidemiological or health threat. Famously, Reagan did not publicly mention the virus until 1985, four years after it was identified in the Centers for Disease Control and Prevention's *Morbidity and Mortality Weekly*. Recent audio unearthed from Reagan administration era press conferences reveals that the situation was as bad as many HIV/AIDS activists assumed: the president's proxy, press secretary Larry Speakes, treated HIV/AIDS as a joke—hectoring journalists who asked about the virus by deflecting and insinuating that they themselves must be gay. Religious officials, such as the Catholic cardinal John O'Connor, spread misinformation about the virus and publicly came out against safer-sex practices that involved the use of condoms. (His solution, perhaps predictably, was abstinence.)

In the face of a lackadaisical and homophobic government, and an overly cautious medical establishment, groups such as the Gay Men's Health Crisis (GMHC) were created to raise money and establish institutions for AIDS research and community healthcare. Out of GMHC emerged activist groups such as the AIDS Coalition to Unleash Power (or ACT UP), which pressured local, state, and national governments, religious institutions, and multinational corporations to do something about the (now global) pandemic. Part of raising awareness among LGBTQ communities and in larger civic and national communities involved the creation of striking visual campaigns, which by turns educated and excoriated those in power for their inaction. Many of the graphics created in response to the AIDS pandemic were developed by collectives of people—an enactment of the coalitional politics of AIDS activist groups. The Silence = Death

Collective's eponymous "Silence = Death" campaign is perhaps the most famous of these, and matches Baker's rainbow flag in prominence as a profoundly influential example of LGBTQ design. The AIDS Quilt—begun by activist Cleve Jones under the aegis of the Names Project—was another popular and visible forum for people to craft their memorials to the dead.

One of the primary directives of groups like ACT UP was to reorient the language of pity and victimization often applied from the outside to those who lived and died from HIV/AIDS. The singer, songwriter, and author Michael Callen in collaboration with his doctor, Joesph Sonnabend, and Richard Berkowitz, coined the term "person/people *living* with AIDS" (PWAs) as a corrective to the popular framing of PWAs as "victims," or otherwise without agency. One famous poster from the era, created by the collective Gran Fury, simply read "All people with AIDS are

innocent," in marked distinction to the language of condemnation popularly applied to those living with HIV/AIDS. Such graphic and linguistic reframings aided in the destigmatization of the ebullient and rich lives of those who were seropositive.

The AIDS pandemic changed everything: LGBTQ institutions, sexual cultures, mainstream understandings of LGBTQ people, and more. "Queer" was introduced as a term to be reclaimed from the trash heap of denigrating language, once used to dismiss the lives and concerns of LGBTQ people. Activist groups such as Queer Nation staked their claim on such uncompromising linguistic acts of assignation, challenging other LGBTQ people to acknowledge and own their radical heritage.

At the same time, cultural production continued apace: records were recorded, magazines produced and distributed, parties thrown, books published,

murals painted, and new symbols created. LGBTQ activism centered the HIV/AIDS pandemic, but was not strictly limited to its concerns. The efforts of Barbara Smith, Audre Lorde, and Cherríe Moraga, all queer women of color, for example, changed publishing and the vision for what was then called "third world" women's writings. Part of their efforts were enacted via their publishing house, Kitchen Table Press, and the striking covers of the books they published. In music, the vivacious performer Sylvester melded glam, funk, and nascent Hi-NRG and Afrofuturist aesthetics to create vibrant political performances that centered the lives, loves, and experiences of LGBTQ people of color.

In New York, the artist Keith Haring developed powerful and populist symbols for an array of LGBTQ organizations. Haring's work crosses realms of fine and popular art and design, and in this book

two examples of his work are included: a logo for the organization Heritage of Pride and a mural completed in the bathroom of the LGBTQ community center. Taken together they reveal that LGBTQ artists and designers honed their messages for different constituencies. The friendly Heritage of Pride logo, akin to the kinds of images Haring made for his Pop Shop in New York, exists in striking contrast to the sexual explicitness of his mural for youth who might need support in destigmatizing their own desires. This reveals one of the central tensions of this book, which is the toggling between design intended for a broadly defined public and design intended for a select community, with specific needs, desires, and cultural contexts.

Finally, the 1980s witnessed the popularization of computers and the Internet, and their attendant hydra-headed anarchic and experimental cultures.

The Internet's introduction not only changed the parameters of design production—for the first time, designers were working with software instead of analog tools—but of the dissemination of design, and the establishment of networked, virtual Internet publics. Pioneers in countercultural production such as Tom Jennings essentially shepherded a new kind of queer object, made out of a new material: computational code. Some, like C. M. Ralph, took software and repurposed it for alternative ends—making the first queer computer game.

In this respect, LGBTQ designers, whether engaged in creating graphics for one of the twentieth century's most dire calamities or for seemingly trivial diversions from overwhelming real-world problems, manifested the truly queer desire to find community and safety in one another.

PINK TRIANGLE

Paragraph 175—part of the German criminal code from 1871 until 1994—stipulated that homosexual acts between men (in addition to bestiality and child abuse) were crimes punishable with imprisonment and a "prompt loss of civil rights." When Adolf Hitler rose to power in the 1930s, he intensified the persecution of gay men, lesbians, and transvestites (transgender was not yet a term of art) as part of a larger bid to purify the German homeland from cultural, racial, and sexual "others." During the course of the Nazi regime approximately 100,000 men were arrested for homosexuality, and a number of these were sent to prisons and concentration camps. Homosexual male prisoners were forced to wear pink triangles on their prison uniforms, no doubt with the idea that such a flamboyant shape would be an inescapable badge of shame. Lesbians were given a black triangle, which was the symbol for "asocial" or "work-shy" prisoners. The pink and black triangles are direct embodiments of genocidal hatred—vile and contemptible symbols of Nazi policies toward homosexuals.

When some in early gay liberation movements began to use the pink triangle as an identifying symbol, there were people (including Harvey Milk) who were uncomfortable with its traumatic associations. It wasn't really until the Silence = Death Collective's iconic design debuted that the pink triangle was solidified as a sign of queer resistance and empowerment (see page 114). Some political groups, such as Boston's Black and Pink, founded in the mid-2000s, use the pink triangle in their visual branding as a tacit acknowledgment of the symbol's historical connection to incarceration and hatred, while also tapping into its empowering potential. Black and Pink, whose work toward "the abolition of the prison-industrial complex is rooted in the experience of currently and formerly incarcerated people," uses the pink triangle as an ad hoc jail cell, drawing a visual connection between the criminalization of queer and trans people across history. Two hands hold the central pink bars, sometimes a letter resting between them—a representation of one of Black and Pink's most successful programs, which is to put people in the "free world" in touch with LGBTQ prisoners.

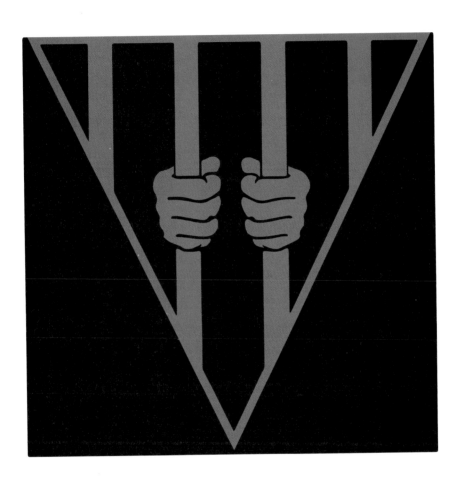

SYLVESTER

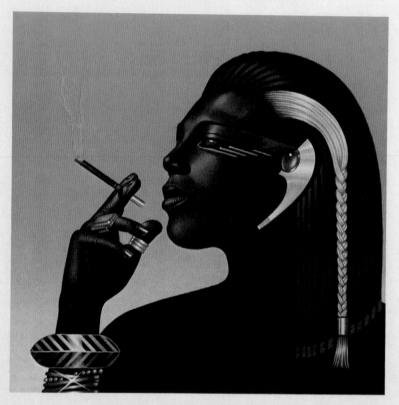

ALL I NEED

SYLVESTER ALBUM COVER

A musical force and a queer performance icon, Sylvester was shaped equally by his early forays into nightlife (as a member of the streetwise party crew known as the Disquotays) and experimental theater (as a participant in the queer troupe Cockettes), becoming an innovator in musical style.

Sylvester James, Jr., grew up in the Pentecostal church and was sexually abused within that community. A short time later he was ejected from his family household for being gay, and was homeless before his sixteenth birthday (a not uncommon fate for LGBTQ youth). Despite, or perhaps because of, these trials, Sylvester cultivated a practiced fabulosity—a state that cultural critic madison moore identifies, in part, as "dangerous, political, confrontational, [and] risky,"

for its associations with "queer, trans, and transfeminine people of color and other marginalized groups."

This record cover, one of two Sylvester albums illustrated by Mike Amerika, is a dazzling example of Sylvester's visual fabulosity, melding his gender-bending presentation with Afrofuturist aesthetics—a literary, philosophical, and visual movement combining black and pan-African imagery and sounds with science fiction tropes. Here Sylvester languorously holds his cigarette aloft—his eyes and earpiece suggesting a cyborg entity. Bangles bling in the lower left corner. In his performances and popular visual representations Sylvester challenged his audiences to rethink the terms of how certain identities could be visually expressed.

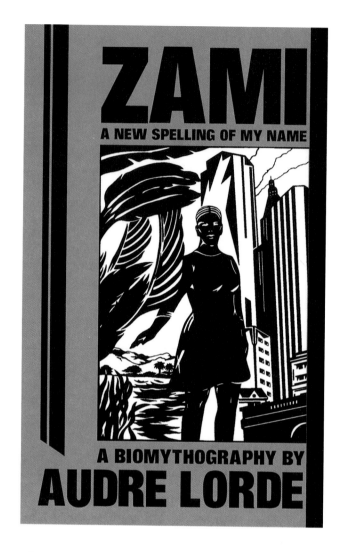

KITCHEN TABLE PRESS BOOK COVERS

A 1986 catalog for Kitchen Table Press describes their work as "both cultural and political, connected to the struggles for freedom of all of our peoples." The brainchild of writers and black/brown feminists Barbara Smith, Audre Lorde, and Cherríe Moraga, Kitchen Table Press was committed not only to producing books by women of color, but to reaching an audience that matched their authors' demographics, essentially building a publishing and distribution model that centered women of color. The kitchen table, then, is symbolic of the grassroots collaborations between women from different backgrounds, gathering together in the feminized space of the kitchen.

Two of the press's most popular volumes are

86,000 Copies Sold

Winner Of The 1986
BEFORE COLUMBUS
FOUNDATION
AMERICAN BOOK
AWARD

THIS BRIDGE CALLED MY BACK

WRITINGS BY RADICAL WOMEN OF COLOR

EDITORS:
CHERRÍE MORAGA
GLORIA ANZALDÚA
FOREWORD:
TONI CADE BAMBARA

included here; their iconic and graphic cover designs influenced the visual style of what was then referred to as "third world" publishing for years to come. Designed by Diane Souza, the cover of Audre Lorde's "biomythography" *Zami: A New Spelling of My Name* depicts a woman split between opposing worlds—one populated with lush vegetation and the other with rectilinear skyscrapers. She looks out at a reader, a hand hovering over a distant mountain range. Artist Johnetta Tinker illustrated the woman featured on the cover of Cherríe Moraga and Gloria Anzaldúa's signal collection of writings by brown and black women. She is the eponymous bridge for those seeking safe passage and a connection with the past.

THE AIDS QUILT

The art historian Julia Bryan Wilson has pointed out that the AIDS Quilt is "the largest ongoing community arts project in the world," and yet, it "continues to be vexed by logistical issues and ideological conflicts over its legacy and its ongoing purpose." Many see it as an effective memorial to those claimed by the pandemic, and its critics see a soft politics of remembrance, where a more insistent activist message might be more effective at creating political and cultural change. Regardless of one's associations or assessment, the AIDS Quilt remains one of the most impressive, coordinated artistic efforts in LGBTQ history. The quilt takes what is normally considered feminized labor and transforms it into public spectacle. Given this public function, a quilt's associations with warmth, or the personal and cultural narratives that often accompany them, are essential to the AIDS Quilt's memorial function.

The quilt's origins can be traced to a 1985 memorial vigil led by San Francisco–based activist Cleve Jones, a close confidant of the politician Harvey Milk. For the vigil, Jones, who describes himself as an "angry, arrogant son of a bitch," had participants write the name of a loved one who had died from AIDS onto white posterboard. These names were then carried through the streets of San Francisco, and eventually taped to the wall of the government building housing the Department of Health and Human Services — visually congealing everyone's disparate losses into a single mass. Jones writes of that moment: "Standing in the drizzle, watching as the posters absorbed the rain and fluttered down to the pavement, I said to myself, *It looks like a quilt*. As I said the word *quilt*, I was flooded with memories of home and family and the warmth of a quilt when it was cold on a winter night."

To manifest his vision, Jones enlisted the help of Gilbert Baker and Ron Cordova (as technical directors) and myriad volunteers, both expressly acknowledged and unacknowledged in Jones's writings of the quilt's story. It was during these early years that the structure of the quilt was cemented — each individual panel of the quilt would be rectangular, measuring three feet by six feet; and these panels would then be sewn together into large, twelve-by-twelve-foot square blocks that could be folded up and stored when not on public display. The quilts were to be folded with what the volunteer Jack Caster named a "lotus fold" — wherein the corners of each square block would be folded into the center, and the process repeated until a small bundle was made. This gave the quilt, particularly its folding

and unfolding, a performative and ceremonial dimension as it was de-installed from public display.

After showings in 1987 and 1992, the AIDS Quilt was given its most dramatic display in 1996—where it stretched from the Capitol building to the Washington Monument. A contemporaneous *New York Times* article covering the display conveyed its solemnity, beginning: "A carpet of grief covered the nation's front yard this weekend." Visitors to the quilt could locate their loved ones via enlisted volunteers who could give the coordinates for each individual memorialized in the quilt. In this respect the quilt not only made visible the enormity of the losses from the AIDS pandemic, but served a quieter, individualized function for those who wished to commune with particular friends and loved ones.

Because the parameters of the quilt are set, the most astonishing thing, from a design perspective, about the quilt is how it allows for individual expression within constraint. Some panels are dedicated to scores of names and others to only a single one. Some panels memorialize public figures claimed by the pandemic—such as Rock Hudson or Sylvester; but most are devoted to more anonymous figures—brothers, sisters, lovers, children, parents, and friends.

Some are truly quilted—stitched by hand or machine sewn; others are appliquéd, glued, and/or collaged. Humor infuses many panels, secret in-jokes or material flamboyances conveying something of the personality of the person being memorialized. Other panels are more solemn and spare. For the people who have made a panel, the experience is an unforgettable one—each design decision an important indicator of something related to the remembered person.

Memory is at once fugitive and felt, escaping any notion of true fidelity. Despite these structural losses, we can sometimes approach the enormity of the intermingled grief and desire to revivify those closest to us. In this respect the AIDS Quilt is an approximation—massive in scale—of the terrible legacy and ongoing losses of AIDS. Some have visceral, bodily memories of walking among the blocks in 1996, in the symbolic heart of our national community—on the "nation's front yard." But regardless of whether one was present for that display, or any of the thousands of local or national presentations of the quilt, one can imagine walking among the blocks, overwhelmed by the affective dimensions of the pandemic and the individual narratives and relationships charted using only a needle, some thread, and a bit of cloth.

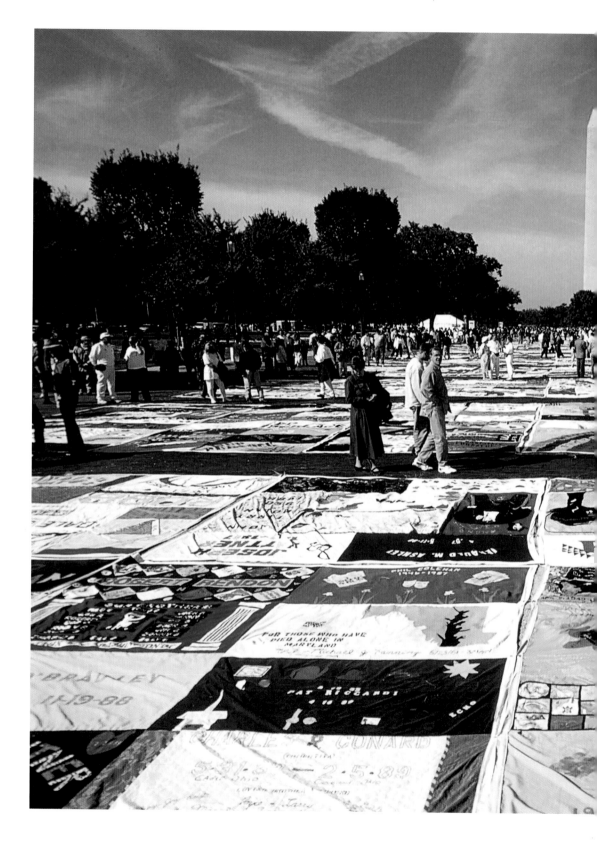

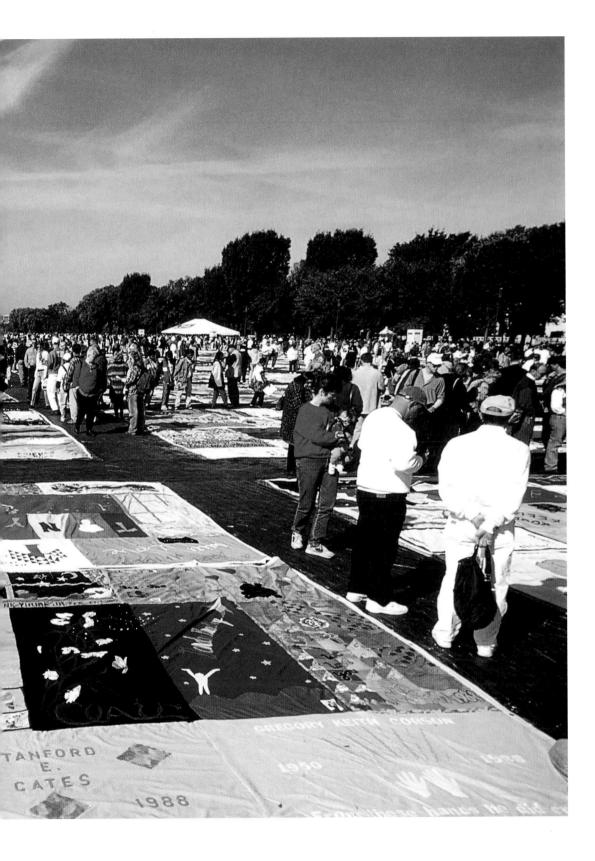

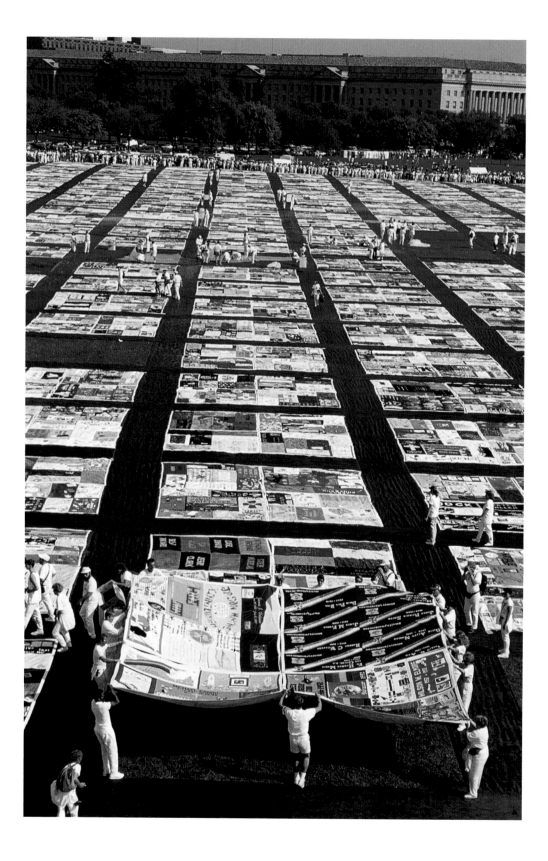

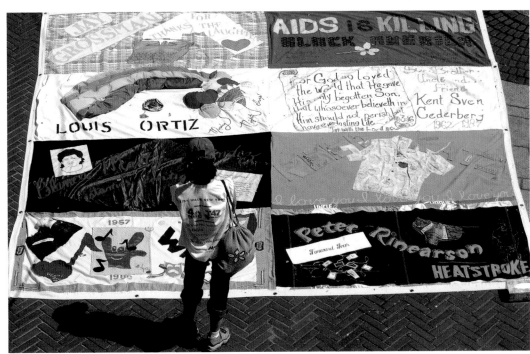

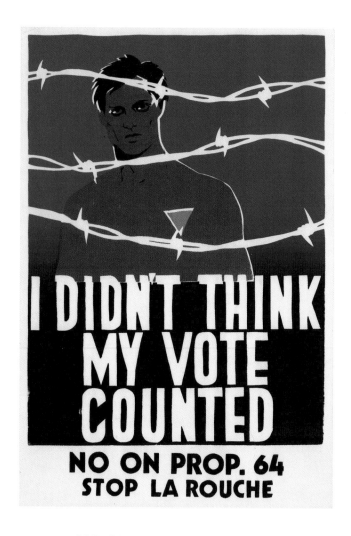

NO ON PROP 64 POSTERS

Perhaps no politician has been so obsessed with AIDS as Lyndon LaRouche, who, in 1986, proposed an initiative for California voters that would have listed AIDS as a communicable disease. LaRouche's initiative was informed by specious science (he believed that one could contract HIV through mosquitos and in the air), and had disastrous and anti-democratic implications; AIDS activists worried that if the initiative passed it would lead to mandatory testing and quarantine in concentration camps. The anonymous maker(s) of these posters and the political organization that distributed them (Central Coast Citizens Against LaRouche) dramatize this prospect with grim effectiveness. The twisting barbed wire creates a continuous pattern across the two posters—allowing for multiple posters to be

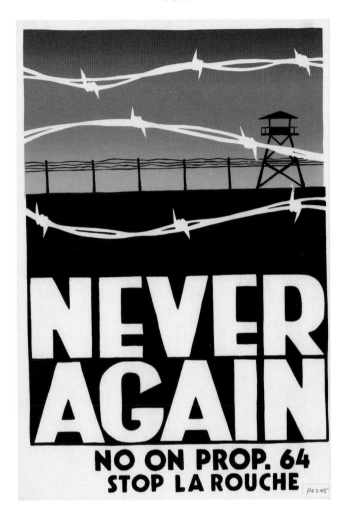

posted in succession to remain unified by the barbed-wire fencing.

One of the paired posters depicts a brown man, shirtless and branded with the pink triangle, a historical symbol of oppression under Nazi Germany. The text "I didn't think my vote counted" relates the consequences of political apathy. The second poster images the vast open—yet still enclosed—space of the quarantine camp. No people are present (have they all perished?), as the yellow and orange colors suggest a sunset of civility. "Never Again"—a phrase often attached to the Holocaust of World War II, is evocatively positioned to draw political parallels between then and now. Ultimately, campaigns like this were extinguished as the LaRouche initiative was roundly, and thankfully, defeated.

ACT UP

Wall Street was the site of ACT UP's (AIDS Coalition to Unleash Power's) first protest demonstration on March 24, 1987. The location had been chosen deliberately: Wall Street represented the heart of the financial interests of U.S.-based multinational corporations, such as the pharmaceutical manufacturer Burroughs-Wellcome, which repurposed an already-extant cancer drug known as azidothymidine (AZT) and tested it as a potential antiretroviral therapy for those living with HIV/AIDS. When introduced to an HIV/AIDS market, AZT was an expensive drug, costing about $10,000 for a year's worth of treatment. Activists in ACT UP agitated for the accessibility of drugs like AZT, and for the Food and Drug Administration to expand and speed up clinical and experimental drug trials that could potentially extend the life of a person living with HIV/AIDS, sometimes by a year or more.

For their first protest, ACT UP made a set of demands, which were collated and distributed on fliers:

1. Immediate release by the federal Food and Drug Administration of drugs that might help save our lives. These drugs include: Ribavirin (ICN Pharmaceuticals); Ampligen (HMR Research Co.); Glucan (Tulane University School of Medicine); DTC (Merieux); DDC (Hoffman-LaRoche); AS 101 (National Patent Development Corp.); MTP-PE (Ciba-Geigy); AL 721 (Praxis Pharmaceuticals).

2. Immediate abolishment of cruel double-blind studies wherein some get the new drugs and some don't.

3. Immediate release of these drugs to everyone with AIDS or ARC.

4. Immediate availability of these drugs at affordable prices. Curb your greed!

5. Immediate massive public education to stop the spread of AIDS.

6. Immediate policy to prohibit discrimination in AIDS treatment, insurance, employment, housing.

7. Immediate establishment of a coordinated, comprehensive, and compassionate national policy on AIDS.

During the protest, members of ACT UP debuted the now iconic "Silence = Death" design, hung an effigy of FDA commissioner Frank Young, and practiced nonviolent civil disobedience, sitting in the street and stopping the flow of downtown Manhattan traffic. In the end seventeen protestors were arrested, and the FDA soon announced that they would be speeding up future drug trials of AIDS medications.

ACT UP understood this action by the FDA to be a direct result of their protest, and soon the group was planning other protests at sites of national and local importance—such as the White House and New York's Memorial Sloan Kettering hospital. The group staged dramatic "die-ins" where members would lie down in front of institutions such as government buildings and churches, each holding their own tombstone at their head. To get around the protesters, people going to work or attending church had to step over the bodies of the dead. ACT UP also held "kiss-ins,"

wherein members of the group would make out in front of the halls of power, forcefully calling attention to the various reactions to publicly expressed queer desire. For the protesters, kissing was an explicit acknowledgment of the pleasures of life—a powerful and public rebuke of the common understandings of AIDS as only, or simply, a dour death sentence.

Although initially founded in New York, chapters of ACT UP were soon launched in dozens of national and international locales. ACT UP spawned a number of break-off groups devoted to developing television documentaries (DIVA-TV) and, in the case of the items on the following pages, visual materials (Gran Fury). One early example of the former was the video *Doctors, Liars and Women: AIDS Activists Say No to Cosmo* (directed by artist and activist Jean Carlomusto), which was produced in response to an article published in *Cosmopolitan* playing down women's risk of contracting HIV. It was the first activist demonstration put on by ACT UP's Women's Caucus, focusing on health concerns particular to women. This coalitional aspect of ACT UP's mission meant that, in the words of art historian Douglas Crimp, "Gay men and lesbians joined the struggle first and are still on its front lines."

In his 1991 memoir *Close to the Knives*, artist and member of ACT UP David Wojnarowicz speculated on the most effective way to bring the pandemic to the nation's attention. He wondered "what it would be like if, each time a lover, friend or stranger died of this disease, their friends, lovers or neighbors would take the dead body and drive with it in a car a hundred miles an hour to Washington DC and blast through the gates of the White House and come to a screeching halt before the entrance and dump their lifeless form on the front steps." This passage inspired the first "ashes actions" put on by ACT UP in 1992—wherein members would carry the ashes of loved ones through the streets of Washington, D.C., and "in an act of grief, and rage and love" deposit them on the lawn of the White House. The first ashes action was documented by James Wentzy for his video series *AIDS Community Television*. It remains one of the most profound protest actions ever performed in the United States.

ACT UP's uncompromising public obstreperousness and artistic creativity are two of its greatest contributions to LGBTQ and U.S. histories. Arguably, many of the advances in the care, treatment, and discourse around HIV/AIDS would not be what they are today without the work of ACT UP and other AIDS activists. (While ACT UP was the most visible, it was hardly the only group dedicated to eradicating HIV/AIDS and the cultural stigmas attached to those who lived with the virus.) Nor is ACT UP a thing of the past, a group only to be discussed in relation to the 1980s and the 1990s; many chapters of ACT UP are still active today and continue to raise political consciousness about the state of the ongoing pandemic. The organization's message "Act up! Fight back! Fight AIDS!" continues to be an unfortunately necessary and clarion exclamation.

SILENCE = DEATH POSTER

Silence = Death: this simple equation reflected and substantiated the grief and pain of thousands of people whose lives were irrevocably changed during the first years of the AIDS pandemic. It wasn't until 1985, when more than five thousand people had already died from the opportunistic infections that accompany the virus (HIV) and its condition (AIDS), that the then-president Ronald Reagan uttered the word "AIDS" in public. We now know things were even worse; as early as 1982 the Reagan administration's press representative rebuffed journalists who pursued an official response to the pandemic as "fairies." The situation was dire.

Created by a group of six men calling themselves the Silence = Death Collective, this path-breaking design has now been taken up by generations of LGBTQ and AIDS activists. The collective members—Avram Finkelstein, Charles Kreloff, Jorge Socarrás, Brian Howard, Chris Lione, and Oliver Johnston—had connections to the art and design worlds, and were intimately familiar with the pandemic that was laying waste to their communities of friends, family, and lovers. Together they created one of the most significant examples of graphic design in the twentieth century, and, perhaps even more importantly, became a support group for one another in the process.

In terms of design, their innovation was to appropriate the pink triangle, a symbol used to identify homosexuals in Nazi concentration camps, and to flip it so that it stood on its base—conveying the strength of an otherwise stigmatized social position. To this they added a simple equation, rendered in sans serif capital letters. The result is a graphic shout; an equation whose math is always wounding. With this design the members of the Silence = Death Collective fulfilled their intention to "turn anger, fear, [and] grief into action."

SILENCE=DEATH

© 1987 THE SILENCE = DEATH PROJECT. Used by permission by ACT UP, the AIDS Coalition To Unleash Power. 496A Hudson St. #G4. NYC 10014

Enjoy

AZT

IS THIS HEALTH CARE OR WEALTH CARE?

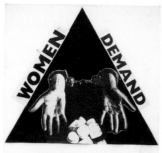

WOMEN DEMAND

ACCESS TO TREATMENTS

ACT UP
LESBIAN FURIES

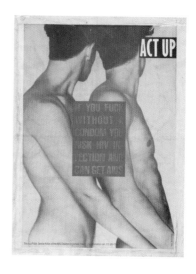

ACT UP

Enjoy

IS THIS HE

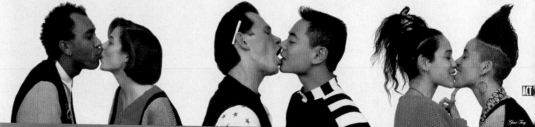

KISSING DOESN'T KILL: GREED AND INDIFFERENCE DO

ACT UP

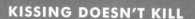

CORPORATE GREED, GOVERNMENT INACTION, AND PUBLIC INDIFFERENCE MAKE AIDS A POLITICAL CRISIS

ACT UP

KISSING DOESN'T KILL

The items on these pages represent the visual and emotional range of ACT UP–affiliated graphics. For example, Gran Fury's "Kissing Doesn't Kill: Greed and Indifference Do"—designed to first appear on Chicago-area public transportation—is quietly informative, dispelling popular myths about the transmission of HIV, while also sending up contemporaneous United Colors of Benetton advertisements. Other posters and graphics evince a powerful rage, calling attention to those deemed culpable. Like the "Silence = Death" design, these posters and signs tend to feature a single graphic in coordination with a condensed textual message. Some, like the "AIDS Crisis Is Not Over" by Little Elvis serve as an early reminder that advances in medicine or policy are not tantamount to the eradication of HIV/AIDS or its social stigmas.

CRISIS
OVER

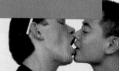

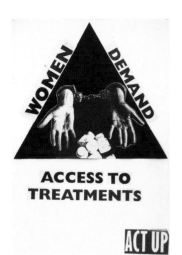

WOMEN DEMAND

ACCESS TO
TREATMENTS

ACT UP
LESBIAN FURIES

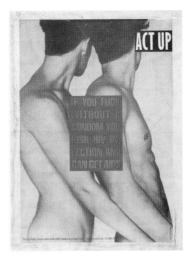

ACT UP

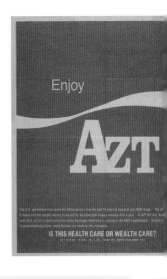

Enjoy

AZT

IS THIS HEALTH CARE OR WEALTH CARE?

THE AIDS CRISIS
IS NOT OVER

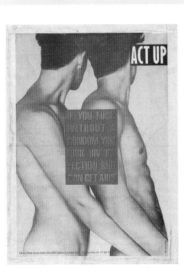

ACT UP
LESBIAN FURIES

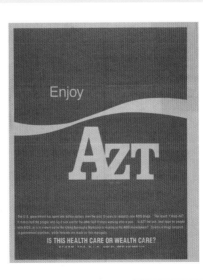

Enjoy

AZT

IS THIS HEALTH CARE OR WEALTH CARE?

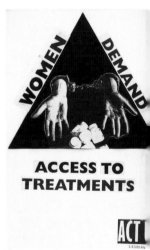

WOMEN DEMAND

ACCESS TO
TREATMENTS

ACT

DIFFERENCE DO.

ACT UP

THE AIDS CR

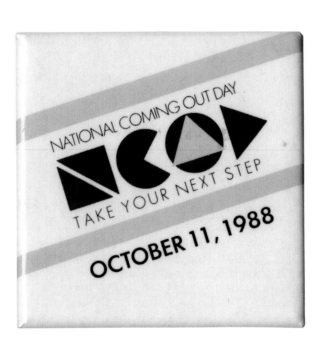

NATIONAL COMING OUT DAY

NCO

TAKE YOUR NEXT STEP

OCTOBER 11, 1988

NATIONAL COMING OUT DAY LOGO

Organized in 1988 on the anniversary of the 1987 March on Washington for Lesbian and Gay Rights, National Coming Out Day was the brainchild of a number of activists living near Washington, D.C. Among these were Jean O'Leary, head of the National Gay Rights Activists, and Rob Eichberg, who founded The Experience, a community-based workshop that helped gay and lesbian people "come out" to their families and friends. Since the establishment of gay liberation movement groups, coming out had been a popular political tactic to personalize the issues that faced LGBTQ people. The hope was that if enough people came out to their family and friends that this would lead to a sea change in the way that gays and lesbians were treated both at home and in culture at large.

By designating a day in which coming out could be celebrated, O'Leary and Eichberg hoped to provide national support for those struggling to live openly among friends and family. Part of that campaign included designing a logo that communicated, with clarity, this process. Although only in use for the first years of the event, this logo rendered the initialism NCOD in purple and pink geometric shapes—each element pointing from left to right, and thus implying a forward motion. The "O" is filled with a pink triangle and the final "D" looks like the tip of a pointed arrow. The logo was printed on buttons, flyers, stickers, cards, and t-shirts. Its embrace of geometric simplicity bespeaks a concurrent interest in postmodern design and architecture to playfully reevaluate design orthodoxy. Nearly as soon as the logo was developed, it was supplanted by an illustration made by Keith Haring of a figure dancing its way out of a closet. While Haring's design is remarkable for its own reasons, it has, by now, completely eclipsed the organization's original design, which possesses a clever and underrecognized design intelligence.

INVITATION FROM THE SAINT

Located in a purpose-built dome and featuring millions of dollars worth of lighting and audio equipment, The Saint nightclub set a remarkable new standard for New York nightlife when it opened in 1980. Bruce Mailman, who also owned the nearby New St. Mark's Baths (and was a producer of off-Broadway theater such as Al Carmines's 1973 musical *The Faggot*), repurposed a former theater for his new nightclub. The Saint was as much defined by its technical wizardry as its exclusivity—a limited number of memberships were sold in the dance club's first year, and women and people of color were a rarity until the club's final years. It was party by design; the main circular dance floor offered no quarter—as it had no corners—for shrinking violets. The club's architecture, designed by Charles Terrell, emphasized the soaring height of the perforated metal dome, which on the weekends when the club was open served as a canvas for the hundreds of stage and special effects lights, including a juiced-up, rotating Spitz Space System projector, the kind often used by planetariums.

This invitation from the club's first year anthropomorphizes some of The Saint's sensorial and architectural conceits. A monumental nude male figure is set against an early morning sky (The Saint's parties didn't start until eleven p.m. and often didn't end until the morning)—stars still visible in the predawn glow. Rainbows shoot out like lasers from the man's eyes, dark searchlights from his fingertips. He places his left hand over his heart, which emanates an otherworldly glow. It is as if he has swallowed the club whole, internalizing its constellated pleasures.

Talent flocked to the club—Sylvester, Grace Jones, and Linda Clifford joined DJs such as Jim Burgess, Robbie Leslie, Nao Nakamura, and Sharon White in the raucous revelry. Susan Tomkin, a former employee at the nightclub, summarizes the mission and atmosphere succinctly, saying, "We felt gay people were entitled to have a fabulous place to go to and dance, and be themselves and part of a community."

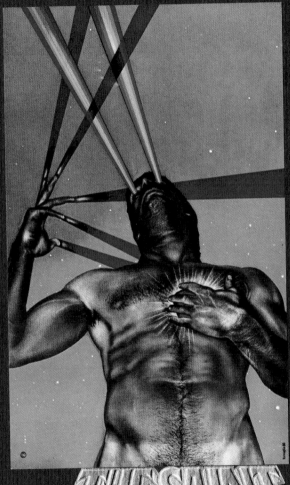

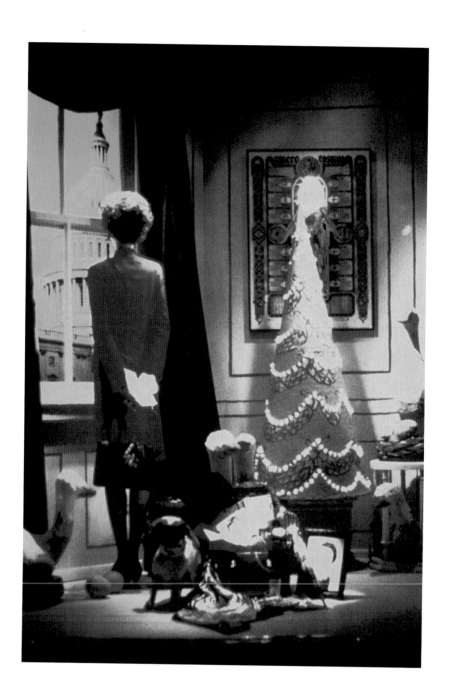

WINDOW DISPLAY DESIGN

Sited at the intersection of commerce and public art, window displays are often a neglected form of popular design. The design firm Matson Jones Custom Display was the corporatized identity of the artistic duo Robert Rauschenberg and Jasper Johns—once lovers, and important figures in the development of modern avant-garde art. Together they designed windows for upscale clients such as Tiffany & Co. and Bonwit Teller (for whom Andy Warhol also completed window displays) that merged the everyday with surrealist visual cues. Such pop-surrealism was also on display in the window designs of Simon Doonan and Mundo Meza, who raided Los Angeles–area prop houses to hilarious and sometimes disturbing effect.

The window featured here (left) was created in 1988 when the Reagans were leaving the White House. It references various aspects of the Nancy years including her obsession with astrology and her extravagant china purchases.

Across the country in New York, artist Greer Lankton designed a series of dolls (many based on real people) that populated the window displays of the East Village boutique Einstein's, operated by her husband (above). Splendid, weird, and finely crafted, Lankton's window displays earned the artist a cult following, and now, years later, her contributions to that heady artistic scene are only beginning to be understood and valued.

LEATHER FLAG

Tony DeBlase, the creator of the leather pride flag, spent his days working in Chicago's Field Museum of Natural History. Taking on the pseudonym "Fledermaus" (German for "bat"), DeBlase spent his nonworking hours publishing, educating, and organizing in Chicago's vibrant leather/BDSM communities. As editor and publisher of magazines like *DungeonMaster* and *Drummer*, DeBlase emphasized that sexiness is always supported by safety and technique when engaging in sadomasochism. Along with the longtime photographer, entrepreneur, and activist Chuck Renslow, DeBlase was a founding member of the Leather Archives and Museum, now located in a former Jewish synagogue in Chicago's Rogers Park neighborhood.

DeBlase's flag design was unveiled at the 1989 International Mr. Leather competition, and unlike Gilbert Baker, who gave an interpretation of his flag's colorway, DeBlase coyly left the design for the viewer to decipher. The colors black and blue certainly have material resonance with the common dress of leather/BDSM—black leather and blue denim. The central white stripe is more wily; oftentimes white is interpreted as signaling "purity" in flag design—but this has never been a significant ideal in leather/BDSM communities. The red heart is clearer, being a common symbol for love.

The Leather Pride flag designed by Tony DeBlase in 1989. On the design, DeBlase wrote, "I do not expect this design to be the final form.... I will leave it to the viewer to interpret the colors and symbols."

KEITH HARING'S HERITAGE OF PRIDE LOGO

Made up of members of the recently disbanded, in 1983, Christopher Street Liberation Day Committee—the group responsible for the annual gay liberation day parades in New York—Heritage of Pride represented a break from previous gay and lesbian activist organizations. Unlike the coalitional efforts of the previous Christopher Street Liberation Day Committee, Heritage of Pride was a membership organization, and an incorporated nonprofit. The scholar Myrl Beam has recently discussed this process as the "nonprofitization" of the gay social movements; one in which direct unsanctioned protest actions are replaced with the coordinated efforts between gay activist communities and governmental organizations. Haring's logo—comprised of two pairs of dancing figures, each pair with interlinked Venus and Mars symbols for heads, respectively—arguably presents a fun and unthreatening image of gay and lesbian people for public consumption.

KEITH HARING'S *ONCE UPON A TIME* MURAL

If Haring's Heritage of Pride logo deemphasized the sexuality of LGBTQ people, the same cannot be said of the men's bathroom mural he painted for New York's Lesbian, Gay, Bisexual & Transgender Community Center (commonly referred to as simply "The Center"). Painted less than a year before he died from AIDS, the mural dynamically renders an orgiastic array of bodies in a variety of sexual activity. Entitled "Once Upon a Time," the mural represents sexual recreation in a space sometimes used as a cruising ground. The title is promiscuous in its meaning—suggesting both a hearkening back to pre-AIDS sexual expression and a potential new beginning in the present. The mural is therefore an acknowledgment and a tacit encouragement of the sexual mores of gay men—even during the HIV/AIDS pandemic. Tongues touch, and men emerge out of the tips of penises—playfully recounting fantastical, impossible sexual escapades. Recently, Haring's mural was restored, and today it continues to inspire and support the sexual lives of LGBTQ people.

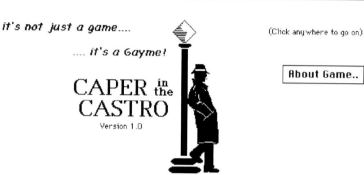

it's not just a game....

.... it's a Gayme!

(Click anywhere to go on)

About Game..

CAPER in the CASTRO

Version 1.0

© 1989 C.M. Ralph All Rights Reserved

A Gay and Lesbian Based Adventure Mystery Game with Sound, Text & Graphics.

Caution: This game includes scenes of violence and other material which may be inappropriate for persons under the age of 18. Please use discretion.

Disclaimer: This game is a work of fiction. Any resemblance to actual places, incidents or people (be they alive or dead) is entirely coincidental.

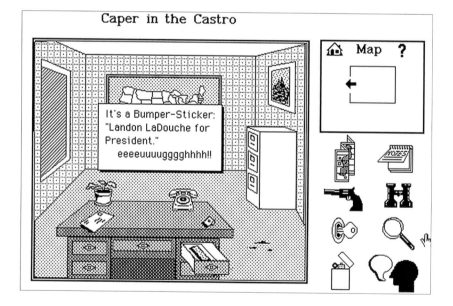

Caper in the Castro

Map ?

It's a Bumper-Sticker:
"Landon LaDouche for President."
eeeeuuuugggghhhh!!

As Tracker McDyke you must enter and sometimes break into spaces in the Castro. Here an opened drawer reveals a political bumper sticker for a quasi-fictional candidate, Landon LaDouche, a satirical take on Lyndon LaRouche, author of anti-gay legislation.

CAPER IN THE CASTRO

When C. M. Ralph and her partner moved from conservative Orange County to the liberal oasis of San Francisco, she thought she was arriving in a gay utopia. Soon, though, the real world came crashing in, as many of her friends and confidantes began to die of AIDS. As Ralph relayed to me, "it was a very dark time in our lives." In the midst of her grief and anger, she tasked herself with learning HyperCard; and while tooling around with the capacities of that database and user interface software, she created what would be the first LGBTQ video game, Caper in the Castro.

The game's story is simple: you are Tracker McDyke, the famous lesbian private eye, trying to solve the recent kidnapping of Tessy LaFemme, noted local drag queen. Exploratory in nature, Caper in the

Castro rewards player curiosity with in-community jokes and broader reflections of a corrupt and homophobic political system (at one point you raid the offices of Dullagan Straightman, finding a bumper sticker for Landon LaDouche's presidential campaign in a desk drawer). To solve the mystery you walk along the Castro collecting clues—and in true hard-boiled fashion, the crime is even worse than imagined.

One of the most touching aspects of the game makes itself apparent from the outset: when booting up the game a note from Ralph pops up, requesting that a player donate to an "AIDS related charity of your choice, for whatever amount you feel is appropriate." Calling her software "CharityWare," C. M. Ralph ingeniously turns devastation into support and renewal.

SAMOIS LOGO

Samois, the first lesbian S/M organization (1978–1983), played an important role in defining the political and social dimensions of lesbian leather/BDSM practice. Samois was an outgrowth of a women's discussion group attached to the Society of Janus (a mixed-gender, mixed-sexuality support and education group founded by San Franciscans Cynthia Slater and Larry Olsen). Key founders of Samois such as Gayle Rubin and Patrick Califia, along with members of later, similarly oriented organizations such as the Lesbian Sex Mafia in New York, were major contributors to a queer and feminist sex-positive philosophy and practice. Califia, for example, wrote a widely read sex advice column for *The Advocate*, and Rubin's academic writings have shaped queer and feminist academic discourse around sex for more than a generation.

The Samois logo, which appears on the masthead of several early newsletters, communicates their ties to lesbian feminism graphically—creating from the tools of sadomasochism (rope and handcuffs) two contiguous Venus symbols (a common graphic rendering for lesbians). Samois's approach was both politically aware and wryly humorous. As part of their statement of purpose, Samois directly addressed their relationship to feminist thought and practice: "We believe that S/M can and should be consistent with the principles of feminism. As feminists, we oppose all forms of social hierarchy based on gender. As radical perverts, we oppose all social hierarchies based on sexual preference." Not everyone in feminist communities felt the same, and Samois and its members weathered intense and unfair scrutiny in defending their lives and ideals.

```
            _
          /   \
        / |oo  \
       (_|  /_)
        _`@/_ \_
       |     | \ \     _
       |     |  \ \    \\
       | (*) |   \ )   ) )
       |__U__|   / /   \//
        // | |   _\     /
      (_/ (_|  (___/
         (jm)
```

FIDONET LOGO

A self-described "fag anarcho nerd troublemaker/ activist," Tom Jennings (who was also the editor of queer zine *Homocore*) began to work on the idea for what would eventually be known as Fidonet in late 1983. Initially conceived of as a bulletin board program where users could post publicly, eventually the program was expanded to also include the exchange of private messages—a "store-and-forward computer mail system," in the words of Jennings. Although run in "a profoundly casual manner" in terms of software design, Fidonet paved the way for many Internet technologies in use today—from forums to emails and direct messaging. The basic concept was that the software network could hold a certain number of "nodes," attached to particular users, who could then send messages to one another. Jennings, who lived in San Francisco, was node number one.

The Fidonet logo was designed by node number two, John Madil, who worked at the time at a Computerland in Baltimore, Maryland. Madil made the image of a dog holding a floppy disk in its mouth using the American Standard Code for Information Interchange (or ASCII) coding system. Although not central in extant histories of Jenning's software, Madil's dog prototypes the relationship between visual imagery and early Internet technologies—where cute mascots stood in for much more complicated code. The metaphorical dog with a stereotypical name, Fido, stands in for the primary function of the software, which is to retrieve and deliver messages—like any dog in a public park.

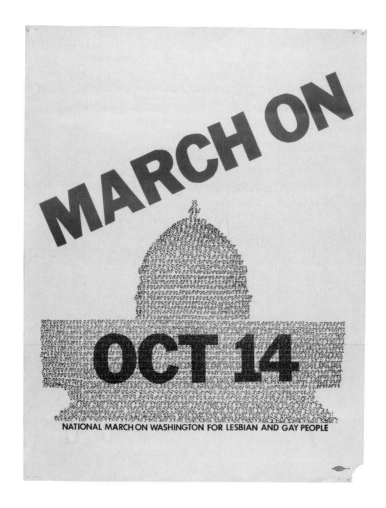

MARCH ON WASHINGTON POSTERS

There have been three large national protest marches in Washington, D.C., for LGBTQ rights. Inspired by the 1963 March on Washington (the event at which Martin Luther King Jr. gave his iconic "I Have a Dream" speech), the first LGBTQ march took place in the summer of 1979, on the tenth anniversary of the Stonewall uprisings. Early organizational efforts were supported by Harvey Milk and a constellated array of regional and localized LGBTQ groups across the United States. Organizers developed a five-part platform asking for a comprehensive lesbian and gay rights bill, an end to discrimination based on sexual orientation at the federal level, a repeal of all anti-gay laws, the abolition of discrimination against lesbian and gay mothers and fathers in custody cases, and a set of protective measures for LGBTQ youth.

This first march set the bar for the following two marches, in 1987 and 1993, respectively, with

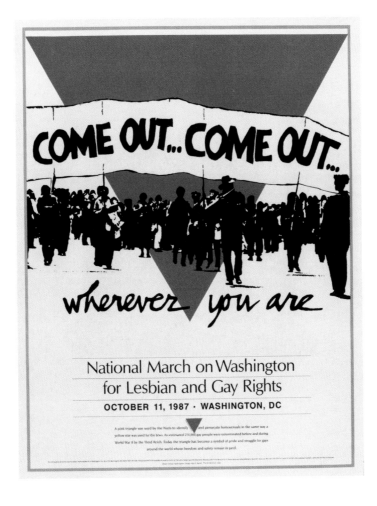

organizers estimating nearly one million people in attendance at the 1993 march. These posters are from the first and second national marches. Both use pink and black as the sole colors—calling attention to popular graphic representations of queerness. In the 1979 poster the nation's Capitol building is composed of rows of tiny pairs of Mars and Venus symbols, a visual reformatting of a national polity. The 1987 poster appropriates a line spoken by Glinda the Good Witch in *The Wizard of Oz* (1939)—a double entendre naming the process of coming out as a personal and national political act. A large pink triangle dominates the design, with the silhouetted forms of people at a protest march below. The visual design of the poster at once signals an intensification of the design strategies used in the earlier 1979 poster and acknowledges the recent reclamation of the pink triangle as a viable symbol in the continuing gay liberation struggle.

DAY WITHOUT ART LOGO

In 1989, on the second annual World AIDS Day (sponsored by the World Health Organization), Visual AIDS, an HIV/AIDS advocacy organization that names art as their "weapon of choice," introduced the concept of a day of "action and mourning" called A Day Without Art. Eventually, more than 800 arts organizations participated with their own programs, events, actions, and rituals. Usually artworks on display in these spaces are shrouded from public view with dropcloths, or gallery lighting is dimmed, depicting the enormous loss of visual artists in the HIV/AIDS pandemic. The first Day Without Art was promoted with a poster that featured Visual AIDS's name in a bold, sans serif font, cracking and breaking apart. For the second year Visual AIDS introduced the logo reproduced here, a square with an "X" inside of it—rendered in graphic brushstrokes. Evincing a literal connection to the activity of art-making (the

square canvas, the brushy lines), the Day Without Art logo, just like the event itself, centers artistic activity in its somber black-and-white design. It is a design that renders a paradox, how to visualize the invisible, or the hidden.

Since the first Day Without Art in 1989, the program has continued to grow. Sound and video works have been distributed by Visual AIDS to accompany museum and gallery presentations of a Day Without Art. One example is the audio work created by Robert Farber, entitled *Every Ten Minutes*. As the title indicates, the work is comprised of a bell that sounds every ten minutes, an aural manifestation of the statistic at the time that one person died of AIDS every ten minutes. Farber's work was shown at many museums and galleries in the early 1990s as a striking meditation on presence, visuality, and absence in the midst of the HIV/AIDS pandemic.

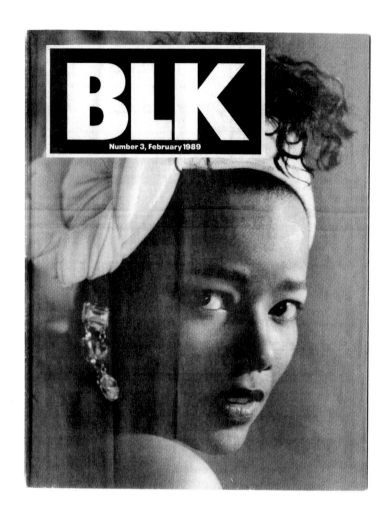

Number 3, February 1989

BLK MAGAZINE

When graphic designer Alan Bell arrived in Los Angeles, he had already been the editor of *Gaysweek* (1977–1979), a weekly newspaper for New York's gay and lesbian communities. Sensing the need for an all-black sex venue, Bell founded Black Jacks, the longest-running, monthly, all-black safer sex party. *BLK* ("Where the news is colored on purpose") was an outgrowth of a small newsletter Bell circulated among Black Jacks attendees, conveying recent news and information about the HIV/AIDS pandemic. Over the course of forty-one issues, *BLK* went from newsprint to full glossy, gathering community events ("BLK Board"), letters to the editor ("BLK Mail"), news, and classifieds ("BLK Market") by and for black gays and lesbians in Los Angeles. Articles ranged from an obituary for the disco diva Sylvester to tongue-in-cheek exposés: which black celebrities were circumcised (Jimi Hendrix—uncircumcised; Sammy

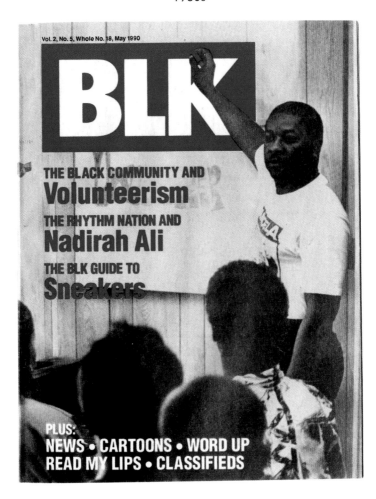

Vol. 2, No. 5, Whole No. 18, May 1990

BLK

THE BLACK COMMUNITY AND
Volunteerism
THE RHYTHM NATION AND
Nadirah Ali
THE BLK GUIDE TO
Sneakers

PLUS:
NEWS • CARTOONS • WORD UP
READ MY LIPS • CLASSIFIEDS

Davis—circumcised). Each issue featured a portrait photograph of a black queer celebrity or political personality (Audre Lorde and Perry Watkins are two notable examples), with *BLK*'s large, sans serif logotype, often printed in a bright, contrasting color.

One of the early hallmarks of *BLK* was the appropriation of cartoons taken from *JET* and *Ebony* magazines—for which Bell and others would write sexually suggestive captions. In a cartoon showing a man talking to a bartender, *BLK*'s caption reads: "I've got ten inches, a big house, a big car and lots of money, but he'd still rather have L.L. Cool J." Bell's publishing company, BLK Inc., produced an astonishing array of magazines targeted toward LGBTQ black demographics, including periodicals that focused on poetry (*Kuumba*), personals and classifieds (*B-Max* and *B-Men*), and erotic stories and photography (*Blackfire* for men, *Black Lace* for women), just to name a few.

ENTERTAINMENT FOR THE ADVENTUROUS LESBIAN

ON OUR BACKS

SUMMER 1987

$4.00

3RD ANNIVERSARY!

ON OUR BACKS MAGAZINE

"Yes, finally a sex magazine for lesbians!" begins a letter to *On Our Backs*'s initial readers. Founded by Myrna Elana and Debi Sundahl, and edited by Susie Bright, *On Our Backs* came rip-roaring into 1985, what the editors proclaimed as "the year of the lustful lesbian." Armed with a wicked sense of humor and a bevy of dyke babes, the magazine made fun of the genre of the porn magazine while also conforming to it. For example, the first issue of *On Our Backs* features a centerfold devised by Honey Lee Cottrell (*On Our Backs*'s staff photographer), as well as an accompanying "Dagger Data Sheet" listing Cottrell's stats, ambitions ("live in another country for 15 years"), turn-ons ("my pocket pepper mill"), and turn-offs ("the refrigerator with rotten food in it"). A year later Cottrell wrote about her submission in the pages of *On Our Backs*,

describing how the feature had allowed her to explore and come to terms with some of the more derisive language ("bulldagger") and stereotypes used to represent lesbians in popular media.

Ultimately, Bright and the *On Our Backs* contributors created a sex-positive forum for lesbians at a time when discussions of sex, especially pornographic representations of sex, were under intense scrutiny within feminist communities. Indeed, the magazine's title was a riff on *Off Our Backs*, a contemporaneous feminist publication that carried an anti-pornography view of feminist sexual politics. The covers of *On Our Backs* are brazen in their depiction of lesbian sexuality. In style, content, and political positioning (not to mention sexual positioning), *On Our Backs* truly lived up to its masthead: "Entertainment for the Adventurous Lesbian."

199

90s

1990s

At the end of the 1980s, U.S. legislative politics devolved into a culture war. Politicians such as U.S. senator from North Carolina Jesse Helms pulled focus away from widespread and growing economic inequality by outrageously grandstanding about gay, lesbian, and queer artists receiving federal support in the form of grants from the National Endowment for the Arts. Performance artists like Ron Athey, Holly Hughes, and Tim Miller were particularly targeted, and nongovernmental political groups such as the American Family Association were dogged in their attempts to publicly shame and destroy the lives and careers of LGBTQ artists, and LGBTQ people more generally. "The right wing," wrote the anthropologist Carol Vance, "is deeply committed to symbolic politics, both in using symbols to mobilize public sentiment and in understanding that, because images do stand in for and motivate social change, the arena of representation is a real ground for struggle."

LGBTQ design was certainly part of this contested ground, at both the community and national level. For example, the transgender and bisexual flags were created during this decade, giving symbolic voice to two of the most marginalized communities within and outside of broader lesbian and gay communities. Simple in their execution and heartfelt in their meaning, these two flags remind us that when political strife is at a fever pitch, the power of design to visualize the presence of LGBTQ people can be fundamentally transformative.

In popular culture, lesbian and gay people were represented in greater numbers on the national stage. Television sitcoms and dramas such as *The Golden Girls*, *Northern Exposure*, *Grace Under Fire*, and *The Simpsons* dedicated special episodes to exploring lesbian and gay themes and characters. Other shows featured prominent gay characters, such as Rickie Vasquez (Wilson Cruz) on *My So-Called Life*, or Ellen

Morgan (Ellen DeGeneres) on *Ellen*. DeGeneres's coming out—which happened nearly simultaneously on her sitcom and in her public life as a celebrity—was a watershed moment. In independent film the first narrative feature to be directed by a queer woman of color, *The Watermelon Woman*, helped to set the bar for an emerging "new queer cinema"—to use the phraseology coined by queer film historian B. Ruby Rich.

But not everyone was equally represented in this newfound mainstream visibility. Carrie Moyer and Sue Schaffner created the agitprop public art duo Dyke Action Machine! (DAM!), in part to draw attention to the absence of lesbians and radical lesbian politics in public life. Moyer identified culture jamming as a primary strategy for "reclaim[ing] public and virtual spaces from the encroachment of corporate sponsorship." "In addition," wrote Moyer, "DAM! injects images of people—dykes—who are *never* represented within the visual culture that surrounds us each time

we step outside or turn on our television sets." Bands and musical artists such as Pansy Division, Fagbash, Tribe 8, Glen Meadmore, and Girls in the Nose defined new genres of punk, often critiquing mainstream and subcultural understandings of LGBTQ people and issues.

One of the groups driving the conversation around LGBTQ people in the mainstream was the Human Rights Campaign Fund, which, in the middle of the decade, rebranded itself with a new logo and dropped the "fund" from their name. The HRC's efforts to lobby around the cause of gay marriage—or marriage equality—helped to define the policy agendas of LGBTQ rights organizations during the decade and after. A truly progressive politics remained elusive at the national level. After all, it was President Bill Clinton, a Democrat, who signed the Defense of Marriage Act into law, stipulating that marriage was to be defined as a union between one man and one

woman. This and other policies falsely articulated by Democratic lawmakers as "tolerant" (especially in relation to the openly homophobic policies of Republican lawmakers), such as the military policy of enforced closeting colloquially known as "Don't Ask, Don't Tell" (another Clinton accomplishment), meant, effectively, that LGBTQ people were left in a lurch by both Republicans and Democrats alike.

While national gay and lesbian political groups such as the HRC set their sights on gay marriage, they pushed aside an array of concerns including housing, healthcare, and basic protections for trans people in the name of political expediency. The story of Brandon Teena (later dramatized in a feature-length documentary and narrative feature film) is a well-known example of the horrors visited upon trans people (and is hardly the only case). Teena, a trans man born and raised in Nebraska, was brutally raped and murdered by two men. His murder shed new and important light on the vulnerability and persistence of trans communities; a glaring lacuna for national gay and lesbian rights organizations. In response to these silences, trans people continued to create their own organizations that could advocate on their behalf.

For the first time there was broad acceptance of gay and lesbian people as consumers, and corporate practices of target marketing operated on the presumption that gay and lesbian people, understood as DINKs (double-income, no kids), had the expendable capital to invest in luxury goods. Conspicuous consumption defined some of these understandings of the gay market. The Japanese car brand Subaru, for example, marketed their all-wheel-drive vehicles to lesbians with coy advertisements that used double entendre ("It's not a choice. It's the way we're built"), and the high-end underwear brand 2(X)IST marketed almost solely to gay men. As the millennium

approached, this made those who claimed a stake in queerness's often oppositional relationship to capitalism uneasy. "We're a movement, not a market" was a common chant at queer events such as the New York Dyke March.

HIV/AIDS continued to lay waste to LGBTQ communities both nationally and globally—and ever new activist tactics were developed to meet the ongoing pandemic. Local efforts, such as the safer sex posters developed by Robert Birch for the student body of Pierce College in Los Angeles, stand alongside national efforts like the red ribbon project developed by the Visual AIDS Artists' Caucus. In encouraging celebrities and everyday people to wear red ribbons it was hoped that a general consciousness could be raised concerning the scale of the pandemic. Other strategies were less benign: the pokey graphics and writings that appeared in the aptly named zine *Diseased Pariah News* were openly critical of the efficacy of "soft" activist tactics like the red ribbon or the ubiquitous and treacly teddy bears. Instead the writers and editors of *DPN* stressed the precariousness and vitality of a seropositive life, producing some of the most caustic and dynamic graphics of the decade.

The growing acceptance and domestication of the Internet as a new presence in daily life meant that it was suddenly possible to connect geographically disparate people and communities—reducing some of the isolation felt by LGBTQ people across the United States. Message boards, BBSs, and chat rooms expanded the social and sexual lives of some LGBTQ folks—instantiating affinity groups like the Digital Queers, whose slogan "We're Here, We're Queer, and We've Got Email" was a play on the in-the-streets Queer Nation battle cry. As the year 2000 came and went, the prominence of the Internet's influence on LGBTQ design only continued to grow.

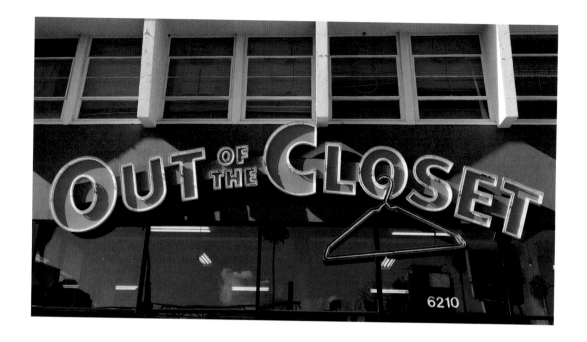

OUT OF THE CLOSET LOGO

When the first Out of the Closet thrift store opened in Los Angeles's Atwater Village, it was under the guise of helping to fund educational initiatives and financially support a local AIDS hospice. Although not original in its model (the Project Ahead Shop in Long Beach predated Out of the Closet and had a similar mission), the thrift store—a project of the AIDS Healthcare Foundation—distinguished itself by its magenta-and-teal exterior coloring and its cartoonish, punning logo. Hinging on the double meaning of "closet"—as both the place where one stores clothes and the metaphorical space from which an LGBTQ person enters public life ("coming out of the closet")—the thrift store's logo reinforces this linguistic play. An empty hanger dangles from the counter

of the "O" of the word "closet" (a counter is a space partially or fully enclosed by a letterform), demonstrating the punning at the center of the thrift store's overall design.

Marc Neighbor, who managed the first Out of the Closet store and was an antiques dealer, remarked in a *Los Angeles Times* article about the store's opening that "having a storefront with this name takes away from that shame. And really, the shame of anything you're afraid of." Today there are nearly twenty Out of the Closet stores, each continuing to financially contribute to the well-being of people living with HIV/AIDS. The stores also offer free rapid HIV testing and can put curious shoppers in touch with HIV/AIDS health resources at a moment's notice.

THE *AIDS IS NOT A GAME* GAME POSTER

The graphic work of Robert Birch, both under his own name and the pseudonym Cardiac Arrest, has not yet been understood in histories of AIDS graphics. While at Pierce College in California, Birch developed an astonishing array of safer sex materials—targeted to his collegiate context. Some campaigns, for example, were formatted as multiple-choice exams or crossword puzzles. This poster dramatizes the vicissitudes of life in the age of AIDS—where a "player" is always only one move away from potentially contracting HIV. With humor and acuity Birch represents puberty as a swamp, teenage years as a maze, and adult life as a highway with twisting hairpin turns. In the center of the game board is the "Vale of HIV," where societal and family rejection interlocks with opportunistic infections, leading ultimately to death. Birch's representation of this process is uncompromisingly gimlet-eyed.

It was for this reason, perhaps, that (according to a contemporaneous *Los Angeles Times* article) Birch's poster riled school and community members. Birch clapped back with a press release aimed at his critics. In unambiguous language he undercut any "pearl-clutching" protestations to his work, writing, "my compatriots in the AIDS community have approved of the flyer because, unlike government-generated materials, it does not sugar-coat reality," concluding with, "The virus is the enemy—not truth." If the truth was uncomfortable for some, so be it.

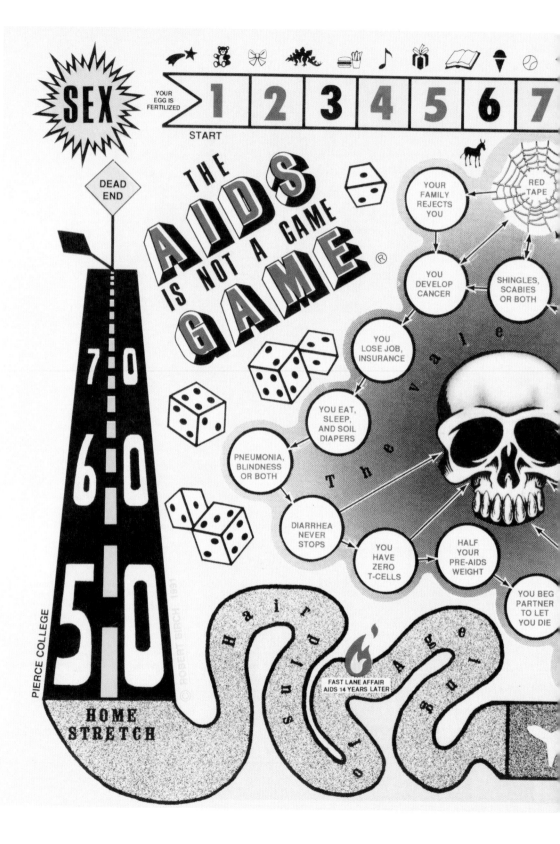

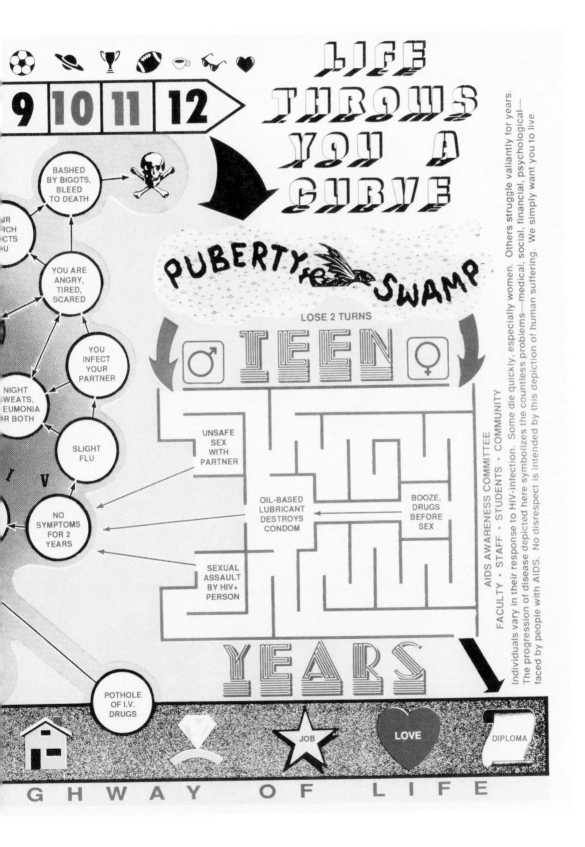

SAFE

UNSAFE

President GEORGE BUSH offers a "kinder, gentler" rhetoric on AIDS, but his policies continue to promote genocide by neglect. Bush has refused to support national health care, thereby denying proper medical treatment to nearly a third of the population. He has refused to rescind the medically useless ban on travel and immigration to the U.S. by people with HIV infection. He has opposed granting emergency federal funding to cities devastated by the disease. Mouthing platitudes while thousands die is not enough: NO MORE WORDS; WE WANT ACTION.

SAFE/UNSAFE POSTER CAMPAIGN

The terms of safe/r sex are explicitly reformatted in these posters, created by an anonymous San Francisco activist collective known variously as Boy with Arms Akimbo and Girl with Arms Akimbo. Using a simple line drawing of a boy or girl with hands on their hips (arms akimbo) as their identifying logo, the collective's "Safe/Unsafe" poster campaign was timed to coincide with the sixth International AIDS Conference, which took place that year in San Francisco. In the lead-up to the event there was concern among AIDS activists about whether or not they were truly welcome at a conference mostly attended by pharmaceutical companies, government epidemiologists, and clinical trial investigators. In one panel Peter Staley, a member of ACT UP, invited his fellow activists up to the stage and led a chant that clarified their demands: "Three hundred thousand dead from AIDS, where is George [Bush]?" (The president was not present at the conference; he was attending a campaign fund-raiser for the virulently homophobic North Carolina senator, Jesse Helms, instead.)

A similar point is made via the strong graphic designs of Boy/Girl with Arms Akimbo. Instead of focusing on the relative risks of different kinds of sex (such as sex with or without a condom), they point to the political and structural harms caused by conservative policies and (in)actions. Labeling funding cuts and travel bans on people entering the United States with HIV as inherently "unsafe," Boy/Girl with Arms Akimbo called out President George H. W. Bush for the hypocrisy of his rhetoric—which famously called for a "kinder, and gentler nation." Importantly this critique is always paired with evocative images of bodies in amorous linkage—always labeled "safe"— suggesting that communities can care for each other in ways that the national government and corporate world consistently failed to do.

HRC LOGO

How does an organization choose a logo—a designed symbol that represents its values and virtues? The case of the Human Rights Campaign Fund (now known by the shortened Human Rights Campaign, or the HRC initialism) is instructive in this regard, offering insights as to how an organization visually "rebrands" itself.

When Steve Endean began his political career, he was an undergraduate student of political science at the University of Minnesota. While still enrolled, Endean founded the Minnesota Committee for Gay Rights, and in time he became a state lobbyist for gay and lesbian causes. As was typical for many gay and lesbian people involved directly in state and national politics, Endean impeded the inclusion of any legislative agenda that included rights or protections for transgender individuals, with the belief that such legislative efforts would be blocked from the get-go. Instead, he put his focus on supporting candidates who could rally to gay and lesbian causes; and eventually he became the director of the Gay Rights National Lobby. Shortly thereafter he began another organization—the Human Rights Campaign Fund—a political action committee that essentially fund-raised for gay- and lesbian-friendly candidates. Endean's goal was simple, and is perhaps best summed up as pushing gay and lesbian rights *into the mainstream* of national politics (uncoincidentally, the phrase "into the mainstream" would be the title of Endean's 1991 memoir).

The first HRCF logo took the form of an illustrated torch—akin to the one held aloft by the Statue

of Liberty. As a symbol of freedom, the torch spoke elegantly to popular notions of progress, a light in darkness. The second component of the HRCF's logo was the typographic rendering of its name. On letterhead and official documents the organization's name was split in two, "Human Rights" in a type that recalled handwriting, and "Campaign Fund" in a Jansonesque typeface, the kind found on edifices of national buildings and monuments. The disparity between the two typefaces could be read as shorthand for the lifespan of progressive political change, starting at the grassroots (handwriting) and moving to the institutional level (Janson).

In the mid-1990s the HRCF sought to expand its advocacy work beyond simply funding political campaigns and thus needed to rebrand itself. In this effort it enlisted the help of designers Robert Stone and Keith Yamashita. The design brief that Stone Yamashita Partners prepared for the leadership of the HRCF is fascinating in its breadth and variety.

This is fairly typical of corporate and large non-profit design processes. The designer or firm works with its client (here the HRCF) to identify the primary values they hope a future design will communicate. In this case, Stone Yamashita identified "Equality, political strength, and an intelligent approach to change" as the core values of the HRCF. Given this information, Stone Yamashita proposed eleven designs that were to be evaluated on five criteria: the design's capacity to communicate the values of the organization clearly, its similarities and differences

from peer nonprofit organizations, its uniqueness and memorability, its strength to inspire organizational growth and change, and finally what the design firm dubbed the "t-shirt factor."

The first four of the proposed eleven designs built upon the HRCF's already extant torch iconography. Stone Yamashita presented two ideations of the symbol, one realistic and the other abstract. Although they identified that the more realistic torch logo would have appeal "inside the beltway," the design firm suggested that the abstract logo would ultimately be more memorable.

The next three designs centered on the equals sign. The first of these is composed of a yellow equals sign inside a royal blue square. Although this design was not the top choice for the focus groups tasked with evaluating the new potential HRCF logos, it nevertheless carried the day with HRCF's leadership, who found it (rightly so) to be the most compelling design. Another design in this category took the same idea but played with a two-color inversion, rendering the equals sign as two contiguous bars, differentiated only by their color. The third design proposed the equals sign as a crossbar for the capital letter "H"—foregrounding the connection between notions of humanity and equality.

Photographic images were incorporated into the next three designs, whose purpose was to literally "put a human face to the cause," and therefore personalize the struggle for gay and lesbian rights, "showing that gays and lesbians are part of everyone's community and family." Variously rendered as a line of square photos, or a rectangular repeating block presenting in conjunction with a simple type lock up of the name, these designs lacked the kind of legibility present in Stone Yamashita's other design suggestions. They would ultimately be difficult to reproduce on a t-shirt or at various sizes.

The final design proposed by Stone Yamashita took the idea of the open hand as a literal symbol of the HRCF's outreach efforts. The idea was that the hand image could be used in coordination with a typographic rendering of the HRCF's initials or a single, heavy-block "H." The designers proposed that this was not only "undeniably hip" but offered maximum flexibility and effect.

Eventually the HRCF chose the blue-and-yellow equality block—and in the process dropped the "fund" from its name, shortening its initialism to HRC. After its debut, the HRC logo quickly became a ubiquitous presence on roads; for even though Stone Yamashita was initially concerned with the "t-shirt factor," the new logo made for a great and easily legible bumper sticker.

In the 2010s, as the fight for gay marriage was coming to a head, the HRC changed the colorway of its logo to pink and red, colors traditionally associated with love—another ingenious visual move to center seemingly shared human values. Whether the HRC will change its logo again remains to be seen, but for the current moment the blue square containing the yellow equals sign has become synonymous with the organization. In other words, design has done its job.

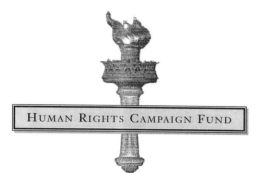

1

2

HUMAN

RIGHTS

CAMPAIGN

FUND

HUMAN RIGHTS
CAMPAIGN FUND

3

4

Images 1 and 2 show an original attempt at rebranding of the HRCF in the tradition of its original logo.
Images 3 and 4 show a more abstract treatment of the torch imagery.

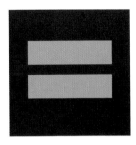

The
Human Rights
Campaign
Fund

H U M A N

R I G H T S

C A M P A I G N

F U N D

5

6

Human

Rights

Campaign

Fund

7

Image 5 shows the proposal for what would eventually become HRC's new logo,
while images 6 and 7 show variations on the equals sign approach.

HUMAN RIGHTS
CAMPAIGN
FUND

8

HUMAN RIGHTS
CAMPAIGN FUND

9 10

Images 8 and 9 show two variations of the photo-driven logo
and image 10 shows the open-hand and typographic treatment.

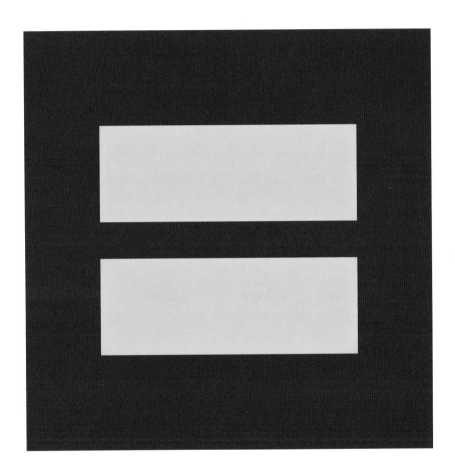

The now iconic equality block logo of the HRC.

THE RIBBON PROJECT

Inspired by the custom of tying a yellow ribbon around a tree to welcome a convict or service member back home, the members of the Visual AIDS Artists' Caucus devised a red ribbon (whose color variously stands for blood, passion, anger, and love) to be a symbol of the ongoing HIV/AIDS pandemic. After the red ribbon debuted publicly at the 1991 Tony Awards, demand outpaced production, and caucus members would hold "ribbon bees"—meetings where attendees would cut and fold ribbons by the thousands for international distribution. The political aims of the ribbon project are made most clear in the group's three-point statement on the copyright of the ribbon:

1. Remain anonymous as individuals and to credit the Visual AIDS Artists' Caucus as a whole in the creation of the Red Ribbon Project, and not to list any individual as the "creator" of the Red Ribbon Project.

2. Keep the image copyright free, so that no individual or organization would profit from the use of the red ribbon.

3. Use the red ribbon as a consciousness-raising symbol, not as a commercial or trademark tool.

This last point is perhaps the most important, as caucus members positioned their design as an overtly political tool, not to be co-opted for corporate needs or ends. While this has not always been the case, the red ribbon remains one of the most visibly recognizable symbols of the ongoing AIDS pandemic, reaching far beyond LGBTQ communities in the United States.

In the years since the AIDS ribbon's public release, it has been worn and depicted countless times. LGBTQ and non-LGBTQ celebrities and politicians such as Elizabeth Taylor, Ellen DeGeneres, and the late Princess Diana wore the ribbon to public-facing events, raising awareness and consciousness about the pandemic. Some AIDS activists have worried that wearing a ribbon, while visually impactful, does not meet the financial and programmatic needs of people living with AIDS—and because of this, the ribbon gives an empty kind of support. These views are balanced out by the many people (both living with AIDS and not) who find solidarity in the symbol, as they adorn t-shirts and banners for the many AIDS charity events around the country. Included here is one of many examples of the ribbon's appearance in LGBTQ material and visual cultures.

The Ribbon Project

Wear a ribbon to show your commitment to the fight against AIDS. The red ribbon demonstrates compassion for people with AIDS and their caretakers; and support for education and research leading to effective treatments, vaccines, or a cure.

The proliferation of red ribbons unifies the many voices seeking a meaningful response to the AIDS epidemic. It is a symbol of hope: the hope that one day soon the AIDS epidemic will be over, that the sick will be healed, that the stress upon our society will be relieved. It serves as a constant reminder of the many people suffering as a result of this disease, and the many people working toward a cure—a day without AIDS.

The Ribbon Project is a grassroots effort: make your own ribbons. Cut red ribbon in 6" length, then fold at the top into an inverted "V" shape. Use a safety pin to attach to clothing.

DECEMBER 1 - DAY WITHOUT ART

Visual AIDS
131 West 24th Street, 3rd Floor
New York, NY 10011
tel 212/206-6578 fax 212/206-8159

DPN REPRINT

DISEASED PARIAH **NEWS #1**

The blood of over 100,000 Americans who have died of AIDS, Mr. President? You're soaking in it!

Inside This Issue:

The PWA Primer

A Short History of Sex

AIDS Testing in Prisons

Captain Condom

and Other Great Things!

DPN ZINE

Caustic and wickedly funny, *Diseased Pariah News* typified the truth-telling speech that queer theorist Michel Foucault dubbed "parrhesia," named after an ancient Greek term meaning to "speak everything freely." Working against popular media tropes that saw people living with AIDS as either broken, pitiable victims or courageous, blameless heroes, the *Diseased Pariah News* cofounders, Beowulf Thorne (né Jack Henry Foster) and Tom Shearer, cut through such confining narratives to offer a vision of the HIV/AIDS pandemic that deeply acknowledged that things were, in fact, not okay. Dotted with T-cell count updates, personal ads that foregrounded Thorne's "danger penis," and the zine's ever-present mascot, a saccharine Disneyesque oncomouse (a type of rodent bred to spontaneously develop cancer for medical research), *Diseased Pariah News* gave life when there seemed to be nothing but death.

This graphic appeared both as the cover to the first issue and as a standalone postcard and t-shirt design. Conceptualized by Thorne and photographed by Shearer, the graphic epitomizes the talents of *DPN*'s founders, as it combines the pizzazz of mainstream product advertising with a potent message aimed at the highest halls of power.

At *DPN* biting sarcasm was the coin of the realm. For example, the zine's health column was called "Get Fat! Don't Die!" But even a good diet could not prevent the death of the zine's founders. Shearer died shortly after the second issue of *DPN* was released, and all duties fell to Thorne, who passed before the last issue was published. Thorne was remembered in true *DPN* style with an article entitled "Dang! Our Founder and Guiding Light Died!"

REPOHISTORY MARKER

Queer Spaces: Places of Struggle, Places of Strength was a radical mapping project created by the artist collective known as REPOhistory, who sought to illuminate the "untold stories of those whose history has been marginalized because of their class, race, gender or sexuality." Taking the form of temporary historical markers in the shape of pink triangles, REPOhistory identified nine sites around Lower Manhattan with particular significance to the histories of LGBTQ people. Some, like the marker for the first ACT UP demonstration (Broadway and Wall Street) or Julius' Bar (159 West 10th Street), celebrate the key organizations and legal victories of LGBTQ

history. Others, such as the marker reproduced here, dedicated to self-identified drag queen and Street Transvestite Action Revolutionary Marsha "Pay It No Mind" Johnson, describe the dire situation faced by many trans people throughout the twentieth and well into the twenty-first century. In effect, Johnson's marker serves as a memorial to her life and death, which was at first ruled a suicide by New York City police, but was then reclassified thanks to the agitation by LGBTQ activists. It remains the case today that trans women of color are at the highest risk of life-threatening violence, making this memorial relevant and, sadly, necessary.

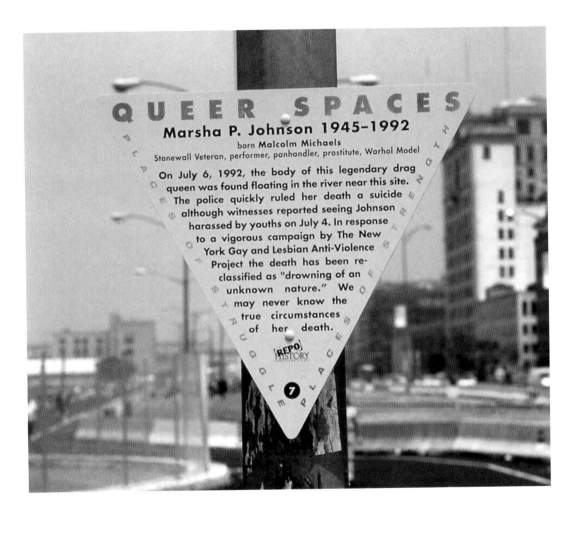

QUEER SPACES

Marsha P. Johnson 1945–1992

born Malcolm Michaels

Stonewall Veteran, performer, panhandler, prostitute, Warhol Model

On July 6, 1992, the body of this legendary drag queen was found floating in the river near this site. The police quickly ruled her death a suicide although witnesses reported seeing Johnson harassed by youths on July 4. In response to a vigorous campaign by The New York Gay and Lesbian Anti-Violence Project the death has been re-classified as "drowning of an unknown nature." We may never know the true circumstances of her death.

REPO HISTORY

7

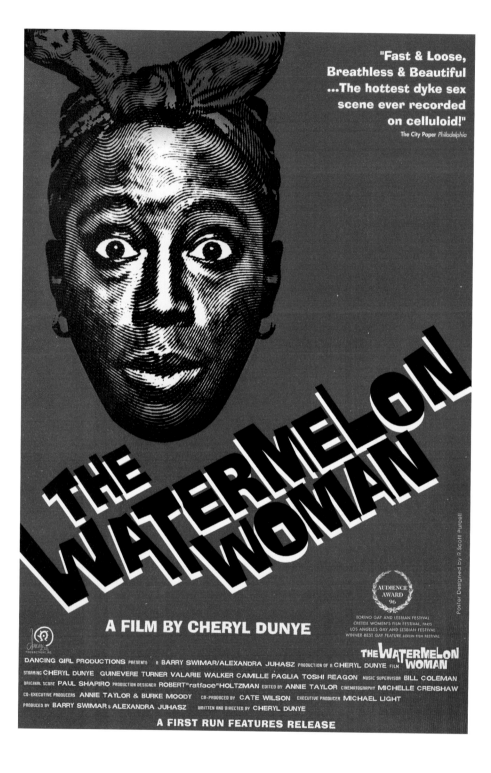

THE WATERMELON WOMAN POSTER

When Cheryl Dunye's *The Watermelon Woman* was released in 1996, it was in the context of a flurry of LGBTQ independent films. As the first feature-length film directed by a self-identified black lesbian, film history is a central concern in Dunye's jocular movie. The narrative follows Cheryl (played by Dunye) as she uncovers the life and legacy of a black lesbian actress named Fae Richards, known for her appearances in the "race films" of the early twentieth century simply under the racialized moniker "The Watermelon Woman." Even though the film is shot in a documentary style, Richards is essentially invented by Dunye, conjuring those whose stories have been largely lost due to a historically segregated and homophobic film industry. Dunye worked with the artist, and member of the activist collective Fierce Pussy, Zoe Leonard to create a fake archive of photographs and documents

relating to Richards's life, blurring the boundaries between reality and fiction.

This poster represents this collapse between documentary and fiction with great acuity. Dunye's face is represented against a saturated red background. She wears a kerchief wrapped around her head, a reference to a common costume element for the characters available to black women in Hollywood films—as antebellum slaves or post-emancipation servants. Such limited roles for black actresses were not uncommon, and the film's title reinforces the existence and persistence of stereotypes in its reference to one of the more insidious visual signifiers of blackness. Dunye's film, like the poster, stages a confrontation between a racist and homophobic past and present, instantiated by a group of people wishing to change the conditions for LGBTQ actors, writers, directors, and producers of color.

XY MAGAZINE

"You don't know how much *XY* has changed my life. I'm no longer ashamed of who I am; I'm gay and proud." So begins a letter from a sixteen-year-old boy to the editor of *XY* magazine. Uncompromising in its support for gay youth, *XY* magazine nurtured and catered to an at-risk youth population with very few public, positive role models. Photographers like Steven Underhill (whose work was visually similar to the beefcake photographs taken by Bruce Weber for the "straight" fashion campaigns of Abercrombie & Fitch then in vogue) contributed to the magazine, as did comic artists Abby Denson and Joe Phillips. Helmed by editor Peter Ian Cummings, the magazine addressed both the mental and erotic health of its young readers.

If the visual style of the magazine referenced wider fashion and youth cultures, the magazine's logo identified the periodical as a comprehensive guide for the specific audience of young, gay men. The magazine's name references the chromosomal makeup of the human male, while the letters "A" and "Z" appear in the crossings of the letters—suggesting that everything from "A to Z" could be found within its covers. After a brief hiatus *XY* magazine recently relaunched in 2016—hopefully inspiring a new generation of gay kids to feel empowered in their identities.

summer
[please don't tease the straights]

$5.95 £4.99 c$7.95

retailer — display until September 30

0 74470 88926 7 92

BISEXUAL FLAG

In his book *Good Flag, Bad Flag* vexillologist Ted Kaye lays out five principles of flag design: keep it simple, use meaningful symbolism, limit to two to three basic colors, no lettering or seals, and be distinctive or be related. On all counts Michael Page's design for a bisexual pride flag succeeds. Modeled off the already extant "biangles"—two overlapping pink and blue triangles, lavender in the overlap—Page's design takes this simple, yet ingenious design idea and clarifies it in the form of a flag. According to Page the magenta stripe represents those attracted to people of the same sex, and the royal blue represents those attracted to people of a different sex. The lavender in the middle represents bisexuality. Here's Page: "The key to understanding the symbolism in the Bi Pride Flag is to know that the purple pixels of color blend unnoticeably into both the pink and blue, just as in the

'real world' where most bi people blend unnotice-ably into both the gay/lesbian and straight com-munities." Often referred to as "bi invisibility," the tendency to minimize or ignore the identities of bisexual people—within straight, lesbian, and gay communities alike—results in what Page describes as "blending in unnoticeably" into those various communities. In this way Page's flag is deeply mean-ingful and serves as a reminder to acknowledge and include the contributions of bisexual members of broader LGBTQ communities. In recent years the term "pansexual" has become more prevalent, and the pansexual flag (see page 218), designed in 2010 by Tumblr user justjasper, features a similar design to Page's bisexual flag—substituting the lavender central band with yellow, representing attraction to folks who identify as androgynous, genderfluid, or non-binary.

TRANSGENDER FLAG

A cofounder of the Transgender American Veterans Association, Monica Helms created the transgender pride flag in 1999, debuting it at a pride celebration in Phoenix, Arizona, in 2000. Since then the flag has been widely embraced, and its distinctive colorway—light blue, pink, and white—has now become synonymous with transgender causes. According to Helms these colors are representative of the gender roles we often assign children at birth, aligning pink with girls and light blue with boys. The white stripe is meant to signify the great heterogeneity of transgender experiences—from those who are transitioning, to intersex and/or gender nonconforming people. Like Michael Page's bisexual flag before it, Helms's flag is designed as a form of social awareness. According to Helms, "the pattern is such that no matter which way you fly it, it is always correct, signifying us finding correctness in our lives." In other words it is a flag with an affirming and therapeutic message; a signal that each trans individual's experience is as valid as it is unique. In 2014 Helms donated her original flag to the Smithsonian National Museum of American History, an important milestone from the halls of national patrimony that transgender people's lives, loves, and political activism have a place in the larger history of the United States.

A is for Alice, who liked to cook soup.

B is for Blanca, who sat on the stoop.

DYKES TO WATCH OUT FOR

Cartoonist and graphic novelist Alison Bechdel began drawing *Dykes to Watch Out For* in 1983. The long-running serial comic strip, which detailed the everyday lives and interactions of a group of lesbians and their familiars, ran in a range of LGBTQ publications such as *Gay Community News*, *Hot Wire*, and *Common Lesbian Lives*, among others. As her comic grew in popularity Bechdel began to self-publish the strip in larger anthologies. In the beginning, though, Bechdel participated in a small but vibrant scene of feminist and LGBTQ cartoonists, most of whom published in alternative weeklies and underground "comix" anthologies. Like Armistead Maupin's *Tales of the City* novels, *Dykes to Watch Out For* is an ongoing and highly addictive serialization of queer life. Bechdel's characters process political happenings and chart their own changing relationships to one another—inviting the reader into a vast extended chosen family.

C is for Cleo, who wouldn't eat meat.

D is for Deirdre, who worked on Wall Street.

In 1986, many of Bechdel's one-off strips were gathered into a collection—the first of many *Dykes to Watch Out For* books. Indicative of Bechdel's humor and playfulness, between strips the cartoonist gives a primer of lesbian types in the form of a rhyming, parochial ABC book: "U is for Una, with charts astrological/V is for Violet, with passions pedagogical." Also included in that first collection was the strip that would popularize what has come to be known as "the Bechdel test" (despite the cartoonist crediting the concept to her friend Liz Wallace), which stipulates a movie is worth watching only if it involves two female characters who talk to each other about something else besides a male love interest. Bechdel stopped regularly producing *Dykes to Watch Out For* in 2008, two years after her graphic memoir *Fun Home* was released to great acclaim. But every now and then, Mo and the gang reappear, and the story continues...

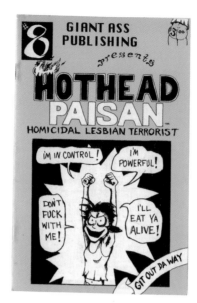

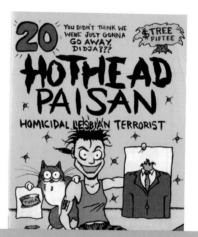

FUNNY BONES

Although Alison Bechdel may be the best known of LGBTQ comics producers, she is certainly not the only one. Diane DiMassa's *Hothead Paisan* and Howard Cruse's *Wendel* presented an affective spectrum of LGBTQ characterizations—from the dynamite-tempered central character of DiMassa's comic to the sunny optimism of Cruse's title character. Cruse has been instrumental as both an artist and editor,

gathering together the first anthologies of comics made by or about LGBTQ people. Some of the cartoonists Cruse included in his collections did not identify as gay or lesbian, such as Roberta Gregory, but drew narratives that incorporated LGBTQ people. In this way Cruse and the other editors of *Gay Comix* called for all cartoonists to consider LGBTQ people as a part of larger social and fictive worlds.

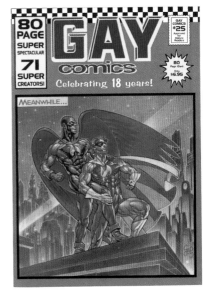

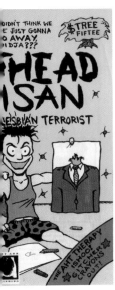

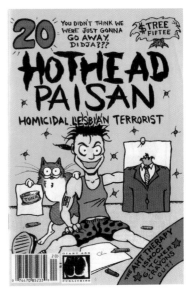

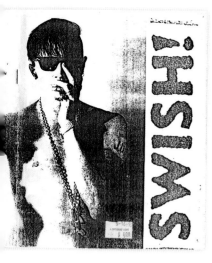

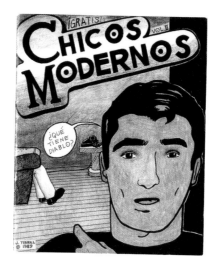

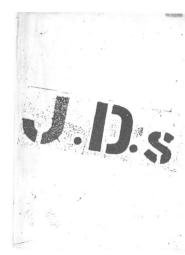

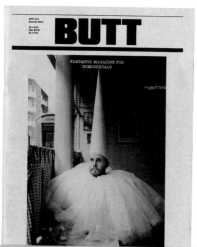

ZINE SCENE

One of the hallmarks of a zine is that it is self-published and self-made, often using cheap reproductive technologies such as photocopiers. In alignment with their DIY methods of construction, LGBTQ zines have also tended to tackle the lives, thoughts, feelings, and opinions of those well outside of the mainstream of LGBTQ politics. This is especially apparent in the zines produced around the homocore (sometimes called queercore) scene emergent in Toronto and San Francisco at the tail end of the 1980s and early 1990s. Punk pugilism and anarchic freedom characterize the text, design, and musical cultures of publications such as *J.D.s* and *Homocore*. "We're mutants," wrote *Homocore*'s editor, Tom Jennings, in his manifesto entitled "What the Fuck is Homocore?" kicking off that zine's inaugural issue, "if we try new things, things that are honest and human, like making our own cultures, preferably lots of them, all with room for each others'."

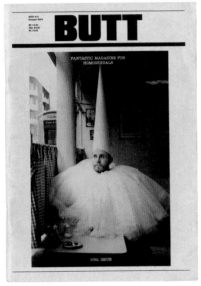

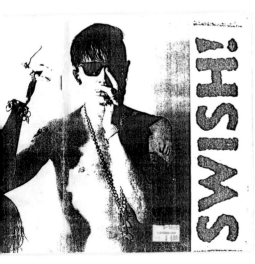

2(X)IST

The brand 2(X)IST represents an interesting case study in the history of LGBTQ design. Founded in the early 1990s by Gregory Sovell, the brand distinguished itself among its competitors by target marketing to a specifically gay male consumer. This was an innovative and generally untested strategy in the 1990s. Famously, Subaru made headlines by marketing its cars directly to lesbians with double entendres and Easter eggs such as license plates reading XENA LVR. Sovell, who had previously worked for Calvin Klein (the dominant force in the male underwear fashion market due to their provocative ads featuring Mark Wahlberg), developed an ad campaign that amplified the successes of his former employer. In print and public advertisements, Sovell pitched 2(X)IST (pronounced "to exist") to a male

homoerotic gaze—offering up nearly nude male models in sexually inviting poses. The campaign worked, and soon 2(X)IST was a ubiquitous presence in shops catering to gay men.

Sovell's company was bought by the Morét Group in 1995, and in 2005 he left the company he founded to begin another underwear brand—C-IN². While many companies have studied Sovell's successes at marketing to a specifically middle-class/affluent gay white male consumer, there is a case to be made that target marketing aids in the assimilation of stigmatized or politicized groups into a mainstream. Some welcome this, and others push against it. In this regard the name of the underwear brand seems a wan and glib repetition of the goals of LGBTQ liberation politics, now reformatted as a simple directive for consumers: to exist.

MONEY STAMP

During the 1970s, 1980s, and 1990s dollar bills stamped with the words "gay money," some with pink triangles, appeared in circulation in major U.S. cities. The result of the uncoordinated efforts of individuals in communities across the country, this ostensibly illegal activity was meant to prove a larger point: namely, to make visible the purchasing power of LGBTQ people. It also served as a metaphor for social stigma—as

anyone who touched gay money would be associated with its circulation.

Frank Kellas, who for a short time owned the Gold Coast, a leather bar in Chicago, was partly responsible for a particularly notable instance of this agitprop tactic. Upset at the failure of a local anti-discrimination ordinance, Kellas along with Marge Summit (who owned the His n' Hers bar) decided to

create a rubber stamp to demonstrate the economic heft of LGBTQ communities. They created about seventy stamps with the words "Gay $," and passed them out to local gay and lesbian business owners, who stamped the bills in their tills before depositing them in banks or circulating them among their customers. The practice worked, in part—although Kellas and Summit received a "cease and desist"

letter from Anton Valukas, the U.S. attorney for the Northern District of Illinois, for defacing legal currency. Summit laid out the purpose of her and Kellas's campaign in a *Chicago Tribune* article, saying, "We feel if there's enough 'Gay $' in everybody's wallet they're going to start thinking about it. The idea is to get people to understand that all we're asking for is what they already have—the right to work and the right to live."

JOAN JETT BLAKK
FOR PRESIDENT

I WANT YOU, HONEY!
LICK BUSH IN '92!
QUEER NATION PARTY

JOAN JETT BLAKK FOR PRESIDENT BUTTON

Alternatives to the binaristic two-party political system have been a mainstay of American politics since its founding, but perhaps no third-party foray has been so fabulous as the candidacy of Terence Smith's drag persona, Joan Jett Blakk, who ran for president under the aegis of the Queer Nation Party in 1992. In her self-described "camp-pain" (as in "putting in the camp, taking out the pain, honey"), Blakk drew attention to the queer lives and issues being ignored by both political parties.

As part of her platform she swore to rename the White House the Lavender House and to get "Dykes on Bikes" to patrol the U.S. border. Such policy positions were at once sincere and satirical—critiquing political systems and imagining them otherwise. This button functions similarly, by visually rendering Blakk in the familiar pose of the famous wartime poster of Uncle Sam pointing at a viewer, exclaiming

"I want YOU for U.S. Army." Instead of the allegorical patriarch's top hat, Blakk wears a Nefertiti-inspired chapeau with a giant "Q" emblazoned on the front, necklaces and bracelets dangling from her neck and wrists. She points with her expertly manicured hands out to a viewer and up to the sky, entreating, "I want you, honey! Lick Bush in '92!" and thus bringing a drag queen's humor to an overly serious political process. Another contemporaneous image of Blakk represents the candidate in Black Panther gear—sunglasses and a 'fro—holding a Nerf gun aloft, the phrase "by any means necessary" running along the bottom. Unfortunately, Blakk did not win her presidential bid in 1992, or in 1996, when she ran under the authority of her own Blakk Pantsuit Party. After her 1992 loss she moved from Chicago to San Francisco and continued to work on behalf of her communities, joining the experimental theater troupe Pomo Afro Homos.

CLIT CLUB UNIFORM

Described by one of its cofounders, the artist Julie Tolentino (to whom this jumpsuit belongs), as, "a convergence, a party, an identity, a homebase, a performance, a club gathering—a lifeblood," the Clit Club was a sex-positive queer/lesbian club night sited in a variety of locations across New York City between 1990 and 2002. Tolentino and Jocelyn Taylor, the other Clit Club cofounder, were both members of House of Color, an ACT UP affinity group and video collective that addressed the dearth of media images of LGBTQ people of color. Taylor and Tolentino's efforts in Clit Club could be seen as an extension of their activist work—creating not only images but a space for people of color and queer-identified people in a landscape of bars that catered mostly to white gay men.

Don Boyle, who was a tattoo artist and served as Clit Club's doorman for the better part of a decade, created the party's official logo—a topless, dark-haired sailor woman, whose breasts point up toward the sky. But Tolentino's jumpsuit takes a different tack, cleverly resituating the logo of a popular soda brand, and thereby subverting its "all-American" brand image. Like other weekly or monthly parties such as Tattooed Love Child or Club Fuck! (in Los Angeles), the Clit Club became a meeting place for queer folks of all kinds and an example of the fertile cross-pollinations of art, love, and life.

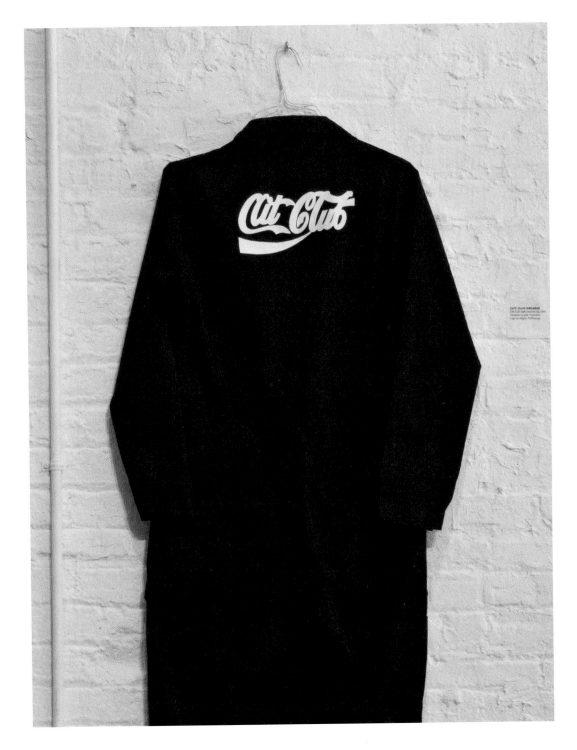

CLIT CLUB ARCHIVE
Clit Club staff uniform, ca. 1994
Designed by Julie Tolentino
Logo by Reggio McLaughlin

21st
Centu

ury

21st CENTURY

The first two decades of the twenty-first century have witnessed both great defeats and wins for LGBTQ individuals and communities. From prominent legal battles to the "transgender tipping point," LGBTQ people have never been so visible and vulnerable within the national consciousness.

On the one hand, existing state sodomy laws were declared unconstitutional (*Lawrence v. Texas*) in 2003, and gay marriage was legalized in all fifty states (*Obergefell v. Hodges*) in 2015. These victories were the result of decades of concerted political effort by a range of LGBTQ organizations who sacrificed both blood and treasure in pursuit of a liberal, rights-granting agenda. Fueling fights such as these were disappointing setbacks, such as when California voters passed Proposition 8, which made gay marriage illegal and left a host of already-married couples in new limbo.

The debates over the political efficacy of gay marriage as a signal fight in LGBTQ politics split conservative, centrist, and progressive arms of LGBTQ communities. For some, gay marriage signaled that LGBTQ people were welcomed into the mainstream of U.S. civic life; and for others, the fight for marriage diverted attention away from more pressing issues — such as immigration, housing justice, prison reform, and violence visited upon transgender, gender nonconforming, and brown and black people. Intersectional politics — a derivation of the term proposed by legal scholar Kimberlé Crenshaw to name the intersectional oppressions of the justice system — has reinvigorated dialogue about the policies and priorities of LGBTQ political groups.

Like Ellen DeGeneres in 1997, the trans actress Laverne Cox appeared on the cover of *Time* magazine,

seventeen years later, signaling a new national visibility for trans people. The cover proclaimed Cox as on the avant-garde of a "trans tipping point," a periodization that often inflames impassioned discussion as to whether this transgender visibility will be a long-lasting shift in the tenor of LGBTQ politics or simply another flash-in-the-pan, like the "lesbian chic" of the 1990s. Susan Stryker, a scholar in trans history and theory, established the first transgender studies program, sited within the University of Arizona's Institute for LGBT Studies, signaling a growing acceptance within gender, women's, and sexuality studies for programs dedicated to the study of trans histories and lives. Although in circulation in the years before the American Dialect Society declared it the word of the year in 2015, the singular "they/them" has become a standard pronoun for transgender and gender non-binary people.

Unlike they had been in previous decades, LGBTQ people were now the producers and stars of their own stories — television shows like *Noah's Arc*, *The L Word*, *Looking*, *Transparent*, and *RuPaul's Drag Race* revealed that LGBTQ stories could adhere to and break generic conventions. But LGBTQ lives are not just fabulous, fun, or dramatic; documentaries such as *Before You Know It* (directed by PJ Raval, released in 2013) revealed aspects of LGBTQ life, such as aging and retirement, that were often outside the purview of mainstream conversations.

But with mainstream acceptance emerges a particular set of pitfalls — for example, the corporatization of long-standing LGBTQ symbols. Pride parades all over the country, no longer ragtag marches, regularly feature large contingents of employees and customers of multinational tech companies, marching under the banners

of rainbow-ized logos. For some the ability to be out at work is a signal achievement of the LGBTQ movement, and for others it signals a "pinkwashing" or "rainbow-washing" of corporate malfeasance. Groups like Against Equality and Queerbomb! have successfully leveled cogent critiques of mainstream gay politics, undergirded by a deep dissatisfaction with the corporate marketing of LGBTQ lives. As the queer theorist José Esteban Muñoz relates, queerness is a horizon of possibility, never fully realized and always shifting. When conspicuous consumption is paired with gay pride, it threatens to sediment radical queer critiques of capitalism, neoliberalism, and white supremacy.

One of the organizations that has achieved particular success in relation to this set of political demands is Black Lives Matter, which formed in response to the 2012 death of Trayvon Martin at the hands of another resident in a small suburb of Orlando, Florida. Two of the three originators of the (now global) movement identify as queer, and Black Lives Matter has consistently focused on centering black trans and queer lives—demanding that any deep societal change must come from an understanding of intersectional oppressions. Their logo—which conveys the strength of the group's convictions—will no doubt be one of the defining designs of the early twenty-first century.

Similar demands are made by a variety of LGBTQ artists and designers, including the indigenous poet, artist, and graphic designer Demian Diné Yazhi' and artist/founder of the Museum of Transgender Hirstory and Art (MOTHA) Chris E. Vargas. In both cases the artists have sought new and ever evolving languages to name and honor the histories they need and desire.

Such projects are bound up in a political optimism—even when rendering particularly withering critiques of governmental or movement politics—which is primarily a politics of imagination.

New mobile technologies have radically resituated the sexual lives of LGBTQ communities, most especially gay men. Cruising, once an activity reserved for bars, public parks, and sex clubs, is now mediated by geolocational apps like Grindr and Scruff. The effect on heterosexual dating and sexual life is also remarkable, as apps like Tinder were inspired, in large part, by the success of gay dating apps. Many men have an ambivalent relationship with these technologies, which facilitate the best and worst tendencies of their user bases.

This book enters the conversation at a time when LGBTQ histories are being newly assessed and re-presented for LGBTQ and mainstream audiences

alike. For example, new versions of Gilbert Baker's rainbow flag have been proposed—ones that include new colored stripes representing transgender and brown/black people. While some critics scoff at these efforts, or dismiss them on the grounds of "bad design," it is worth remembering that LGBTQ design histories (at least as sketched out here) suggest that the emendation, shoring, repurposing, and contestation of previous designs is a crucial part of a queer design ethos. Change is the constant, and our heterogeneous communities move in myriad directions at once—this has always been true. To capture, or even claim to capture, this unruly and beautiful array is to purposely court a kind of failure. The best we can do is acknowledge and honor these contradictions as the ground from which a transformative politics might continue to be built.

ellen

ELLEN LOGO

When Ellen DeGeneres declared on the cover of *Time* magazine, "Yep, I'm gay," it was an unambiguous signal that LGBTQ struggles had breached the mainstream. At the time DeGeneres was the lead in her own sitcom and had been a successful stand-up comedian for years before that. But this revelation of the comedian's lesbian identity was tempered by the fact that shortly after she came out, her sitcom was cancelled.

DeGeneres's next foray into network television didn't occur until 2003, when NBC placed her at the helm of her own daytime talk show. Since then, the *Ellen DeGeneres Show*—usually shortened to the simpler *Ellen*—has logged more than 2,500 episodes.

The typeface used for the show's logo is a permutation of Helvetica (originally called Neue Haas Grotesk), a widely used Swiss typeface designed in the mid-twentieth century and vaunted for its clean, unfussy lines. Every design decision has a political dimension, and the choice to use Helvetica as the defining type for DeGeneres's show speaks to the program's ambitions to reach a broad audience, inclusive of but not exclusively comprised of LGBTQ people. The use of light blue is perhaps speaking to gender and sexuality with poised restraint—not unlike DeGeneres's dry and charismatic comic sensibility.

GRINDR LOGO

When Grindr debuted in the Apple app store in 2009, it was not clear at the time how significantly it would change gay male sexual sociality. A little over three years later four million users had created profiles on the app, making it the most-used platform for gay male online cruising and dating. Grindr's innovation was to combine online dating websites, in which users created profiles and searched for other potential users to date, with the geolocational map functions of a phone. In essence you could not only see other people's profiles, but could tell how far away you were from them at any given time.

It's interesting to examine Grindr's logo design, a masklike face, sometimes rendered with grooves of a gear rimming the chin, in light of the app's statement of inclusiveness. Grindr's founder, Joel Simkhai, discussed the origin of his app's logo in an online interview, saying, "We looked at this notion of meeting people and the idea is very much a basic human need to relax and to socialize. I went back to primitive tribal arts in Africa and Polynesia. One of the things I saw was these primal masks. It brings us back to basics, primal needs. Socialization is the basis of humanity." Simkhai's purpose in creating the Grindr logo to represent the inherent human need for socialization across sexual divides may be admirable, but referencing ideas of "primitive" or "primal" cultures when describing gay male sexual life might only serve to reiterate dominant cultural divides.

The website domain Gay.com, which was donated to the Los Angeles LGBT Center in 2017, now redirects to the Center's blog *LGBT News Now*.

GAY.COM LOGO/GLAAD LOGO

These examples of the evolving gay.com and Gay & Lesbian Alliance Against Defamation (GLAAD) logos exemplify design's ability to speak to the changing concerns and identities of corporations and organizations alike. Launched in 1996, gay.com focused on creating an online forum for gay personal ads—serving to connect LGBTQ people to other similarly minded individuals. This goal is unambiguously communicated in the company's first logo: a rectilinear design

evoking three interlinked people. After the company was bought by PlanetOut (a direct competitor) in 2001, the company relaunched its site in 2008 with a new, simpler logo—a two-color, sans serif logotype. Along with a new visual identity, the site featured a new chat service, no longer based in the Java programming language.

The trajectory of GLAAD's logo (founded in 1985) is similar, if more successful. Initially, the

organization's logo featured a lavender lambda-like design, made from the two A's in their acronym. Bespeaking the tendency of 1980s design to use slick and dynamic letterforms, this logo was given up at some point in the late 1990s and a new logo, designed by Enterprise IG, took its place. This new logo, featuring two separate circles melding into a singular form, stood for "change with a recognition of the critical role of process," according to Joan M. Garry, then executive director of the organization. The logo changed a third time in 2010, when the vaunted New York design firm Lippincott donated their services to reimagining the brand identity of the nonprofit. Working from the keyword "amplification," the current GLAAD logo features a ribbon-like design, evoking a voice speaking out. As the volume gets louder, the hue of the logo gets more saturated, suggesting that the organization's message only intensifies as it moves outward.

SYLVIA RIVERA ⚲ LAW PROJECT

SYLVIA RIVERA LAW PROJECT LOGO

Named after the famed transgender activist, the Sylvia Rivera Law Project (founded by transgender legal scholar and civil rights activist Dean Spade) has been helping low-income, people navigate the U.S. legal system and a wide variety of public services and programs. Founded in 2002, the year Sylvia Rivera died, the organization has continued to center the communities that Rivera fought so hard to make visible. Using a halved design of the combined Mars and Venus symbols (a common signifier of trans identities), the collectively based legal organization visually suggests that their work must be coordinated with the people they aim to serve (as the more hand-drawn logo reproduced at right indicates).

While the gay and lesbian movements of the 1950s and 1960s focused on repressive legal regimes that unabashedly targeted their livelihoods and made

significant gains, transgender people have historically been left in the dust in mainstream gay and lesbian politics. In a talk she gave at the Gay and Lesbian Community Services Center in New York City, Rivera spoke frankly of the sex work that many transgender individuals resorted to because it was "the only alternative that we ha[d] to survive because the laws d[id] not give us the right to go and get a job the way we feel comfortable." She continued, "I do not want to go to work looking like a man when I know I am not a man." Fighting for legal, economic, and racial justice, the Sylvia Rivera Law Project's mission seeks to correct the historical omission of trans people's lives from mainstream gay and lesbian political movements. The transgender Venus/Mars symbol pointing downward suggests that it is within this mission that any true change might be grounded.

BLACK LIVES MATTER

One of the most important and visible civil rights movements of our time was begun by a trio of black women—Alicia Garza, Patrisse Cullors, and Opal Tometi—two of whom self-identify as queer. The movement began with Garza's Facebook response to the acquittal of Trayvon Martin's killer: "Black people. I love you. I love us. Our lives matter." Cullors responded with the hashtag #BlackLivesMatter. Soon thereafter the organizers enlisted the Oakland-based creative studio Design Action Collective to create a logo. One of the people who worked on the project, Josh Warren-White, described the challenge in an interview with *Fast Company*: "Being easily replicable was the main goal since we know within movements people don't have budgets to do professional printers—they're hand painting logos, and the level of skill to replicate a logo by hand varies. We wanted to make something that people could pick up and use in myriad ways."

Warren-White and the other designers at Design Action Collective created a graphic with two interrelated components. The best known of these components is the phrase "Black Lives Matter" rendered in sans serif capital letters in an alternating black and highlighter-yellow colorway. Readers of this book might recall a similar textual strategy used by the members of the Silence = Death Collective. The other component is not as familiar (but is no less remarkable), consisting of a rendering of a black person wearing a hoodie (which Martin was wearing when he was murdered), shouting and holding a dandelion in their fist. The weed sheds its seeds in the blowing wind. It is an image of intersectional movement building, an act of protest and regeneration in the face of systemic police violence against black people. It is incumbent upon LGBTQ people of *all* racial and ethnic identifications, who have historically protested police brutality within their communities, to join black communities in affirming the significance and mattering of black lives.

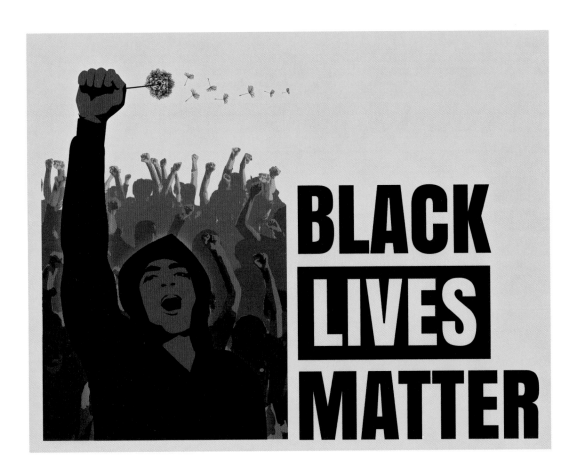

GC2B CHEST BINDER

For some trans people chest binders can help minimize the prominence or appearance of breasts, and for many years the only binders available were designed for non-trans men as medical compression garments. This meant that for people with breasts, chest binding was at the very least a painful and uncomfortable prospect. Gc2b's binders are not only designed by a transgender person, Marli J. Washington, but with a transgender customer in mind. Washington, who is based in Baltimore, Maryland, created a special patent for their invention, which according to many customer accounts achieves the same effects as compression binders without the pain.

Washington centers the heterogeneity of transgender communities in both the range of fleshy colors that the gc2b chest binder comes in, as well in the brand's forward-thinking advertising campaigns, which feature models of all shapes, colors, and gendered presentations. Like gay and lesbian communities before them, transgender communities are designing products to meet the particular needs of trans people. Although gc2b was the first to offer a chest binder designed by and for trans people, there are now more companies that offer similar products—revealing just how great the need is for this kind of garment within trans and gender nonconforming communities.

They've got angelic tendencies like some boys tend to act like queens.

DEMIAN DINÉYAZHI' PRINTS

A Portland-based transdisciplinary artist and poet, Demian Diné Yazhi' creates works and graphics that center indigenous life and politics. These two prints, one depicting the nineteenth-century Zuni lhamana, We'Wha, and the other reflecting on the Diné teachings of hózhó—a complex system of beliefs incorporating wellness in thoughts, actions, and speech—feature Diné Yazhi's signature visual style, melding poetic words gathered from popular culture with striking colorways.

We'Wha is a historical figure who has yet to receive broader attention within larger LGBTQ histories. Designated a "lhamana"—a Zuni term for male-bodied people who perform social and cultural roles assigned to females and serve as mediators within the community—We'Wha was an ambassador to those wishing to learn about Zuni arts and ways of life. Trained in pottery and weaving, they were also the first Zuni to meet with a sitting U.S. president, Grover Cleveland. While some would designate We'Wha as a two-spirit person—a pan-indigenous term adopted in 1990 to replace the anthropological and often denigrating term "berdache"—this would not have been the term used within Zuni communities during the time We'Wha lived. Here Diné Yazhi' pairs an image of We'Wha with a lyric from "Terrible Angels," a song by the band CocoRosie.

A similar tactic is used in *There's No Place Like Hózhó*, which pairs a famous line spoken by Dorothy Gale in the queer filmic ur-text, *The Wizard of Oz* with the Diné idea of hózhó. The scholar Vincent Werito writes that "while the essence of the meaning of hózhó could be interpreted as a fixed or constant idea to imply a state of peace and harmony, it can also be interpreted and understood as an ever-changing, evolving, and transformative idea."

AESTORY BEARSTORY
BISTORY BLACKSTORY
BROWNSTORY
GAYSTORY
EARTHSTORY EIRSTORY
FAWNSTORY
FAERSTORY FEYSTORY
ITSTORY HAYSTORY
HERSTORY
HIRSTORY
HISTORY HUSTORY
LEZSTORY
MEOWSTORY MYSTORY
NONSTORY NUNSTORY
ONESTORY OURSTORY
PAWSTORY PERSTORY
TERSTORY THEIRSTORY
TRANSTORY
VISTORY WITCHSTORY
XYRSTORY ZIRSTORY

MUSEUM OF TRΛNSGENDER
HIRSTORY & ΛRT

MOTHA PRONOUN SHOWDOWN

The American Dialect Society chose the singular "they" as their word of the year in 2015, signaling that grassroots efforts to make the English language more accommodating to transgender and gender non-conforming people had gained significant traction among linguists and activists alike. Like feminist movements before, transgender movements have placed focus on the social function of everyday language—suggesting that a simple reorientation of basic components of language could build and support a more inclusive world. They/them pronouns are far from the first attempt at building grassroots support for gender-neutral pronouns: ze/zir, hir, and other gender-neutral pronouns have been proposed at various points in transgender history.

This poster, created by Chris E. Vargas for their Museum of Transgender Hirstory and Art (MOTHA), is one of the clearest examples of the currently nomadic and erstwhile organization's insistence "on an expansive and unstable definition of transgender, one that is able to encompass all trans, non-binary, and gender non-conformed art and artists." Circulating as both a poster and a digital graphic, the list of different renderings of "history"—formatted from A to Z—values not just human but animal and ecological concerns as well. At the center, placed between "history" and "herstory" (between binaristic understandings of gender), and rendered in slightly larger type, is the word "hirstory," MOTHA's own chosen descriptor. Between "aestory" and "zir-story" is where we might find "ourstory."

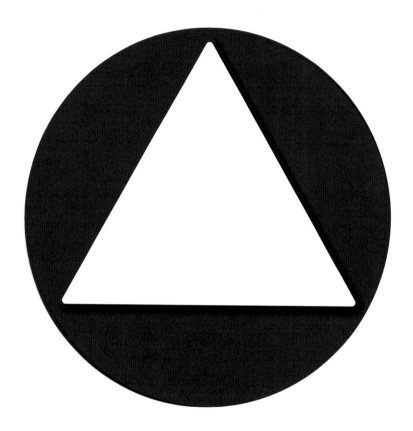

CALIFORNIA RESTROOM SIGNAGE

In the spring of 2017, all single-user restrooms in the state of California were legally required to change their signage to identify them as "all gender" bathrooms. Unlike gender-specific restrooms with pictograms indicating they are male- or female-exclusive spaces, the new all-gender restrooms utilize a familiar symbol in LGBTQ design history: the triangle. This time, the triangle's empty interior is meant to indicate inclusiveness—not just for men and women, but for trans and gender non-binary people alike. The

accompanying signage—both in braille and print—legislated by the state can read "All-Gender Restroom," "Unisex Restroom," or the simple yet effective "Restroom." Other approved signage, like the one at right, combines common symbols for males, females, and transgender people (via the Mars, Venus, and combined Mars/Venus design).

A slew of discriminatory legislation and resultant legal challenges have come before U.S. courts over the past decade—each attempting to limn out the rights

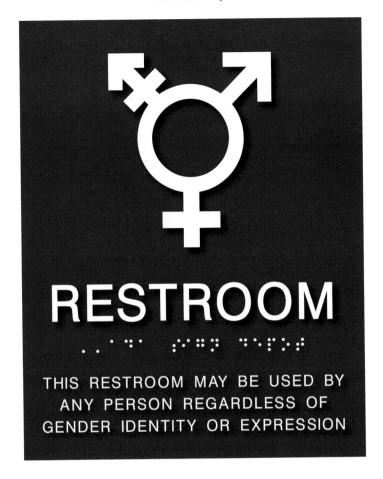

RESTROOM

THIS RESTROOM MAY BE USED BY
ANY PERSON REGARDLESS OF
GENDER IDENTITY OR EXPRESSION

of transgender and gender nonconforming people to use the bathroom of their choosing. These legislative and judicial cases have come to be known colloquially as "bathroom bills" and, akin to the campaigns concerning whether gays and lesbians could serve in the armed forces decades before, many campaigns waged against the rights of transgender and gender nonconforming people have turned on moral panic and fear. One notable bathroom bill television campaign in Houston suggested that allowing transgender people to use the bathroom of their choice was tantamount to inviting sexual predators to prey upon young children in restrooms. Sadly, such tactics have worked on voting populations, leaving it to state and national legislators to introduce meaningful reform. The hope is that this state bill, supported by civil rights groups such as California NOW, Equality California, and the Transgender Law Center, will pave the way for future transgender and gender nonconforming bathroom laws in other states and in the nation at large.

Gilbert

GILBERT BAKER TYPEFACE

Occasioned by the death of Gilbert Baker—the designer and one of the creative forces behind the rainbow flag—NewFest, NYC Pride, Ogilvy & Mather, and Fontself teamed up to create a memorial typeface inspired by Baker's signal design achievement. The result is "Gilbert," a font family made for use at public scale—on wheat-pasted posters and protest banners. Although it comes in a black-and-white version, the eight colors of Baker's original rainbow flag make this unique among color fonts and typefaces. A curvy, sans serif tour de force, the font's playfulness stems, in part, from its deployment of semi-transparent color, which when used in combination generates a seemingly endless possibility of rainbow hues.

Importantly, Gilbert is free and under Creative Commons license is available for sharing and adaptation, making the font friendly to many potential uses. For example, the font is animated on the @typewithpride Instagram account, with each letter of the alphabet standing for a key personality, event, or concept in LGBTQ history ("D" is for Donny the Punk; "F" is for fluidity). Almost two years after its debut, many artists, designers, and organizations have adopted the font—and we should expect those numbers to grow as LGBTQ people across the nation can now type with pride.

type
with
pride

Gilbert Baker Pride Flag

Traditional Gay Pride Flag

Philadelphia Pride Flag

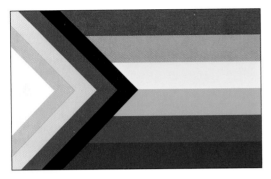

Progress Pride Flag

Bisexual Flag

PRIDE FLAGS

Since Gilbert Baker and his collaborators debuted the rainbow flag, dozens of flags representing different communities have been designed and taken up in earnest. A cynical interpretation of this process would be skeptical at the ever more atomic segmentation of LGBTQ communities; but I would argue that such identifications are important not only for the people who invest in them as a lived reality, but for those of us who do not—as oftentimes these categories help to raise awareness about the truly dazzling heterogeneity of our communities. Monica Helms, the originator of the transgender pride flag, sometimes uses the metaphor of national and state flags to talk about the relationship between Baker's pride flag and all the other flags developed by more specific LGBTQ communities. One doesn't necessarily invalidate the other—rather, each of the many flags on these pages has been crafted with particular audiences in mind. Each has its own history; follows its own design logic; and has a particular relationship with the community it intends to represent. For example, intersex individuals are often situated under the umbrella of transgender identities, but their struggles and political imperatives might be different than the broader transgender community's. The intersex flag—a wonderfully graphic purple circle on a bright yellow ground, designed by Intersex Human Rights Australia—indicates that intersex communities are finding value in networking and identifying with one another as intersex. This is something to be celebrated and supported. In the coming years we should expect more, not fewer, flags, as they are ultimately evidence that we are continuing to find one another, to hone, define, and value our experiences within the long arc of LGBTQ history, imagining collective and individual futures.

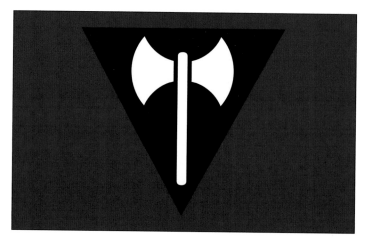

Lesbian Pride Flag

Polyamory Flag

Intersex Flag

Pansexual Pride

Asexual Flag

Transgender Flag

Genderfluid/Genderflexible Flag

Genderqueer Flag

Polysexual Flag

Femme / Lipstick Lesbian Flag

Leather Pride Flag

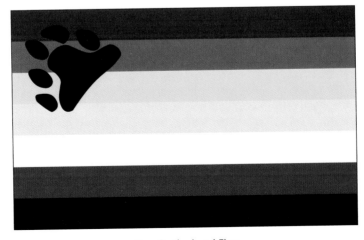

Bear Brotherhood Flag

Aromantic Flag

Agender Flag

Non-Binary Flag

Rubber Pride Flag

Pony Flag

Straight Ally Flag

AGAINST EQUALITY LOGO

A collective of artists and writers, Against Equality generated thoughtful critiques of mainstream gay and lesbian politics, questioning the centrality of the concept of "equality" in rights-gaining rhetoric. This point is made visually in the group's appropriation of the HRC's logo, whose equality sign has been changed to a greater-than symbol—a mathematical symbol indicating unequal sides of an equation.

During a time when gay marriage dominated national political discussions of LGBTQ people, the Against Equality collective was questioning what marriage, as a series of privileges granted to those sanctioned as worthy by the nation or state, was doing to help curb other, more dire problems, such as the high death and incarceration rates among queer and trans communities (especially in regard to suicide);

international military campaigns that furthered patriarchal and imperialist goals; as well as increased policing around queer sex in public spaces. One of the group's cofounders, Yasmin Nair, puts this critique succinctly when she writes that "the history of gay marriage is now used to overwrite all of queer history as if the gay entrance into that institution were a leap into modernity, as if marriage is all that queers have ever aspired to, as if everything we have wrought and seen and known were all towards this one goal." As we have seen in this book, gay marriage was preceded for decades by concerns about egregious and violent policing and social and cultural stigmatization. Against Equality is simply continuing the line of activist thought and action at the root of LGBTQ political movements.

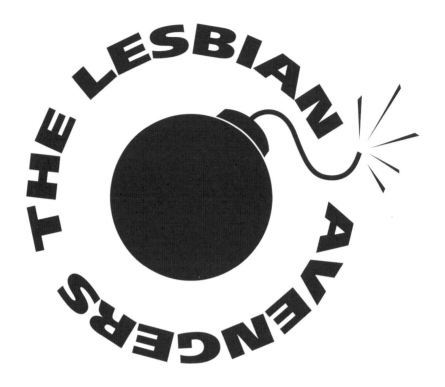

LESBIAN AVENGERS LOGO

Like the "Gay is Good" button and the "Gay Is Angry" poster earlier in the book (see page 50), this and the Queer Bomb design on the facing page suggest the ways in which LGBTQ identities continue to be tied to struggle and anti-assimilationist politics. Designed by artist Carrie Moyer, the Lesbian Avengers logo uses the cartoonish image of a bomb as a signal of queerness's disruptive potential. In another riff of this logo, Moyer rings the bomb with the phrase "bomb is a rose is a bomb is a rose is a bomb is a rose is a," implying a never-ending equivocation. The text is a sly call out to Gertrude Stein's famous line, "A rose is a rose

is a rose," which is often interpreted as a statement of identity, even though the intent and emphasis of the line shifted across Stein's remarkable career (Stein would later write, "I made poetry and what did I do I caressed completely caressed and addressed a noun"). Moyer replaces Stein's tautology with metaphor; the roles reverse and the bomb becomes a kind of gift or token and the rose a call to explosive action. This humor was characteristic of the Lesbian Avengers' visual output, much of it designed by Moyer—evident in the group's unofficial motto: "We recruit."

QUEER BOMB LOGO

QueerBomb! also uses the bomb as a visual metaphor for conflict and agitation. The group was founded by a group of self-identified LGBTQ people in Austin, Texas, in 2010. Its formation was a direct response to the politics of respectability practiced by the city's long-running pride organizations. Held on the eve of the city's pride celebrations, QueerBomb! branded itself an upstart alternative to the city's pride events, commencing with a rally and ending with a march in the streets of downtown Austin. The group's logo puts the "queer" in LGBTQ at the center of an exploding bomb—a visualization of the political power of queer people working together.

NOH8

Like the 1970s protests of Anita Bryant's Save Our Children campaign, and those combating Lyndon LaRouche's amendment nearly a decade later, the NOH8 campaign was instigated by a piece of discriminatory legislation, a California ballot proposition known colloquially as "Prop 8," banning same-sex marriage. Although eventually overturned in 2010, two years after the majority of Californians voted in favor of it, the proposition became the ideological center of national debates concerning gay marriage.

Shortly after Prop 8 passed, photographer Adam Bouska and his partner, Jeff Parshley, began to take photos of LGBTQ people and their allies with duct tape over their mouths. The message was clear— discriminatory laws silence the voices, lives, and experiences of LGBTQ people. Bouska posed his subjects against a bright, monochromatic white background, and temporarily tattooed "NOH8" on their cheeks—giving a visual homogeneity to the campaign. The "H8" in the campaign's title is doubly meaningful—both as a popular rendering of the word "hate" in Internet or "leet" language, and also as a critical rebranding of the California proposition number. Bouska's photographs circulated primarily through social media, giving a visual identity to a variety of campaigns seeking to overturn this and other anti-gay marriage propositions. Celebrities and tens of thousands of everyday people participated in the campaign, which remains an example of visual protest in the era of social media.

PRIDE FLAG EMOJI

First created by Shigetaka Kurita in 1999, the initial group of 176 twelve-by-twelve-pixel emoji remained largely insular to the world of Japanese telecommunications until Unicode translated them for an international market a little over a decade later. Since then the growth and expansion of emoji has been consistent. Discussions for a rainbow flag emoji began in earnest after the U.S. Supreme Court's *Obergefell v. Hodges* decision required all states to grant same-sex marriage licenses.

Added to the Emoji 4.0 update in 2016, the rainbow pride flag emoji joined other LGBTQ-themed emoji such as same-sex couples (added in 2012) and families with children and same-sex parents (added 2015). A subcommittee of the Unicode Consortium—a group of corporate representatives (Apple, Huawei, Google, and Facebook are all full voting members) responsible for maintaining industry standards regarding the encoding of the world's writing systems—develops and vets proposals for new emoji. The criteria for new emoji stipulate that proposed emoji must be popular, visually distinct, and somewhat open-ended and probably unintended regarding potential usage (think of the various ways the eggplant and peach emoji are used).

Currently there is a proposal written by a global group of authors to create a transgender pride flag emoji.

All Times

365 days
24 hours a day

No bigotry, hatred, or prejudice allowed at this station at any time.

Travel alternative:

This train only moves forward.

Reminder:

Your homophobia is probably just a phase.

Visit PrideTrain.com and follow @PrideTrain
on Instagram for more.

POST: June 2018, All over NYC; REMOVE: When everyone
has equal rights regardless of race, gender, sexual orientation,
nationality, ethnicity, language, religion, or any other status.

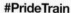

PRIDE TRAIN TAKEOVER

One of the tribulations of getting around New York City's subways is the ubiquitous MTA service advisories—publicly posted signs informing commuters of delays, cessations of service, and, sometimes, re-routings of their daily commute. Taking an object that usually invokes annoyance and distress and transforming it into a public reassurance for LGBTQ people is a queer move to be sure. When President Trump failed to acknowledge June as Pride Month in 2017 (the acknowledgment is by now a fairly boilerplate expectation of those sitting in the White House), Thomas Shim and his collaborators Jack Welles and Ezequiel Consoli designed a suite of six posters in the style of MTA service advisories, unequivocally declaring the month of June a holiday and stipulating "no bigotry, hatred, and prejudice at this station."

In their parodies of MTA service advisories (there are now twelve in total) Shim and his growing roster of collaborators have included wry references to *RuPaul's Drag Race*, *The Lion King*, and meme culture. The rainbow is used as a header for the posters (a clear symbol that they are not put out by the MTA), and the six train lines "affected" by the faux service advisories (1, F, R, 6, A, 7) together represent the six colors of Gilbert Baker's abridged rainbow pride flag. Since the Pride Train campaign's debut, Shim, who at the time worked as a global creative director at the advertising agency Y&R New York, expanded the scope of the project to include guerilla MTA notices that address racism—drawing commuters' attention to hate crimes that took place in particular subway stations—and, most recently, voting rights. The groups' interventions are documented on their Instagram account (@PrideTrain) and will hopefully be a perennial presence in New York's pride celebrations, encouraging revelers and rioters alike on their daily commute.

All Times

365 days
24 hours a day

No bigotry, hatred, or prejudice allowed at this station at any time.

Travel alternatives:

None. This train only moves forward.

Reminder:

Your homophobia is probably just a phase.

Visit PrideTrain.com and follow @PrideTrain
on Instagram for more.

POST: June 2018, All over NYC; REMOVE: When everyone
has equal rights regardless of race, gender, sexual orientation,
nationality, ethnicity, language, religion, or any other status.

#PrideTrain

All Times

365 days
24 hours a day

No bigotry, hatred, or prejudice allowed at this station at any time.

Travel alternative:

Five G's please: Good God Get a Grip Girl!

Reminder:

We're all born naked and the rest is drag.

Visit PrideTrain.com and follow @PrideTrain
on Instagram for more.

POST: June 2018, All over NYC; REMOVE: When everyone
has equal rights regardless of race, gender, sexual orientation,
nationality, ethnicity, language, religion, or any other status.

#PrideTrain

All Times

365 days
24 hours a day

No bigotry, hatred, or prejudice allowed at this station at any time.

Travel alternative:

Nothin'. What's a-motto with you?

Reminder:

Two men raised Simba and he turned out just fine.

Visit PrideTrain.com and follow @PrideTrain
on Instagram for more.

POST: June 2018, All over NYC; REMOVE: When everyone
has equal rights regardless of race, gender, sexual orientation,
nationality, ethnicity, language, religion, or any other status.

All Times

365 days
24 hours a day

No bigotry, hatred, or prejudice allowed at this station at any time.

Travel alternative:

All these flavors and you choose to be salty.

Reminder:

Love is love is love is love is love is love is love is love.

Visit PrideTrain.com and follow @PrideTrain
on Instagram for more.

POST: June 2018, All over NYC; REMOVE: When everyone
has equal rights regardless of race, gender, sexual orientation,
nationality, ethnicity, language, religion, or any other status.

#PrideTrain

BUCK-OFF

Buck Angel, a trans-masculine sex worker and porn star, developed his own sex toy in coordination with Perfect Fit Brand in 2016. Hilariously named Buck-Off, the toy is a sleeve masturbator made specifically for trans men. Small enough to fit in the palm of your hand, and made of Perfect Fit's proprietary SilaSkin material, Buck Angel's toy is an example of design centering the needs of trans bodies. As Angel discussed in an interview with the *Huffington Post*: "The toys that [have] existed on the market were made for cisgender people. Trans men have different genitals which means they have different needs."

As this book's final object, the Buck Off sleeve highlights some of the hallmarks of LGBTQ design. It is first and foremost designed by and for a segment of the LGBTQ community. Secondly, the toy centers the body and its pleasures, for which LGBTQ people have been historically marked as cultural and societal "others." And finally, the toy puts the terms and politics of liberation (here both personal and sexual) in the palm of one's hand. The toy suggests that *everyone* should have access to a satisfying and consensual erotic life. More pleasure...more life...more design.

PERFECTFIT
BRAND
BUCK-OFF
Official Buck Angel® FTM Stroker

SilaSkin™

AMAZING IS OUR STANDARD!™

ACKNOWLEDGMENTS

I'd like to thank all the archivists at institutions large and small who daily steward the material remains of the myriad LGBTQ communities and individuals represented in this book. Archivists at places like ONE National Gay and Lesbian Archives, the Lesbian Herstory Archives, the GLBT Historical Society, the June L. Mazer Lesbian Archives, and many other institutions that might not be specifically dedicated to LGBTQ folks and communities but who nevertheless seek to preserve and make available and accessible the stuff of our many overlapping and separate histories. Most especially I'd like to thank Loni Shibuyama, whose extensive knowledge and good humor during the research and image-gathering phases of this book were vital to its manifestation. Joseph Hawkins, Michael Oliveira, Bud Thomas, and Cooper Moll at ONE Archives provided guidance, context, and sometimes much-needed assurance in this book's assembly. The following trusted advisors gave insights that shaped this project in countless ways: Sarah Luna, Alexis Salas, Chelsea Weathers, Theodore Kerr, Kate X Messer, Jo Labow, Kay Turner, Jonesy, Beth Schindler, Lex Vaughn, Lucas Hilderbrand, Jennifer Tyburczy, Melissa Threadgill, Jessica Brier, Beth Payne, Anna Elise Johnson, Haven Lin-Kirk, Sherin Guirguis, Christopher Mangum-James, Hannah Grossman, David Frantz, Dan Paz, Rachel Hess, Char Skidmore, Ivan Lozano, and Amelia Jones. I have Ann Reynolds and Ann Cvetkovich to thank for introducing me to archival work and its generative possibilities. Graduate and undergraduate students at USC whose interests in queer visual culture are a constant wellspring of energy and inspiration—a reminder that there is always more, and that this work is ongoing—all played a key part in thinking about which objects to

ART AND PHOTOGRAPHY CREDITS

ONE Archives at the USC Libraries: X, XV, 8, 9, 10, 11, 12, 13 (all), 16, 17 (left and right), 18, 19 (top), 20, 24, 25, 26 (top and bottom), 27, 30, 31, 32, 33, 45, 47, 50, 60, 61, 63, 64, 67, 70, 71, 72, 73, 74 (left and right), 78, 79, 80, 110, 111, 118, 121, 134, 135, 138, 139, 149, 150–151, 162, 169, 178, 179, 182–183, 184

Jeanne Manford Papers, Manuscripts and Archives Division, The New York Public Library: VIII

Copyright © PFLAG National, All Rights Reserved: IX, XI

Manuscripts and Archives Division, The New York Public Library: XIII, 44, 53, 54, 55, 115, 116, 117

Courtesy of Lindsey Taylor: XIV

Stuart A. Rose Manuscript, Archives & Rare Book Library, Emory University: 6, 7

Copyright © Morgan Gwenwald: 19 (bottom)

Art by Irare Sabasu, courtesy Lesbian Herstory Archives: 20

Copyright © Liza Cowan: 20, 48, 49

Infograx via Getty Images: 28

Courtesy of the Leather Archives & Museum: 29, 125

Bob Mizer Foundation: 34, 35

GLBT Historical Society: 37 (bottom), 60, 66, 75, 131, 152

Wisconsin Historical Society: 51

Courtesy Lesbian Herstory Archives: 52

Copyright © Joey Terrill: 54, 55

Photographs by Simon Lee: 54, 55, 56, 57, 100, 161, 180, 197

Courtesy of Dean Sameshima: 56

Beinecke Rare Book & Manuscript Library: 58

Courtesy of Judy Dlugacz / Art Direction by Kate Winter, 1976: 68, 69

Courtesy of Pleasure Chest: 76–77

Photograph by Arizona Newsum and Derek Haas, courtesy of Richard Ferrara: 84–85

Copyright © Hal Fischer: 88, 89, 90, 91

Copyright © 1981 by Cherríe Moraga and Gloria Anzaldúa, by permission of Stuart Bernstein Representation for artists: 103

Photo by Evan Agostini/Liaison: 106–107

Photo by Jeffrey Markowitz/Sygma via Getty Images: 108

Photo by Stephen Chemin/Getty Images: 109 (top)

Photo by © Louise Gubb/CORBIS SABA/Corbis via Getty Images: 109 (bottom)

Copyright © Rick Sugden (aka *Little Elvis*), 1988: 116

Copyright © Barneys New York: 122

Copyright © Greer Lankton: 123

Keith Haring artwork © Keith Haring Foundation: 126, 127

Copyright © 2019 C.M. Ralph, All Rights Reserved: 128 (top and bottom)

Courtesy of Tom Jennings: 132, 178

Courtesy of Visual AIDS: 136, 137

Susie Bright Papers, Division of Rare and Manuscript Collections, Cornell University Library: 140

Copyright © Stone Yamashita: 156 (all), 157 (all), 158 (all), 159

Courtesy of REPOhistory: 165

Copyright © 13th Gen, Inc., Poster Design: R. Scott Purcell for Dancing Girl Productions, 1996: 166

Copyright © 2008 by Alison Bechdel. Reprinted by permission of Houghton Mifflin Harcourt Publishing Company: 174–175

Copyright © 1994 Roberta Gregory and Fantagraphics Books: 176, 177

Courtesy of Diane DiMassa: 176, 177

Courtesy of 2(X)IST: 180

Courtesy of Shigeru "Shigi" McPherson: 187

Copyright © Grindr LLC 2009–2018, All Rights Reserved: 197

Courtesy of GLAAD: 199 (all)

Courtesy of Roan Boucher: 200

Courtesy of Sylvia Law Project: 201

Courtesy of Black Lives Matter Global Network: 203

Copyright © gc2b: 204

Courtesy of Demian Diné Yazhi´: 206, 207

Courtesy of Chris E. Vargas: 208

Copyright © ADA Sign Depo, Inc.: 210, 211

-1001- via Getty Images: 216 (top and middle)

Sunshine_Art via Getty Images: 219 (top and bottom)

oleksii arseniuk via Getty Images: 221 (bottom)

Designed by Ryan Conrad for Against Equality, againstequality.org, 2009: 223

Copyright © 1993, Carrie Moyer: 224

Courtesy of NOH8 Campaign, photo by Adam Bouska: 226

Copyright © 2019 Perfect Fit Brand, Inc.: 234, 235

Copyright © Thomas Shim: 228, 229, 230, 231, 232, 233

Text copyright © 2019 by Andrew Campbell
Compilation copyright © 2019 by Andrew Campbell and Black Dog & Leventhal Publishers,
an imprint of Perseus Books, LLC, a subsidiary of Hachette Book Group, Inc.

Cover design by Katie Benezra
Cover photograph by Arizona Newsum and Derek Haas
35th Anniversary Rainbow Flag hand dyed and sewn by Gilbert Baker, courtesy of Richard Ferrara
The flag in this photograph is signed in the lower right corner and is flag #6 in a series of 35 flags
made in 2013 by Gilbert Baker for the 35th anniversary of the creation of the Rainbow Flag.
One of the flags from this series was given to President Barak Obama in June 2016.
Another was added to the permanent collection of the London Design Museum in 2017.
Cover copyright © 2019 by Hachette Book Group, Inc.

Hachette Book Group supports the right to free expression and the value of copyright. The purpose
of copyright is to encourage writers and artists to produce the creative works that enrich our culture.

The scanning, uploading, and distribution of this book without permission is a theft of the author's
intellectual property. If you would like permission to use material from the book (other than for review
purposes), please contact permissions@hbgusa.com. Thank you for your support of the author's rights.

Black Dog & Leventhal Publishers
Hachette Book Group
1290 Avenue of the Americas
New York, NY 10104

www.hachettebookgroup.com
www.blackdogandleventhal.com

First Edition: May 2019

Black Dog & Leventhal Publishers is an imprint of Perseus Books, LLC, a subsidiary of
Hachette Book Group, Inc. The Black Dog & Leventhal Publishers name and logo are
trademarks of Hachette Book Group, Inc.

The publisher is not responsible for websites (or their content) that are not owned by the publisher.

The third party trademarks used in this book are the property of their respective owners.
The owners of these trademarks have not endorsed, authorized, or sponsored this book.

The Hachette Speakers Bureau provides a wide range of authors for speaking events.
To find out more, go to www.HachetteSpeakersBureau.com or call (866) 376-6591.

Print book interior design by Katie Benezra
Back cover art and end sheet art copyright © 2019 by Xavier Schipani

LCCN: 2019930099

ISBNs: 978-0-7624-6785-3 (paper over board); 978-0-7624-6791-4 (ebook)

Printed in USA

WW

10 9 8 7 6 5 4 3 2 1